# PASTICHE

# PASTICHE

INDIANA UNIVERSITY PRESS

BLOOMINGTON AND INDIANAPOLIS

CULTURAL MEMORY IN ART, FILM, LITERATURE

Ingeborg Hoesterey

This book is a publication of

Indiana University Press
601 North Morton Street
Bloomington, IN 47404-3797 USA

http: //www.indiana.edu/~iupress

*Telephone orders* 800-842-6796
*Fax orders* 812-855-7931
*Orders by e-mail* iuporder@indiana.edu

© 2001 by Ingeborg Hoesterey

**Library of Congress Cataloging-in-Publication Data**

Hoesterey, Ingeborg.
    Pastiche : cultural memory in art, film, literature /
Ingeborg Hoesterey.
       p.   cm.
    Includes bibliographical references and index.
    ISBN 0-253-33880-8 (cl : alk. paper)—ISBN
0-253-21445-9 (pa : alk. paper)
       1. Postmodernism. 2. Imitation in art.
3. Appropriation (Art) 4. Arts, Modern—20th
century.   I. Title.

NX456.5.P66 H63 2001
700'.9'049—dc21
                                           00-061397
 1   2   3   4   5  06   05   04   03   02   01

# CONTENTS

ACKNOWLEDGMENTS • VII

INTRODUCTION • IX

1. **A Discourse History of Pasticcio and Pastiche** • 1

2. **Pastiche in the Visual Arts** • 16

3. **Cinematic Pastiche** • 45

4. **Literary Pastiche** • 80

5. **Pastiche Culture Beyond High and Low:** Advertising
Narratives, MTV, Performance Styles • 104

Coda • 118

NOTES • 121

WORKS CITED • 127

INDEX • 133

ACKNOWLEDGMENTS

From the beginning, the risky interdisciplinary nature of this project invited the collaboration of colleagues in different humanities disciplines. While a fellow in the University of California Humanities Research Institute at Irvine in 1991, I was fortunate to be able to assemble, on campus, an amenable team of advisors. The art historians Linda Bauer, George Bauer, and Anna Gonosova gave generously of their expertise and time, while Romance literature scholar Judd Hubert kindly introduced me to the etymological past of pasticcio/pastiche. Chris Aschan, the Institute's librarian, helped to digitally access the diffuse bibliographic identity of pastiche, as did later, targeting art-historical evidence, Mary Clare Altenhofen at Harvard's Fine Arts Library.

Dialogical input continued to accrue in a nomadic fashion. Numerous papers and talks given to responsive audiences in this country and in Europe during the nineties invariably left their traces on the meandering path of conception, writing, and rewriting. In particular, I would like to thank Frances Fergusson and Silke von der Emde of Vassar College for letting me air my material before a discriminating faculty, and Karin Wurst for inviting me as a plenary speaker to a conference at Michigan State University, which produced the first major article: "Postmodern Pastiche: A Critical Aesthetic" (*Centennial Review* 39, no. 3 [1995]). Fellowships in 1998 and 1999 at the Institute for Cultural Studies in Essen, Germany, provided (also) an opportunity to develop an article in German on the topic of pastiche and to discuss it with Alexander Honold and Doris Kolesch. I praise Walter Grünzweig (Dortmund) and Helmut Schneider (Bonn) for introducing it to their academic communities. Thanks to the encouragement of Paul Michael Lützeler of Washington University, St. Louis, the digest version then made it from an Essen conference into the upgraded volume edited by Lützeler.

At Indiana University, Leonard Hinds made his solid knowledge of the French encyclopedic tradition of the seventeenth and eighteenth centuries available to my search for lost origins. Conversations with Elinor Leach, Peter

Bondanella, Katrin Sieg, Willis Barnstone, and Henrik Birus (visiting from Munich) helped in various ways to strengthen my argument. John Durbin deserves acknowledgment for his work on the bibliography. At the University of Wisconsin, Jost Hermand gladly lent his discerning eye to an early version of the manuscript. And for her productive reading of a more advanced version, Judith Ryan of Harvard University deserves my sincere gratitude.

I am especially indebted to the staff of Indiana University Press—to Jane Lyle, managing editor, for her kind perfectionism; to Michael Lundell for his obliging editorial assistance; and to Joan Catapano, senior editor and assistant director, whose commitment to the project and its author has been invaluable.

For gestures of kindness and advice over the years, my last note of thanks goes to my friends Jens Rieckmann, Dorrit Cohn, Ursula Block, and Monika Totten, and last but not least, to my daughter, Kay Moffett.

# Introduction

*pasticcio*—A medley of various ingredients; a hotchpotch, farrago, jumble; *pastiche*—to copy or imitate the style of.
— *Oxford English Dictionary* (1989)

*pastiche*—f. It. *pasticcio*—a literary, artistic, or musical work that closely and usually deliberately imitates the style of a previous work. . . .
— *Webster's Third New International Dictionary, Unabridged*

*Pastiche*—pâté, mishmash, art fake.
— *Metzler Literaturlexikon* 1984

Binding norms [for art] produce nothing but pastiche.
—THEODOR W. ADORNO (1967)

One of the most significant features or practices in postmodernism today is pastiche.
—FREDRIC JAMESON (1983)

Pastiche—chopped liver.
—GARRISON KEILLOR (1997)

This jumbled collage of some recent statements about an age-old genre of dubious reputation may offer a glimpse of the discursive status of the twin concepts "pasticcio" and "pastiche." What these few, abbreviated quotations do not disclose is a greater than usual discrepancy between critical discourse concerning the arts and actual artistic practice. The rebirth of pastiche in the spirit of postmodernism has taken place across the spectrum of the arts, yet critical theorists of differing shades have been curiously shy about challenging the common notion of pastiche as *quantité négligeable.* Considering the impact that Foucauldian discourse analysis and deconstruction have had on many operations of contemporary critical discourse, the problematizing and "rewriting" that has become the academic's daily bread, it is surprising that the term "pastiche" continues to be used in a vaguely traditional, predominantly negative sense. Even most enlightened minds do not probe into the historicity of genre construction and signification with regard to this scintillating exemplar.

The *locus classicus* for the lack of critical reflection about the classification in question is Fredric Jameson's commentary on pastiche, first published in Hal Foster's anthology *The Anti-Aesthetic* in 1983 and

a year later in an essay for *New Left Review*. In "Postmodernism, or The Cultural Logic of Late Capitalism," the prominent critic dismisses postmodern pastiche as "blank parody." Jameson writes, "Pastiche is, like parody, the imitation of a peculiar mask, speech in a dead language; but it is a neutral practice of such mimicry, without any of parody's ulterior motives, amputated of the satiric impulse" (Jameson 1983: 114; 1984: 65).

The much-cited statement was pivotal for many participants in the debate on postmodernism and puzzling for those observers of "aesthetic postmodernism" who may also practice ideological critique, but not necessarily within the framework of Marxist aesthetics, the dominant in Fredric Jameson's composite theoretical position.[1] It should be remembered that cultural Marxism and Frankfurt School critical theory tend to collapse all art forms into "art" as a generic entity. Theodor W. Adorno's *Theory of Aesthetics*, for instance, brilliantly attests to philosophy's neglect of medium difference, the specific materiality and structurality that shape each art form's identity. This blindspot has traditionally been a privilege of philosophical aesthetics devoted to conceptualizing the enterprise of art in most general terms that annul all formal difference, for instance between literature and the plastic arts.

Since the twentieth century, directly and more basically involved observers of the visual arts—here including architecture, design, and film—have typically been closer in sensibility to artists, their works, and the art world in general than philosophical commentators. A position of affinity to the artistic process can be felt throughout the book. It is informed, however, by the theoretical insight of the philosopher and practicing art critic for *The Nation*, Arthur C. Danto. Asked by *The New York Times* along with other public figures to answer the question "Is it Art? Is it Good? And Who Says So?," Danto supplied a *vade mecum* for twenty-first-century encounters with visual culture: "Art these days has very little to do with aesthetic responses; it has more to do with intellectual responses" (Dec. 12, 1997). For Danto, something qualifies today as a work of art when it can make a meaningful contribution to social and artistic conversations.[2]

This book attempts to refigure the mercurial pastiche genre from the Other of high art to an aesthetic of difference, a refiguration that situates itself in the discursive space projected by Danto.[3] If I propose to look at pastiche structuration across a spectrum of various arts, I am keenly aware of the fact that I am isolating one direction among many. This is particularly true of the plastic arts, where diversity has taken on overwhelming proportions that cannot be contained by the consoling label of "The New Pluralism," which the

Museum of Modern Art in New York suggested in one of its "writings on the wall" in the mid-nineties.

The production and reception of contemporary visual art (often posing as non-art) are in turn embedded in a larger theoretical framework of postmodernisms; it is a positionality shared to a degree with other arts and part of the radical hybridity that the philosopher Cornel West sees as operative in the social practices of contemporary society. In the waning decades of this century, producers of art (in the widest sense) are involved in these general processes of heterogeneous conjunction, not least through the redefinition of pasticcio/pastiche, which for centuries were modes of artistic expression on the fringe of aesthetic canons, elusive, notorious. Metamorphoses of the multifaceted *genre mineur* can be found today in architecture, painting, sculpture/assemblage, in film and literature, in commercial art, in popular music, and in performance modes ranging from neo-operatic to MTV idioms.

Postmodern pastiche is about cultural memory and the merging of horizons past and present.[4] One of the markers that set aesthetic postmodernism apart from modernism is that its artistic practices borrow ostentatiously from the archive of Western culture that modernism, in its search for the "unperform'd," dismissed.[5] Artists have been re-examining traditions that modernism eclipsed in its pursuit of the "Shock of the New" (Robert Hughes) or, in the case of the architects, the functionalism of the international style.

The swift social success of postmodern architecture led to an incision that is significant for our argument. For two decades architects practiced the evolving aesthetics of quotation and incorporation of past forms and styles with a vengeance. At the end of the eighties, avant-garde practitioners turned away from postmodernist architectural style, which had begun its decline, toward the myriad of watered-down copies in general building practices across the land, with the usual compromises. As ambitious architects pursue new directions, "deconstruction" and/or "second modernism,"[6] their move allows us to historicize postmodern style and separate it, to a degree, from (post)modernity as an epoch. It becomes possible to look at pastiche structuration in several arts as an exemplary feature of aesthetic postmodernism. Not a unified discourse formation, to be sure, aesthetic postmodernism positions itself in general culture beyond a high-low dichotomy, in contrast to modernism.

A focus on the materiality of pastiche structuration in the plastic arts, film, and literature, as well as popular and commercial culture, is therefore by no means a return to a formalist position, as much as form does matter in our discussion. On the contrary, postmodern pastiche, shedding the genre's vague

image, will be portrayed as aspiring to attain the status of a critical art that could legitimately claim to represent an emancipatory aesthetics, i.e., art that fosters critical thinking.[7]

Pastiche as cultural critique: the proposition describes artistic form in the service of enlightened discourse, whether these works are associated with the plastic arts, film, or literature. The material of chapter 5 on "Pastiche Culture"—commodity pastiche and popular culture—caused a crisis of legitimation of sorts. The challenge issued by the pastiches introduced under more traditional generic headings in earlier chapters, namely a mediation between high and low culture, led directly to the necessity of an inquiry into the dialectic of the law of the market versus the authentic ambitions on the part of commercial artists.

Before the pastiche genre reached the status of cultural relevance envisioned here, its spotty but by no means only negative past had to be unraveled. Chapter 1 is the Ariadne thread that traces the discourse on pasticcio/pastiche from its inception in sixteenth-century Italian art circles to today, at times resembling a detective story. It is hoped that the historical narrative of the assorted discursive fates of pasticcio/pastiche may help alleviate the dilemma of cultural (mis)understanding alluded to above.

The conflation of genres appears to be one of the undisputed characteristics of aesthetic postmodernism. In this light, it may seem odd that the arrangement of the chapters in this book follows traditional genre designations. This move was, first of all, one of self-preservation: the material gathered over seven years turned into a menacing presence with infinite potential for overlapping signification; structuring in accordance with proven criteria answered an emotional-intellectual need. Cross-referentiality and noted correspondences among the different segments break up the sober arrangement. Furthermore, a background in structuralist narratology *and* form-oriented art history/criticism favors an adherence to genre difference. Finally, it is this membership in two methodologically different fields, literary studies and art history, that allowed me to delve into comparative arts, a sub-discipline of Comparative Literature.

Any exercise in comparative arts is guilty of transgression. It naturally begs the caveat of limited liability: drawing upon the scholarly traditions of several disciplines often means sacrificing depth for breadth. My emphatic apologies to the experts of popular culture, whose field becomes—in chapter five—the stage for the satyr play of the non-expert. Pastiche structures are, however, pervasive in the varied manifestations of popular culture, and to ig-

nore them seemed more offensive than to introduce them in a rudimentary fashion.

Since there is no monograph on pastiche and no book-length study from a comparative arts perspective, the interpretive display of the archive emerged as a must.[8] To this effect, the lengthy case studies in the chapters on the plastic arts, film, and literature are each supplemented by a catalogue of further pertinent examples—"short takes." Archive fever and an archeology of the new.

# PASTICHE

# A DISCOURSE HISTORY OF
# PASTICCIO AND PASTICHE

1

To write a discourse history of the terms "pasticcio" and "pastiche" is nothing short of adventurous. First of all, there is only sporadic and scattered scholarship pertaining to the evolution of the *genre mineur* and its varied presence in the visual arts, in music practices, and in literature, and none from a comparative arts perspective. French scholarship has discussed literary pastiche extensively, but in an exclusive fashion, sealing it off from developments in the other arts. Art history of this century has used the notion of pastiche predominantly to mark the Other of high art. Despite its lowly status, the genre of pastiche functions as a fixed convention in the language of art history, which may account for the absence of critical inquiry on the subject (see chapter 2). Our inquiry becomes more thrilling with the discovery that the authorship of the most cited definition of pastiche—the one that truly establishes the identity of the genre—is clouded in a fog of attributions. Before we set off down the path of philological detection, we must visit the pasticcio past of pastiche.

Literally, "pasticcio," derived from Common Romance *pasta*, denoted in early modern Italian a pâté of various ingredients—a hodgepodge of meat, vegetables, eggs, and a variety of other possible additions (Battaglia 1984: 791). In the wake of the Renaissance, the art scene grabbed "pasticcio" as a metaphor to describe a genre of painting of questionable quality that was the product of a "pittore eclettico che dipinge con techniche e stili diversi" (an eclectic painter who drew upon diverse techniques and styles; Battaglia 1984: 790). Pasticcio was highly imitative painting that synthesized—"stirred together"—the styles of major artists, often with seemingly fraudulent intention, i.e., to deceive viewers and patrons. (In today's common Italian, pasticcio usually denotes a flaky piecrust or pie, but the figurative meaning retains its ties to the older hodgepodge pâté in signifying "a mess," "confusione mentale," or bad work.)

# PASTICHE

We have little information about the production of *pasticci*. We know that the growing demand for Renaissance art in Rome and Florence in the sixteenth century led to a lively market, which encouraged many average painters to produce covert imitations of High Renaissance masters (Hempel 1965: 165). These artists would skillfully combine elements from several originals into a product of their own making, approximating a sort of generic High Renaissance style that was then sold to buyers as authentic, or as the work of an authentic master.

The process of amalgamating stylistic features in a work of fine art was not entirely new. Roman artists had made a living copying parts of classical, often partially extant Greek, originals and combining them into a new whole with an ancient identity (Lützeler 1962: 534). In *Ancient Painting*, Mary Swindler discusses a similar process of synthetic copying that was used in the creation of a Roman fresco on stucco, the Aldobrandini Wedding (Vatican Library): "Whether it is a copy of an earlier Greek work or a late creation of a Neo-Attic master with eclectic tendencies remains uncertain" (Swindler 1929: 329).

The sixteenth-century practice of creative yet fraudulent copies may also have flourished in the context of a certain academic discourse, the "selection theory" that had governed formal art training since Alberti, i.e., since the early Renaissance. We are well-informed about the program of "selection" from an aesthetic canon as a result of its dismissal by the baroque sculptor and architect Bernini (Lavin 1980: 11).[1] At the core of the selection aesthetic was a legend about a Helena figure made by the ancient Greek painter Zeuxis which allegedly combined the most perfect features of several different maidens. Artists interpreted the idea of selection by making use, for instance, of the drawing of this painter and the color of that one to arrive at an ideal depiction and an optimal work. It was said that Tintoretto combined Michelangelo's *disegno* and Titian's color. Bernini criticized this selection practice and argued that one woman's eye would not look good on another's face. He had, as one might speculate, a different synthesis on his agenda, namely unifying previously separate visual art forms—painting, sculpture, architecture—in the baroque splendor of St. Peter's. As composite paintings, *pasticci* may have been viewed as lowly variants of works executed according to the "selection theory," art that conflated the specific formal features found in different masters.

Typically, however, the producers of pastiches were not theoretically motivated; they were highly talented appropriation artists such as Luca Giordano, the seventeenth-century painter from Naples, who pastiched the heads of Guido Reni and the style of Carracci so efficiently that he earned the nick-

name "il-fa-presto," the fast one (*Encyclopédie* 1765: 156). Guido Reni was at the same time the object of active admiration by the accomplished and very busy copyist Sassoferrato, as was Raphael. Sassoferrato specialized in devotional art, re-creating Raphaelesque madonnas for a large clientele of indiscriminate patrons (Russell 1977: 699). "Sassaferrato's Raphaels and Renis had a dual social and aesthetic function, meticulously painted icons for those whom circumstance debarred from possession of originals and yet who wished to own religious images of a recognisably traditional cast" (700).

The assessment of the contemporary art historian suggests the climate of a growing art appreciation that stimulated the production of *pasticci,* often, as in Sassoferrato's case, tending toward copy rather than eclectically blended pasticcio. Whereas the latter mode was often held in low esteem, the brilliantly executed copy of a single masterwork of painting met with a somewhat different reception. The High Renaissance artist Andrea del Sarto from Florence painted a copy of Raphael's portrait of Pope Leo X soon after the completion of the original in 1518, a pastiche that became famous for having deceived even insiders such as Giulio Romano (*Encyclopédie* 1765: 156). Most of these pastiches were executed in the medium of painting, although sculpture was not excluded. The stucco figures for the Sala Regia in the Vatican by Daniel da Volterra (mid-sixteenth-century) simulated the sculptural genius of Michelangelo, and they, too, apparently were admired.[2]

We can further document the admiration for counterfeit paintings and sculptures through a statement made by Filippo Baldinucci, the seventeenth-century critic who continued Vasari's biographical enterprise: "Dicevano che egli era un pasticciere die quadri; ma gli uomini di buon gusto, e privi d'ogni passione non lasciavano pero mai di provvedersi de' suoi pasticci" (It was said that he [Baldinucci does not name a specific artist] was a *pasticciere* of paintings; but those with good taste and free of passion never had any inhibition about acquiring his *pasticci*) (Battaglia 1984: 790). A century later, the *Encyclopédie* (1765: 155) offers a more laudatory comment on the talent of the pasticcio artist: "One needs to have a genius very similar to that of the painter one wants to copy for the work to be taken as being this painter's" (my trans.).

By the mid-seventeenth century, at roughly the time of Baldinucci's writing, the Italian art scene could look back on a hundred years of pasticcio production. Appreciation for the genre wavered between admiration for the superbly executed copy of a masterwork, the fraudulent copy made for a "mass market," and the ambivalent reception of the pasticcio as stylistic medley. The second, mass-market copy was by definition anti-classical, since it bastardized the acknowledged achievement of classical art rewritten by the Renaissance,

whereas pasticcio as quasi-homage to and assimilation of a great master received a positive reception that was to spill over into developments in literature in France a century later.

It is generally assumed that the Italian concept traveled to France in the seventeenth century, where it became known as "pastiche." A cognate of "pasticcio" meaning "pâté," the word "pastiche" derives from old Provencal *pastis* and medieval Latin *pasticium* (*"Le Grand Robert"* 1985: 164). Already immersed in the elusive genre, we now embark upon an etymological investigation with the available encyclopedic material and visit the authentic textual environment of the alleged first mention of the French term. Numerous references point to the art theorist Roger de Piles (1635–1707/1709) as one who first described "pastiche," in a treatise published in 1677. This inaugural date reappears again and again in criticism and reference works from the eighteenth century to today, with or without the definition attributed to de Piles. Newer dictionaries borrow the definition as quoted and partially amended in the *Histoire de la Langue Française*, compiled by the well-known philologist Ferdinand Brunot:

> Quant aux *pastiches*, ce sont des "Tableaux, qui ne sont ni des Originaux, ni des Copies," mais des contrefaçons. Leur nom vient de l'italien "*pastici* [*sic*], qui veut dire *Pâtez:* parceque de même que les choses différentes qui assaisonnent un Pâté, se reduisent à un seul Goût; ainsi les faussetez qui composent un *Pastiche*, ne tendent qu'à faire une verité." (Brunot 1930: 718)[3]

The material in quotation marks is annotated as "R.de Piles, *Connaiss. des Tabl.*, III," and is undated. The desire to go to the source of what has become the most prominent formula of pastiche was surely not unusual. This minor philological inquiry, however, led into a jungle of conflicting references, which roused the detective in this scholar in ways quite out of proportion with the project at hand.

Of the ten books authored by Roger de Piles, none has a title that directly corresponds to the one quoted in Brunot; nor do any of the numerous reviews written by this prolific writer on art (Teyssèdre 1957: 656–78). One is inclined to read the title given in the note, *Connaiss. des Tabl.*, to refer to two verbal items in the full title of the Roger de Piles treatise of 1677 alluded to above, *Conversations sur la Connaissance de la Peinture/ et sur le Jugement qu'on doit faire des Tableaux*. The reading of the 1677 treatise leads one to the Rubens lover Roger de Piles and his concern for problems of color, quality, and imitation of the ancients. The object of desire, the much-sought-after quotation attributed to de Piles, is nowhere to be seen. Furthermore, Brunot's reference

suggests a Part III in the title cited, and the 1677 volume has only two parts. It does have an extensive index of concepts wherein one might well expect to find "pastiche" between "passion de l'âme" (passion of the soul) and "peintre" (painter). The absence of such an entry, however, confirms the absence of a mention of "pastiche" in this work.

As stated above, 1677 is the date given in numerous reputable dictionaries, including *Le Grand Robert* (1985), for the first occurrence of the word "pastiche."[4] It is tempting indeed to delve into the question of how and when the discursive juncture occurred that prompted writers of dictionary entries and critics to attribute the formula "ni originaux, ni copies" to Roger de Piles and his 1677 treatise (Hempel 1965: 165). By now our innocent philological inquiry has taken on the appearance of a sleuthing operation. More signs of the well-known inconsistencies in the transmission of data over a long period of time emerge: the Brunot annotation refers us to the Richelet (1680) and Furétiere (1727) dictionaries, yet neither lists an entry on pastiche or pasticcio. Other references cited by Brunot fail to throw light on the enigma surrounding our most wanted definition. Some encyclopedic works (not named by Brunot) give the date of the quotation that Brunot attributes to de Piles as 1751 (or 1752), the first publication date of the initial volume (s) of the *Encyclopédie*. The *Oxford English Dictionary* (1989) dates its citation of the "de Piles" formula in translation to 1706, without further documentation.

Our desire to trace the statement that could establish the discourse tradition of a genre—that indeed has been identified with it for more than two hundred years—inadvertently revealed what poststructuralists have been maintaining all along: that there is not one origin (Derrida) but a forest of origins; that discursive conventions come about through displacements and transformations, through successive rules of use (cf. Foucault 1982: 4). Thus, we forced the detective genie back into the bottle, gave up the micrological optics of a private eye (from a neighboring discipline), and decided to do as Romance studies scholars do: to treat all those referential uncertainties that we encountered as discursive facts. Working with the definitions and data that the great encyclopedic tradition handed down to us will henceforth enlighten our argument, not arouse longings for positivistic certainty. That discourses create realities is a topos in culture studies. Although the effect of discourse discussed here hardly holds the urgency associated, for example, with the construction of gendered identity past and present, it does demonstrate how the system of linguistic cultural production works—lots of chaos on the way to signification.

The quasi-anonymous definition of pastiche as "neither original nor copy"

that traveled from treatise to article and dictionary to encyclopedia established the genre as we now know it. The tail end of the "de Piles" formula as related in Brunot is significant for a more differentiated theorization of the genre: its comparison to the taste of pâté. As the different ingredients that season a pâté create one flavor, the falsities that make up a pastiche create a kind of truth, "une verité." The use of the concept of "verité" has been challenged by Wido Hempel, rendering the authenticity of the whole quotation uncertain.[5] Perhaps "verité" signifies the peculiar type of unifying sensibility that a typical pastiche projects, albeit stemming from a unity of stylistically heterogeneous elements. It is conceivable that the author of the "de Piles" definition needed a sufficiently abstract analogy to compare the flavor of pastiched paintings to the savor of a pâté.

Our perusal of so many eighteenth-century dictionaries brought us back again and again to the great Enlightenment project of the *Encyclopédie,* and to our chosen 1765 "Neufchastel" edition. The two columns on pastiche in the twelfth volume must be viewed as the most extensive write-up on the subject of pastiche in any work of reference at that time. That the entry focuses exclusively on pastiche in the visual arts suggests that the dissemination of the new concept and its application to literature did not occur until the last third of the eighteenth century.

> . . . Les *pastiches,* en italien *pastici* [*sic*], son certains tableaux qu'on peut appeller ni *originaux,* ni *copies.* . . .

> ( . . . certain pictures that one could call neither originals nor copies. . . .)

Then the definition abandons the "de Piles formula," echoing the earlier Baldinucci description of the pasticcio:

> but they are made in the sensibility and manner of another painter, with such artistry that the most clever have sometimes been deceived. (My trans.)

Except for the assessment of "Jordane le Napolitain" (the same Luca Giordano mentioned above), the definition does not stress the hodgepodge nature of the genre indicated in the Italian etymology. It focuses on pastiche both as an ingenious, acknowledged copy of a masterwork—for example, del Sarto's copy of Raphael—and as a counterfeit painting. Possibly inspired by the critical reflections of the early comparatist of the arts Jean Baptiste Dubos on the subject of pastiched art, the author of the *Encyclopédie* entry, "D.J." (Chevalier de Jaucourt), reports several deceptive pastiche operations, including fraudulent versions of Poussin landscapes by a Nicolas Le Loir and pastiches of Ital-

ian paintings by a Bon Boulogne that were said to have fooled collectors and cost them dearly.[6] At the end of the rather anecdotal entry, the author suggests a means for discovering the artifice in pastiches: one should meticulously compare them to the expression as well as the preference in design and color of the original.

As editor of the *Encyclopédie*, Diderot did not choose to write the columns on pastiche, despite his considerable interest in art. He is, however, known to have complained in his roughly 500-page critique of the artworks in the "Salon 1767" that the derogatory use of the term "pastiche" might discourage artists from imitating the best of the old masters (Brunot 1930: 718, note 3).

We find the same concern about the lowly status of pastiches and the endangered merits of imitation in the writings of the theoretician Jean-François Marmontel, who adopted the notion of pastiche for French literature. In his *Elémens de littérature* of 1787, Marmontel considers the literary pastiche "une imitation affectée de la manière et du style d'un écrivain" (an affected imitation of the manner and style of a writer), comparing this effort to the picture done in the manner of a great artist and fraudulently traded as the original (Marmontel 1787: 187). "Affected" is the key word here, for classical poetics did not oppose imitation per se of a great author. The ancients fed on their tradition by imitation. The imitation Marmontel had in mind "translates" freely from one "language" into another, all the while comparing itself to the ancient work. Virgil did so and surpassed his model, Apollonius of Rhodes (206).

The poetician closes the entry on pastiche with his theory of imitation in mind when he points to a potentially more positive assessment of pastiche: "A rare talent," Marmontel writes, "one who is high above the pettiness of that exercise one calls pastiche, may be able to truly assimilate to the greatness of a writer, to penetrate his soul and his genius, be it as an homage or because he wants to write in the master's genre" (190, my trans.). To Marmontel, mediocre imitators take nothing but the "feathers" of the exemplary work; their pastiches copy merely exterior or weak features (Hollier 1975: 9168). The formidable tradition of literary pastiches that developed in the nineteenth century in France—and almost exclusively in this culture—can be traced back to Marmontel's ambivalent, albeit encouraging, assessment of the pastiche genre.

Before we show how an early-twentieth-century redefinition of the literary pastiche became crucial for our notion of postmodern pastiche, it is necessary to hark back to another offshoot of the original pasticcio metaphor, the specific discourse formation in the musical arts, which also contributes to the

identity of pastiche today. The fluctuation in the semantics of the pasticcio genre between negative and positive poles was in full swing in the European music community from the end of the seventeenth century onward.[7] A complex typology evolved that retained the cumulative structure of the early pasticcio as composite painting. Pasticcio in both spiritual and worldly music began to signify the practice of arranging pieces by several composers into a new work and entity.

A new positive value became attached to the genre as a result of the pragmatics of the music scene in the eighteenth century: the commercial exploitation of "favorite arias," which were assembled in quasi-operatic works billed as new. (Not that this fooled music critics, as the reaction to the pasticcio opera of the troupe of Angelo Mingotti in Dresden 1746 showed [MGG].) The creation of a pasticcio, more than that of an original opera, depended upon a balance of interests among the impresario, the singers or their managers, and the musical director, all of whom had to agree on the selection and arrangement of the work (Grove). The pasticcio enabled wandering opera troupes to offer attractive novelties wherever they went, although they had only a limited musical repertory. Music historians claim that without these pasticcio performances, the Italian opera would not have gained a foothold in France and elsewhere in Europe.

Subsequently, pasticcio structures themselves became an important part of operatic (and general) composition, from John Gay's *The Beggars' Opera* to Gilbert and Sullivan to Leonard Bernstein's *Candide*. Some music historians point out that with the rise in the nineteenth century of the notion of originality, the pasticcio experienced a devaluation on artistic grounds (MGG). Twentieth-century, musicological discourse by artists and critics tended to use the term "pastiche" to denote the self-conscious emulation on the part of a major modern composer of an earlier one or an earlier style, e.g., Serge Prokofiev's Classical Symphony, No. 1 in D-minor, based on a work by Haydn (who liked to quote one of his compositions in another).

Encyclopedias are mills that grind out their negotiable facts slowly, unable to furnish current data; general music references fail to account for the vitalization of pastiche across the gamut of contemporary music production. John Corigliano, Richard Danielpour, Anne Dudley, Michael Nyman (see chapter 3), Stephen Sondheim, Alfred Schnittke, and Wolfgang von Schweinitz are among the composers of musical pastiches.[8] Their work frequently harks back to the old pasticcio model that blends the styles of different artists, as do the pieces of certain interesting practitioners of popular music.[9] Of course, this is done self-consciously and with artistic ambition, which links these

practices very distinctively to pastiche developments in the other arts. Self-consciousness was likewise the key element in the crucial revaluation process in French literary culture at the beginning of the twentieth century, which shaped our conceptualization of postmodern pastiche.

Marcel Proust's *Pastiches et mélanges*, whose various pieces were written after 1900 and published in 1919, yields the important redefinition of the status of the genre relevant for criticism today. For Proust, according to Denis Hollier, the pastiche is not so much writing but reading (Hollier 1975)—pastiche as the ideal form of creative critical activity, as *Auseinandersetzung* (to use one of Derrida's favorite German words), the coming to grips of a writer with the works of revered authors.[10] The Proustian pastiche is seen by Hollier as constituting the intertextual play that is literature. It is this dialogical mode of pastiche that becomes a major focus of cultural production in postmodernism.

Despite the progressiveness of Proust's interactive model of artistic growth, the typical understanding of pastiche by literary scholars still adheres to the imitation paradigm proposed by Marmontel, which involves a pasticher who emulates the style of one writer or work.

Given the French predilection for the aesthetic forms of antiquity, it is curious that the Greek-Latin cento never made it into the structure of literary pastiches in France. The cento (see chapter 4) is a patchwork text of borrowings from famous authors and is structurally similar to the hodgepodge type of the early pasticcio. Musicologists use the term "cento" as a synonym for "pasticcio" when they describe a libretto that has several producers of text and/or diverse textual sources, as does Hofmannsthal's libretto for Richard Strauss's *Der Rosenkavalier* (MGG; Weisstein 1987). The chapter on literary pastiche will resurrect the cento form to accommodate a specifically postmodern type of literary pastiche, which distinctly differs from the French standard of quasi-homage, and which we will call "cento pastiche." The designation is redundant in the other postmodern arts—visual art, film, cultural hybrids, music—since here the first definition of pastiche is a "stylistic medley" or blend of diverse ingredients.

The slippery quality associated with the pastiche genre is in part due to the dual structural profile that was there from the outset: imitation of a masterwork and the "pâté" of components. Vagueness of image also continues to be part of the genre's discourse history, because certain qualities and features of the pastiche mode overlap with other aesthetic categories. We are dealing with a vast semantic field in which such superimpositions of genre and mode come about as a result of cultural perceptions and conceptual traditions. The

following glossary aims to chart the contested territory that surrounds the mercurial genre of pastiche.

## The Semantic Environment of Pastiche: A Glossary

### Adaptation

In cultural discourse, adaptation means the modification of artistic material transposed from one genre to another. Adaptation may be part of pastiche structuration and can take various forms (see my discussion of the "Michelangelo Vase" in chapter 2).

### Appropriation

(1) In the early eighties, the term "Appropriation Art" was coined to describe the advent of the citational style in painting and other mediums. At the time, "pastiche" was only negatively coded. "Appropriation art" stresses the intentionality of the act of borrowing and the historical attitude of the borrower.

(2) In late capitalism, appropriation, usually covert, is a pervasive practice in the global economy and in the practice of advertising in particular (cf. Nelson and Schiff 1996: 116–28).

### Bricolage

A concept introduced by Claude Lévi-Strauss in *La pensée sauvage* (*The Savage Mind*, 1962). The "bricoleur" works with what is on hand, and this tinkering, according to the structuralist anthropologist, can produce brilliant and unforeseen results. Gérard Genette subsequently used "bricolage" as a metaphor for the work of the literary critic. In *Palimpsestes* bricolage is defined as "the making of something new out of something old" and is aligned with pastiche as yet another manifestation of "hypertextuality" (Genette 1982: 451). More generally, "bricoleur" today describes a creative persona who draws for his/her work upon heterogeneous models and sources.

### Capriccio

Like the pastiche, the capriccio is traditionally seen as a mixing together of different forms and styles and as anti-classical (Grimm 1968: 103). In visual art, music, or literary texts, a capriccio typically manifests itself as a flight of fantasy and sudden whim that surprises a conventional scene or setting. Capriccio is, like pastiche, a *genre mineur;* the two genres are often mixed up, because they both sport an elusive and vague identity. Recently, art-historical

research has discovered the contemporary relevance of the capriccio (Mai 1996). In his film *The Draughtsman's Contract* (1982), Peter Greenaway creates a postmodern capriccio which features a live classical sculpture pastiched as body art colored blue that makes sudden nightly appearances, Batman-like, in a rococo park.

## Cento

In antiquity, patchwork texts were produced that borrowed from famous authors such as Homer and Virgil and were intended as parodies of their work. The structure of the cento provides the most important prototype for the patchwork pastiche, the type most commonly found in aesthetic postmodernism (discussed in chapter 4).

## Collage

The term most often substituted by users who do not feel comfortable using "pastiche." The collage developed in the wake of Braque's and Picasso's *papiers collés* around 1910, a process whereby reality snippets—newspaper cutouts, cigarette pack paper—were pasted into cubist compositions. In a typical collage (e.g., in Hannah Höch's *Cut with the Kitchen Knife* [1919, Berlinische Galerie]), images are arranged in a cumulative fashion that differs from the accumulation effect of a patchwork pastiche. In a collage the physical identity of the different motifs is preserved in the overall diversity, as the pasted pieces in the cubist model. A medley pastiche aims at a seamless blend which has in the past often been compared to the unified taste of a pâté of diverse ingredients. A formulation such as "Ms. . . . creates multi-layered theatrical collages, splicing classic plays with other texts and filtering them through . . . non-naturalistic performing styles from vaudeville to Kabuki" describes pastiche structuration, not collage.

## Contrefaçon

Etym. metallurgy; Fr. for counterfeit work, fraudulent imitation, fake, synonym of pastiche (see Brunot, above); cf. *Kontrafaktur*, German philology, denoting the adoption and rewriting of Romance-language medieval epics into Middle High German songs; in musicology *Kontrafaktur* likewise refers to the legitimate adoption of song material from another European music culture into one's own (MGG).

## Fake

Beginning in the sixteenth century, *pasticci* and later pastiches of the works of famous painters were regularly produced for collectors with or with-

out fraudulent intention. Modern forgeries, by contrast, are perfect copies for the art market that lack the impurity of pastiche fakes. Pastiche as fake takes on a new identity for Ada Louise Huxtable writing on Las Vegas: "The outrageous fake fake [*sic*] has developed its own indigenous style and lifestyle to become a real place" (Huxtable 1997).

### Farrago

Rarely used to describe a confused mixture, a hodgepodge, and a medley—features associated with the pasticcio. One of the meanings of pasticcio in common Italian is "mental confusion."

### Faux (e.g., Faux Faulkner, faux Baroque)

The French adjective meaning "false, untrue," recently arrived in English.

(1) It indicates the *ersatz* quality of imitative material, as in "faux alligator," especially in high-style advertising.

(2) It has a blasé quality when used by connoisseurs who are eager to make known that they know the real thing.

(3) "Faux Faulkner" is a yearly competition to write a pastiche of the author's literary style.

### Imitation

(1) Not in and of itself a negative activity (certainly not for Winckelmann); for Marmontel (see above), the dialogue with the (classical) tradition is best conducted by first imitating the author in question; origin of French literary pastiche tradition; in the nineteenth century, imitation was considered close to plagiarism in general cultural discourse.

(2) The basic structure of pastiche is a degree of imitation. What happens beyond this determines the artistic success of both the traditional and the postmodern pastiche.

### Montage

Used at times as a synonym for pastiche—"a weak montage of cultural elements—a pastiche whose bits and pieces . . . " (LaCapra 1989: 7).

(1) Joining different images in a seamless manner and photographing the new entity produces a photomontage, a genre closely associated with the work of the leftist and anti-fascist artist John Heartfield between 1920 and 1933, which is now a convention in graphic design. Although photomontage is structurally similar to pastiche, the single image created from parts is a repre-

sentational sign without trace of its composite nature. The "à un seul goût" tendency of pastiche, often discredited as "mush," retains its multi-origin quality as atmosphere; to use the original metaphor, one can still taste the ingredients that make up the pâté. The radical illusionism of a Heartfield photomontage is precisely the agent that establishes the singular political message of the montage. This message is missing in the case of the relatively new *digital montage* used in film and video—the blend, untraceable for the viewer, of frames/scenes stemming from separate filmic material. The fraudulent aspect of this process does provide a link to the past of pastiche, not (or less so) to postmodern pastiche as projected in this study.

(2) The "intellectual montage" in film—e.g., Eisenstein's famous juxtaposition of cattle being chased into the slaughterhouse and workers being chased into their misery (*Strike*, 1924)—is a filmic metaphor: men = cattle. The patchwork of Kafka motifs in Soderbergh's *Kafka* is a pastiche (see chapter 3).

(3) Types of montage structures found in literary texts:

"space montage": several different plot strands happen simultaneously in different places;

a "montaged" character who is a composite of two or more authentic and fictional figures;

Walter Benjamin called the accumulation of reflections and exterior text fragments in his *Passagen-Werk* "literary montage" (Benjamin 1982: 574); the text form is actually closer to an ideological-critical collage or an intellectual pastiche.

### Palimpsest

Literally, a palimpsest is a parchment on which the first inscription has been erased and replaced by another, leaving a trace of the initial writing. It is a popular metaphor for intertextuality. In *Palimpsestes,* Gérard Genette links pastiche and parody to what he calls the "hypertexte," a term to embrace all works derived from earlier works (Genette 1982: 14).

### Parody

Since its inception in Greek antiquity, the genre has called forth innumerable concretizations. A working definition for our limited purpose is "a work of literature or another art that imitates an existent piece which is well-known to its readers, viewers, or listeners with satirical, critical, or polemical inten-

tion. Characteristic features of the work are retained but are imitated with contrastive intention, whereas in pastiche this relationship is one of similarity."

The editors of the *Anthologie du Pastiche* introduce their collection of French literary pastiches by minimizing the difference between pastiche and parody (Deffoux and Dufay 1926), whereas Albertsen (1971: 2) maximizes it (see chapter 4).

Linda Hutcheon has revised previous notions of parody as counter-song by focusing on a suppressed aspect of the prefix "para" which renders a meaning of "rewriting" or "transposition" (Hutcheon 1985). The parodist stages a "confrontation" with a canonical text of the past (Calinescu 1987: 185), thereby dramatizing the difference between the partners.

This understanding of parody moves in the direction of our concept of postmodern pastiche, which is in part derived from the semiotic model of intertextuality (Kristeva 1969: 146). Hutcheon's theory works best for literary texts (as well as some of those discussed in chapter 5), but it has less relevance for the pastiches as cultural critique in the visual arts, including film (chapters 2 and 3).

### Plagiarism

Copying or imitating the language and ideas of another author and presenting them as one's original work; this process corresponds to the pastiche of the sixteenth through the eighteenth centuries, which copied original work with deceptive intent.

In his *Poésies* Lautréamont stated, "Le plagiat est nécessaire" (Hollier 1975). Here plagiarism is a synonym for pastiche in the sense of the imitative writing of a budding author which positions him/her in the system of literature.

### Recycling

A new term derived from environmentalist practice and adopted by the discourse on the arts and popular culture to describe the not necessarily creative reuse of traditions, motifs, and ways of seeing and doing by contemporary artists and designers. With regard to the production of pastiches both old and new, "recycling" is a metaphor for citational activity.

### Refiguration

The "art of refiguration takes formal elements of past styles, and brings them forward into a contemporary context, resulting in a sometimes disquiet-

ing synthesis of past form and present context. At work is a process of refiguration, or conversion: the past form is converted into a sign of the present, while the present is historicized through its containment within a formal element taken from the past" (Barbiero 1990: 11).

### Simulacrum

A mere, faint, or unreal semblance; for Baudrillard, the simulation of the real is no longer "a question of imitation, nor even of parody. It is rather a question of substituting signs of the real for the real itself" (Baudrillard 1983: 4).

In "Le pastiche radical comme art du chaud-froid" (Radical Pastiche as the Art of the Warm-Cold) Thierry Lenain posits an aesthetic of the *simulacre radical* (radical simulacrum) as a strategy of revisiting the imaginary museum, i.e., the archive, which is seen as a postmodern alternative to the nineteenth-century positivistic historicism condemned by Nietzsche (Lenain 1989: 127).

### Travesty

Ital. *travestire*, theatrical language: to dress, disguise. Satire, often comical, which uses earlier, original material but changes the stylistic level drastically. The wit and effect of a travesty result from the discrepancy between an old content and the new, lowly mode of presentation. A 1984 photograph by Claire Santrot may serve as an instantly persuasive example. Thirteen good-looking young boys are sitting or standing behind a lengthy table, in the middle of which is an outstanding figure, gesturing with open hands—a travesty of the Last Supper.

As to literary travesty, it presupposes, like parody, a polemical relationship of the later author to the canonical work engaged, a relationship not typical of the traditional literary pastiche in the French tradition, but often part of its postmodern version.

# PASTICHE IN THE
# VISUAL ARTS

2

## Painting, Sculpture/Assemblage, Mixed Media

"It's a nineteenth-century pastiche, a composite, neither Renaissance nor mannerist," commented Philippe de Montebello in April 1992 about an art object displayed in a *Nova* show entitled "Fakes." This statement by the director of the Metropolitan Museum of Art contains a typical use of the term "pastiche" in the highly differentiated critical discourse of art history. As we saw in chapter 1, the precursor concept of pastiche, "pasticcio," originated in the community of the visual arts, and Montebello's remark shows how little has changed with respect to the definition of pastiche as a medley as well as a copy—more or less fraudulent in nature—of a valuable original. With the ascent of modernism in the nineteenth century, the notion of pastiche became an essential part of the standards used to measure originality and authenticity in a work of art. For example, a recent examination of catalogue sales of eighty-eight "authentic" paintings by Antoine Watteau in London between 1724 and 1760 showed that only two were actually by the artist's hand (Raines 1977).

As aesthetic category *ex negativo*, albeit one of high pragmatic value, pastiche played the important role of the Other of authentic art. As the eighteenth-century connoisseurs already knew, the creator of a fake had to be fairly close in "genius" to the producer of the original work of art (see chapter 1). Pastiches that are composites of several styles and motifs appear—impure as they are—less as fakes than as eclectic choices of minor artists. A typical example is the large majolica mosaic of 1907 by a Leopold Forstner in the Grand Hotel Wiesler in Graz, Austria (fig. 1). It borrows its central motif from Botticelli's most famous painting, *The Birth of Venus* (c. 1480), moves its figure attempting to clothe Venus from right to left, and binds these and two lesser figures into a decorative tableau trimmed in the style of Klimt and Vi-

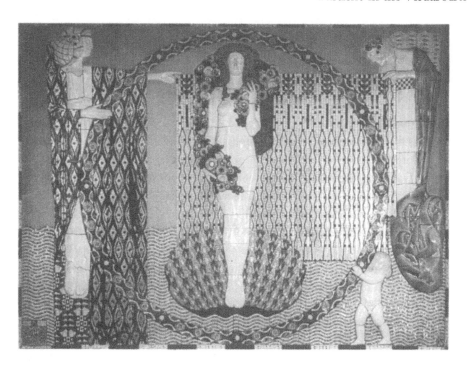

Fig. 1. Leopold Forstner, *Spring*, 1907. Courtesy the Weitzer Family, Grand Hotel Wiesner, Graz.

enna Workshop designs. The work is called *Der Frühling* (Spring); the title inevitably recalls another Botticelli painting. Whether it is an ironic comment on the part of the artist or the joy of conflation, the work exhibits the characteristic quality of the medley pastiche, the peculiarly unifying energy that the "de Piles" formula called "à un seul goût"—toward a single taste, manner, style derived from styles.

For traditional art history, pastiche as a *genre mineur* has functioned very well as a convention to work with but to which one does not devote scholarship.[1] Even the 34-volume, 32,600-page Grove *Dictionary of Art*, published in 1996, grants no more than a few lines to "pastiche," although the description therein registers, however vaguely, some of the semantic changes that the genre has recently undergone:

Pastiche [It. *pasticcio*]. Image that self-consciously borrows its style, technique or motifs from other works of art yet is not a direct copy. The result can be some-

what incoherent and at times is deliberately exaggerated and satirical, as in cari-
cature. The term is generally applied in a derogatory sense, implying that the
artist was unoriginal.

An artist who self-consciously borrows from another may be a pasticher, but
he or she is merely a beginning practitioner of the fine arts emulating an ad-
mired master chosen from the tradition, a topos of the artistic production
process through the ages. The uneasiness with which some art historians view
the contested realm of the pastiche genre—what is pastiche, what is not—
stems from the knowledge of and continual encounter with the intense and
active involvement of artists with the work of their predecessors. In post-
Renaissance times, most art comes from art, to paraphrase E. H. Gombrich.

The system of art is characterized by an intertextuality of seeing and in-
novation, as a creative transformation of the archive. As is well known, artists
often rework prominent motifs executed by their precursors, such as the
"Venus" picture tradition. From Giorgione's *Sleeping Venus* to Titian's *Venus
of Urbino*, from Goya's *Maya* to Manet's *Olympia*, from Ingres's *Odalisque* to
Delacroix's counterpiece and Kirchner's *Reclining Nude*, a count of the reinter-
pretations would fill a monograph. Here the iconographical convention allows
for the formal invention of the successor. Rubens was inspired by Titian's por-
trait of the Duke of Urbino of 1537 when he painted *Thomas Howard, Earl of
Arundel* in 1630. Or one might think of the influence of Pompeian wall paint-
ing on Böcklin, de Chirico's debt to Böcklin, and Max Ernst's relation to de
Chirico, to sample once more the finely woven texture of affinities that shape
an artist's choices. Inspiration and influence have long fueled the making of
visual art. "Perhaps there is no such thing as a deep or genuinely important
art based solely on innovation," mused Robert Hughes on the occasion of an
exhibition of modernist revisionism in the 1920s that included certain works
by Picasso (Hughes 1990). A few years later, the art historian Rosalind Krauss
would call these works pastiches in a derogatory sense, and the paragon of
artistic innovation a pasticheur.[2]

The "new art history" which stresses critical theory and textuality over
traditional approaches (and which Rosalind Krauss helped create as a founder
and editor of *October*) has not been shy about toppling idols and idolatries of
the modernist rhetoric. Yet it has so far avoided investigating the new critical
potential of the pastiche genre that artists have productively explored during
the last quarter of the twentieth century.

The overbearing authority of modernist formalism, which the New York
Art scene identified with the practical criticism of Clement Greenberg (who
loathed the term "theory"), was a pressure strongly felt by the generation of

artists starting out at the end of the fifties and later. Abstract expressionism had canceled the century-old hegemony of the Ecole de Paris and shifted the center of the art world to New York. The canonization of the founding movement of the "New York School" in the halls of the Metropolitan Museum of Art in 1970, installed by Henry Geldzahler, was as much triumph as testament; Roy Lichtenstein's "Big Painting" series had already ironically pastiched de Kooning's brushstroke in the sixties. After pop art's dismissal of programmatic formal innovation, other, less Dadaistic forms of re-engaging the past surfaced. The dialogical mode of pastiche that Proust—according to Denis Hollier—saw in the literary variant of the genre became, courtesy more of the *zeitgeist* than of direct influence, a central concern of producers of visual art. To be sure, the visual pastiche, which can be subsumed under "appropriation art," is but one direction in the extremely pluralistic landscape of contemporary art.

The following *tour d'horizon* of postmodern pastiches executed in the mediums of painting, sculpture/assemblage, and conceptual mixed media can claim only exemplary status. They are largely of the composite type of pastiche; the quasi-copy of one master or one masterwork is the exception—which does not, however, preclude a layering of the two types in certain pieces.

### Destruction: A Classic

The postmodern pastiche as medley is superbly exemplified by the patchwork of visual sources and quotations in the painting entitled *O, Ilium!* by the Irish artist Stephen McKenna (fig. 2). On the large canvas—72 x 100 inches—McKenna depicts the making of a cultural memory, contoured by the metaconvention of the classical. The sculptures and images represented in the 1982 work are not so much faithful quotations of classical monuments as conflations of typologically similar works and references to classical themes and neo-classical renderings thereof.[3] Among the mythical figures and configurations that populate McKenna's dystopian vision of the classical world are

• a "Zeus with Thunderbolt," reminiscent of the bronze from Dodona in Berlin (470 B.C.E.) or of a similar work in the National Museum of Athens; the sculpture is depicted turned around and appears more aggressive with the thunderbolt resembling a modern weapon;

• the killing of the Niobids, the many children of Niobe, daughter of Tantalos and the first mortal lover of Zeus; this image is filtered through Max Ernst's *Two Children Are Threatened by a Nightingale* (1924, MOMA);

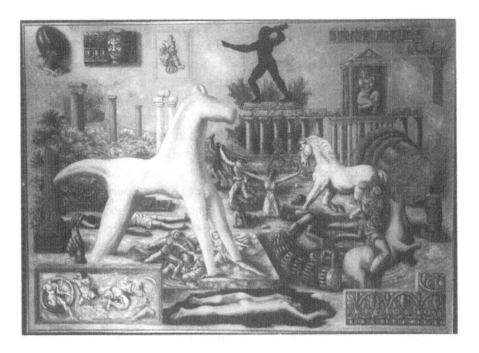

Fig. 2. Stephen McKenna, *O, Ilium!*, 1982. Courtesy Galerie Christine et Isy Brachot, Brussels.

• various reliefs and friezes of battle scenes reminiscent of the *Battle of Greeks and Amazons* from Halicarnassus in the British Museum and parts of the Pergamon Altar in Berlin;

• Doric and Corinthian columns, as in various types of ruin configurations and Brancusi's "Broken Column";

• a "Crouching Aphrodite," Athena as the goddess of war, a Nike figure, and other citations;

• the abstract, stylized sculpture of a horse that functions formally to pull together the loose pictorial grouping; as an archaic, sixth-century B.C.E. Boetian terracotta, it can be seen as a link between pre-classical form and the form of twentieth-century abstract art.

It is worthwhile to compare the archetypal chaos of *O, Ilium!* with *Roma Antica,* a catalogue of extant classical monuments painted by Giampaolo Pa-

nini in several versions during the eighteenth century. (The Metropolitan Museum has a variant.) These pictures reflect the optimism of the encyclopedic age as well as the idealization of classical Greek art in Rome as fancied by someone such as Winckelmann. His exemplar for the "noble simplicity, quiet grandeur" of the Greeks, the Laocoon group, was at the time of Panini's painting part of the classical canon. (Archaeology would later date it as Hellenistic.) There is no quiet grandeur in McKenna's picture, but rather a battlefield of cultural myths.

The past-present shape of the horse, which integrates all other surrounding signs on the picture plane, figures semantically—and more urgently—as the Trojan horse of destructive technologies. Following the critic Jon Thomson (1985: 29), Charles Jencks called it "the blind force of multinational materialism, crushing everything in its way" (1987: 121). Western culture pastiched turns out to be a "Wasteland."

The transition of the pastiche genre from a negative identity to a more positive signification and its emancipation as a critical mode should also be seen in the context of the merger of "high" and "low" cultural discourses that literary theorists such as Leslie Fiedler and Ihab Hassan proposed in the 1960s, and which are now a staple of a more general concept of postmodernism (Fiedler 1969/1971; Hassan 1975). Furthermore, the influence of critical theory on the visual arts, as on architecture and film, has led to the emergence of a pastiche style as epistemological program that transcends the codes of parody and travesty typical of traditional literary pastiches.

### Composite Identity

The assemblage created by the best-known Danish sculptor, Bjorn Norgaard, in 1975 and entitled *Christian III's Monument* (fig. 3) is one of the earliest postmodern pastiches (if we set postmodernism's beginning in the sixties, according to the foundational discourse in architecture; see below). Norgaard worked with Joseph Beuys and other members of the European Fluxus group who resurrected the Dadaist impulse in different ways than the American pop artists did. "Fluxus" (which alluded to flowing borderlines between the mediums) stayed with the *objet trouvé* aesthetic of Dada and its subsequent pictorial presence in surrealism.

On first sight, the piece in the Aarhus Museum is offputting in its radical eclecticism; it was bound to collide with the prevalent horizon of seeing in the late seventies, still structured by the experience of (American) abstraction. True, concept art and related articulations in performance and video had begun to shift visual art perspectives toward accepting modes of textualization

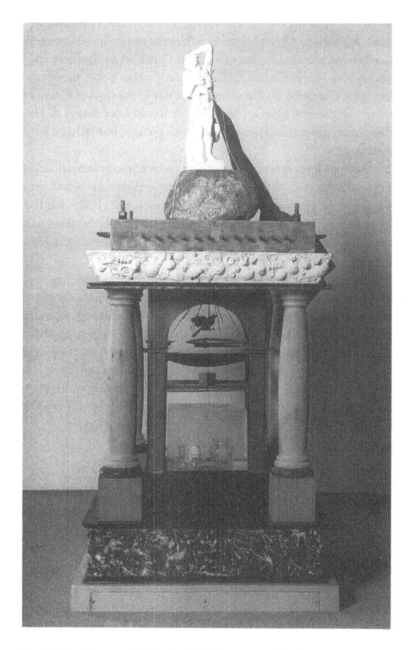

Fig. 3. Bjorn Norgaard, *Christian III's Monument*, 1975. Courtesy
the artist and Aarhus Kunstmuseum, Denmark.

previously unfamiliar in the discourse of fine arts. Literariness, of course, was once anathema to the theory and practice of modernist art built on a formalist view of the French and American avant-garde. The move away from "formalism" would naturally lead to the adoption of a polar position to the *l'art pour l'art* approach and posit the potential of visual art as cultural commentary and critique.

The maker of *Christian III's Monument* mourns, mocks, and cherishes, as well as critiques, the conglomeration of impulses that make up Danish cultural nationalism. The columns, the frieze, and the crowning copy of Michelangelo's *Dying Slave* are references to the classicism of the sculptor Bertel Thorvaldsen (1768–1844), celebrated in Copenhagen with a significant museum site and collection. The neo-classicist is clearly a central force in the cultural imagination and self-definition of the Danes. Yet the classical, Norgaard's work suggests, is imported from Italy: Thorvaldsen lived in Rome for forty years. Other signs pastiched together point to the Germanic past of Danish culture, including a pegged wooden base on which an erratic boulder rests, reminiscent of the megalithic graves in the Danish landscape.

The boulder is weighing on the alien import, but it is also quiet, resting in itself. It functions to support the minuscule plaster copy of Michelangelo's *Dying Slave,* the inevitable embrace of the Italian Renaissance. Stakes—actually clothespins—pierce the figure's body, connoting the iconography of the "Martyrdom of St. Sebastian." Danish cultural identity as martyr? The ambiguity of Norgaard's complex piece allows for a different interpretation. The stakes that torture the *Slave* figure can also be read as a reference to vampirism—the Italian Renaissance, perceived as the ultimate authority for the direction of Western art, as the vampire of other European cultures.

Returning to the martyr motif, the clothespins hold a red flag dragged by the *Slave* figure. It is clearly not the triumphant red flag of Delacroix's *Liberty Leading the People* (1830). This flag drags on the floor of a failed revolution, represented by Christian III's sixteenth-century entrapments in German politics. The interior of the assemblage is filled with objects of the Danish vernacular, the coffee culture of the Danes, with Royal Copenhagen porcelain and constructivist design.

The different elements of the assemblage, incongruous as they are, nevertheless strive "à un seul goût," toward one textual effect: a critical reflection on Danish cultural identity. The visual textuality of this pastiche has little in common with the historical designation of the genre as the fraudulent copying of a work of high art. Even the French formula, "ni un original ni une copie"— cited here for a change in the singular, as preferred by today's Larousse—

no longer applies, since postmodern art is expressive precisely by virtue of its language of quotation. (The old formula certainly does apply to a transposition of Michelangelo's slave sculptures into Wedgwood Jasperware. The grand "Michelangelo Vase" [1790–1800] in Harvard's Fogg Art Museum is an adaptation pastiche that cannot but be admired for its ingenuity of appropriation and sheer craft—although the term "kitsch" has also been applied.)

Postmodern pastiche rewrites the dichotomy of original vs. copy that Duchamp problematized earlier and that pop artists such as Rauschenberg refined in mixed-media works in the sixties, pastiching old-masterly paintings against an industrial age backdrop. The Dali Museum in St. Petersburg, Florida, owns a pastiche by the surrealist painter entitled *The Hallucinogenic Toreador* (1969) that quotes the *Venus of Milo* in a Duchampian manner as a multiple line-up before an antique amphitheater. A very different act of appropriation is at work in *The Killing of Frank O'Hara, 1966*, a 1975 painting by Alfred Leslie that caused a stir with its conflation of Caravaggio's *Deposition* and the new-realist idiom of the contemporary artist. The ensuing intertextuality, the identification of the death of the prominent poet and art critic with the death of Christ, struck some critics as sacrilegious.

Although these pieces—representing many others—are clearly pastiches in the self-conscious manner named by the Grove definition, they were not seen as such because of the continued marginality of the genre. It was only in the late seventies that the highly influential discourse of the new, "postmodern" architecture and its revival of classical building forms (see below) changed the image of the act of borrowing from the arsenal of the classical. Pastiche, the least classical of genres, can now be posited as a challenge to the canonization of the classical, whose material presence it problematizes as ideological. And it does so from within classical rhetoric by using a figure cherished in the Renaissance and baroque up to the beaux-arts tradition of the nineteenth century: allegory.

A host of evaluative definitions of this trope are possible here, with plenty of ties to cultural as well as medium specificity. In our immediate context, we will focus on the definition most familiar to the discourse in fine arts: a pictorial representation of a concept, an idea, to be perceived by the senses. Handy examples would be Michelangelo's sculptures for the tomb of Giuliano de'Medici, *Night* and *Day*, in the Medici Chapel in Florence, or Dürer's *Melencolia* engravings.[4]

Norgaard's pastiche, finally, is an allegory of Danish culture and its conflicting sources, allegiances, and ambivalences. It is, to be sure, a different allegorical procedure from the thematic preoccupation of much of the visual arts production from the sixteenth to the nineteenth centuries. In this tradition an

allegorical message signified with the force of convention; the visual referents pointed to stable meanings—a skull and an hourglass always denoted *vanitas* and *memento mori*, reminding viewers of their mortality. Norgaard, Mariani, Tansey, and other producers of allegorically charged pastiches no longer work within a conventional framework of signification when it comes to allegorical expression; they construct meaning by reassembling and reappropriating pieces from the past, thereby adopting a dialectical stance toward history. They interrogate the way Western thought has dictated our ways of seeing, splendidly exemplified in a sculpture installation entitled *Mimesis* by Giulio Paolini (Neues Museum Weimar, collection Paul Maenz, fig. 4). Two identical female statues, half baroque, half neo-classical, are placed opposite each other, a confrontation that foregrounds the question of representation.

### The Learned Painter

A neo-classical painting such as Carlo Maria Mariani's *La Mano Ubbidisce all'Inteletto* (The Hand Submits to the Intellect, fig. 5) of 1983 is as inaccessible as completely abstract painting was and often still is. *La Mano* qualifies as the most publicized and notorious pastiche of the eighties; the San Francisco Museum of Modern Art even reproduced it on a T-shirt issued on the occasion of its 1986 exhibition "Second Sight: Exploring the Future of the Past." Mariani reactivates a Michelangelesque style to accommodate conceptual figuration that has gone through the monochrome color field of postpainterly abstraction. The work poses as a plea for conceptual art via the figure of allegory. In the classical tradition, which extended into the nineteenth century, a muse type of allegorical figure was always female, as, for example, in Wright of Derby's *The Corinthian Maid* (1783, National Gallery, Washington, D.C.). *La Mano* rewrites the muse topos as male.

*The Hand Submits to the Intellect* is rendered ambiguous by the hand moving to the head of the opposite figure and that figure's hand pointing to the heart of his opposite: the emotional drive is there at the same time as the intellectual conceptualization of painting. The figure touching, pointing to the heart, is the older, wiser one; there are more leaves in his laurel wreath. The neophyte is more sensuous and in need of intellectuality. The older one is invigorated and inspired by the younger one. The union is underscored by a visual quotation of Goethe's "altar of good fortune" (*Stein des guten Glücks*) that separates the original vertical arrangement of the sphere on a cube in the poet's garden in Weimar and redistributes the shapes as supports for *both* figures. The cold, precise beauty of this pastiche is authoritative; on initial inspection, its intertextuality seems to serve the theme of artistic self-reflexivity. The allusion to the notion of an "aesthetic education," possibly Schillerian,

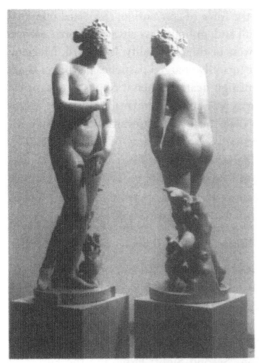

Fig. 4. Giulio Paolini, *Mimesis*, 1975. Plaster copies ("Venus Medici"). Courtesy Neues Museum Weimar. Collection Paul Maenz.

Fig. 5. Carlo Maria Mariani, *La Mano Ubbidisce all' Inteletto*, 1983. Oil on Canvas. Courtesy the artist and Hackett-Freedman Gallery, San Francisco. Copyright © Carlo Maria Mariani/VAGA, New York, N.Y.

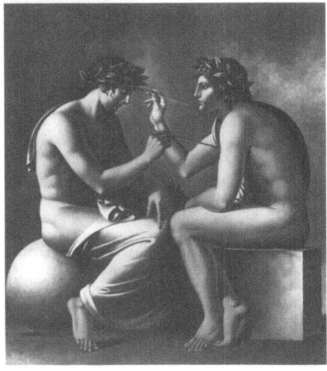

gives the allegory of *La Mano* a dialogical turn: art must engage the ideas and the art of the past. The painting's stylized neo-classicism in particular evokes antiquity and its ideals of classical beauty. It is not surprising that the work would appeal to a homosocial community in search of an eminent past. The artist himself is known to have refuted interpretations advanced by Charles Jencks and others who have seen the picture as a celebration of homosexual culture (Jencks 1987: 48). For Mariani such a reading turns the painting into an ideological program; it is far more desirable that the viewer of *La Mano* engage the dialectic of conceptual and formal aspects that gives shape to the artist's dialogue with the past.

Mariani appears to play with hybridizing opposites in the *discordia concors* spirit of mannerist conceits: realism versus abstraction, Wölfflin's famous binary opposition of the "linear" (here the figurative constellation) versus the "painterly" (here a monochrome color field as background). The richness of art-historical, philosophical, and cultural reference to be found in *La Mano Ubbidisce all'Inteletto* will continue to challenge the reception of the painting.

Pastiche as art does not insist that it *is* culture, as modernist art implicitly did, but its "allegorical impulse" makes it art *about* culture.[5] The viewer of visual arts is made into a reader; unless one can decipher the intertexts, many postmodern works will offer only a banal aesthetic experience. The question arises, Who can read these allegorically active pastiches such as *La Mano* or, for that matter, newer works by Mariani such as *Monument to Poetry* (Mariani 1997: 8–9)? The visual art object moves into the arena of multiple layers of interpretation typical of the reception of a work of literature.

### Reproduction as Original

The art of Cindy Sherman is classified as photography (Library of Congress), but it actually merges photography and a whole range of formal tendencies operative in the visual art scene since the seventies. All of Sherman's works are self-portraits, with the self assimilated into the most diverse environments, styles, and materials. In the 1991 Whitney Biennial, the artist showed a monumental color photograph, *Untitled No. 228* (1990, fig. 6), that makes an interesting addition to our catalogue of pastiche strategies. It is a rendering of the *Judith and Holofernes* motif, but rather than directly quoting any one of the many pictorial interpretations, it seems to call to the fore all the baroque paintings with this theme.

Judith was, according to the Old Testament, the beautiful young widow, still a virgin, who was sent by her Jewish people into the battle camp of the enemy, the Assyrians, where, after three days, she beheaded their general,

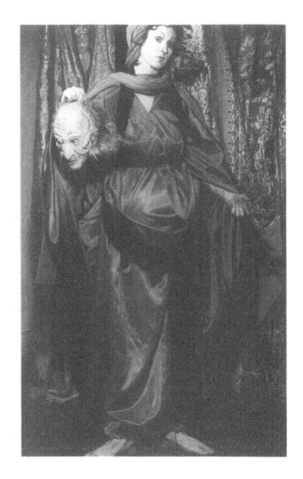

Fig. 6. Cindy Sherman,
*Untitled No. 228,* 1990.
Photograph. Courtesy of
Metro Pictures, New York.

Holofernes. Sherman rewrites the pictorial tradition of several centuries, an almost exclusively male tradition that focused on the sensuous female appearance of a notorious heroine. The feminist artist gives the established iconography a twist: Judith is pregnant, which leads to the immediate suspicion in viewers that Holofernes raped the virgin. This is not feasible, according to the schedule of the biblical narrative; Sherman is interested in a layering of cultural memory that includes women's fears, and not primarily in realistic depiction.

As a critical commentary on the history of art, the work suggests that the aesthetics of old-masterly painting would not have tolerated a demonstratively pregnant female body. Sherman's rewriting of the theme must be seen in relation to the recently discovered seventeenth-century woman artist Artemisia Gentileschi and her optically aggressive series of *Judith and Holofernes* paint-

ings (cf. Garrard 1989). But precisely because Sherman pastiches old-masterly painting styles literally onto her own body, a work such as *Untitled No. 228* has to be seen in the "original," an extra-large photographic print that is framed like an old-masterly painting (roughly 36 x 72 inches). Only then can the viewer experience the hybrid quality so important for the feminism and critical expressiveness of Sherman's work. As concept art, it attempts to re-write art history (as does her posing as Caravaggio's *Sick Bacchus;* see chapter 3); yet the formal complexity of the mixed media status does not lend itself to mere description—a necessary evil here—but instead needs to be seen as a concrete presence on exhibit. In this, the postmodern color print ironically refutes a recently prominent position in critical theory, namely Walter Benjamin's claim, formulated in the thirties while he was exiled in Paris, that the aura of art was lost in the "Age of Mechanical Reproduction," an age shaped by the photographic print (Benjamin 1968).

The gesture of exhibiting, of foregrounding the structures of mediation of older art to viewers of a different mentality and cultural makeup, is typical for most enterprises of the postmodern sensibility. Pastiche structuration lends itself to exposing and refiguring cultural codifications that for centuries marginalized unconventional identities. The art of Mariani and Sherman, like the films of Jarman (chapter 3), make us aware of the emancipatory potential of the intellectual pastiche.

### Theory Painting

The contemporary pasticheurs whose formally varied art has been introduced in these pages work in the context of postmodern theoretical reflection. None, however, has made this context his or her locus of creativity to the same degree as the American Mark Tansey. Tansey's paintings are allegories of "theory," especially poststructuralism. An early work called *Mont Sainte-Victoire* (1987) conflates Cézanne's favorite motif with a generic version of the artist's *Bathers.* A monochrome Caravaggesque tint unifies the strange scene in which Roland Barthes, Baudrillard, and Lacan gaze, Narcissus-like, at their reflection in the water while Derrida opens his coat to exhibit a modeled bare chest, the gesture as signifier rather than signified. In keeping with the conspicuous ambivalence of *S/Z,* Barthes is mirrored in the water as a female figure.

Anyone working in or familiar with literary criticism will chuckle at Tansey's allegorical representation of the scholarly topos *Close Reading* (1990, MOMA Fort Worth). A young woman exerts herself climbing a rock covered with writing that we as viewers cannot decipher. Arthur C. Danto, who considers the rock-climber too close to the text, muses, "Perhaps, given the text, there is no distance from which legibility is to be attained" (1992: 28).

Fig. 7. Mark Tansey, *Derrida Queries de Man*, 1990. Oil on Canvas. Collection of Penny and Mike Winton, Minneapolis. Courtesy the artist and Curt Marcus Gallery, New York.

*Derrida Queries Paul de Man* (1990) is perhaps the most intriguing of Tansey's visual commentaries on issues in critical theory and recent art history (fig. 7). On first viewing, the painting seems merely a playful treatment of a minor scandal that tore through academia in the late eighties. The pictorial source for the scene is Sidney Paget's illustration for a story by Arthur Conan Doyle about the (projected) death of Sherlock Homes together with his alleged murderer Moriarty. We see them struggling at an abyss of the Reichenbach Falls in the mountains near Berne, Switzerland. Conan Doyle was vacationing there, tired of writing stories for *Strand* magazine, assignments that he believed prevented him from working on his beloved historical novels. He therefore decided to kill his fictional hero, and in April 1893 he wrote what he believed to be his last Holmes story, entitled "The Final Problem."

Tansey's pastiche works on several levels of intertextual meaning. The detective genre is a favorite text type in postmodernism, since it functions like a

literary allegory of semiotics, hermeneutics, and its radical version, deconstruction. The title of the story, "The Final Problem," evokes the Fascist *Endlösung*, the "final solution" that we know as the Holocaust. It directs the reader-viewer of the painting to those de Man essays that prompted Derrida (in part) to investigate the "Politics of Friendship" in a series of seminars in 1989, each session of which began with a saying attributed to, but not found in, Aristotle: "Oh, my friends, there is no friend."[6] The intertextual charge of the painting asks the viewer to contemplate whether Derrida is Sherlock Holmes and Paul de Man is Moriarty as brute historical force that commits all radical questioning—Holmes/Derrida—to a reality abyss. Are they dancing rather than struggling at the abyss of *écriture*? The lower part of the canvas shows rock formations that are covered with writing (as in many of Tansey's pictures). The painterly, blue monochromy of the canvas, however, has *presence*, anathema to deconstructive operations.

The beholder is challenged to detect and decipher the intertextual fabric of a work. Pastiches, based on the principle of cumulation, have always abounded in ambiguity and indeterminacy. Today's intellectual pastiches are about culture as a process of meaning constitution; they critically reflect upon the historicity of aesthetic judgment and taste. The artistically ambitious, new type of pastiche has little or nothing in common with the vast number of copies after originals, fraudulent "rip-offs," and lowly imitations that continue to be produced in the most diverse contexts. A pop travesty such as Munch's *Scream* as inflatable plastic figure may be great fun and may effectively sell expressionism to undergraduate students, but it is not the critically upgraded pastiche pursued on these pages. Not that the genre lacks potential to be very witty; William Wegman's piece, *Man Ray Contemplating a Bust of Man Ray* of 1978 is a case in point. The performance photograph ironically restages Rembrandt's painting *Aristotle Contemplating the Bust of Homer*, with the artist's signature Weimaraner "Man Ray" (after the Dadaist) as Aristotle facing a tiny plastic head of a dog, same race, same name. Wegman's facetious caveat: Is a critical pasticheur not also a Narcissus of sorts?

## Architecture and Design

### Architecture

The new, dialogical sense of pastiche has manifested itself most concretely in important monuments of postmodern architecture, now a historical style (see the Introduction). It came about in the 1960s, in response to a number of issues that plagued functionalist modernism on an international scale.

The purism of the Bauhaus aesthetic and related programs originally based on utopian impulses completely ignored the archive of classical building elements and the dimension of the decorative.[7] Postmodern architects set out to rehabilitate the vocabulary of the past in the framework of modern technology—with a vengeance. Architects such as Michael Graves, Hans Hollein, Charles Moore, James Stirling, and Ricardo Bofill, to name but a few, self-consciously harked back to the classical code and blended it, ironically more often than nostalgically, with pop art elements, art deco, baroque theatricality, and modernist features. The styles that evolved had little in common with the eclecticism of European historicism as exported by the Ecole des Beaux Arts, which dominated American architectural education from the middle of the nineteenth century into the first decades of the twentieth. Nevertheless, an exhibit entitled "Architecture of the Ecole de Beaux Arts" at the Museum of Modern Art in 1976, as much as it seemed a sacrilege at the time, effectively put modern architecture in question and fueled the general discontent with functionalism.

Robert Venturi's manifesto for *Contradiction and Complexity in Architecture* gave the signal for a hybrid building style as rebellion against the "clean" and "straightforward" form of modernism in architecture. In his book, which was to become the bible of postmodernism, Venturi pleaded for an architecture that could elicit "many levels of meaning" in its users, and for a space that was readable in multiple ways (Venturi 1966: 16). The Philadelphia architect's gutsy credo, "I am for messy vitality over obvious unity . . . I am for richness of meaning rather than clarity of meaning," became a liberating slogan for many of his colleagues. "Messy vitality"—one of the definitions of Italian *pasticcio* is "a mess." That architects in the seventies would turn to pastiche as a strategy for breaking with the modern code is not surprising.

Observing the multifarious breakthroughs that had started to occur in architectural practice internationally, Charles Jencks, an American architect living in London, single-handedly laid the historical and theoretical foundation for postmodernism in *The Language of Post-Modern Architecture,* published in the United States in 1977. The architect turned architectural historian (a major in English at Harvard helped) chose to call the new movement in architecture postmodern, to mean "the end of avant-garde extremism, the partial return to tradition, and the central role of communicating with the public" that functionalist modernism had ignored (Jencks 1984: 6).[8] In all of his publications, Jencks is at pains to stress the portmanteau quality of the label "postmodern architecture"; nevertheless, it was the "new classicism" (his term) in architecture and art that he privileged in the eighties and documented in a luxuriously illustrated volume (Jencks 1987).

The return to the archive of classical forms—the column above all, the pediment, and the Roman arch—was given its first spectacular blessing at the Venice Biennale of 1980 entitled "The Present of the Past," thereafter a motto of aesthetic postmodernism.[9] Harking back to the archetypes of Western building was not just a matter of retrieving the vocabulary of historical forms that the modernist drive for constructivism chose to neglect. The postmodernist's desire to reintroduce architectural meaning, to create narrative architecture, was also dialectically opposed to modernism's insistence on the non-significatory presence of pure, unadorned materials. Postmodern architecture attempted to communicate to the public and be context-sensitive, sensitive to the existent environment, a chronic weakness of functionalism. It was thought that architectural meaning could henceforth mark historical continuity.

The "textuality" of architecture, to be deciphered like a text, became a central topos in the discourse on architectural form and ornament. This "narrative turn" meant a reshuffling of categories, inspiring, for instance, architects to make figures of rhetoric such as irony part of their signifying strategies. Semiotics, a field of inquiry that was booming in the eighties, offered an approach to reading a double-or multi-coded building; planning and subsequent critical analysis could now interrelate spatial, social, historical, psychological, cultural, and other symbolic codes. Philip Johnson, the arch-modernist turned postmodernist for a limited engagement, summed up the paradigm shift in architecture with one of his famously succinct dicta: "One cannot not know history."

### Classical Columns, Neon Necks

CHARLES MOORE

*Piazza d'Italia, New Orleans, 1975–80*

Precisely because it is one of the most eccentric projects of seventies postmodernism, the Piazza d'Italia in New Orleans has historical significance now because it maps out the subsequent development in architecture so clearly. This extravaganza of urban revival was only partially completed, and it now exists in reduced form because of city politics, which may have reacted to its negative reception by New Orleans's burghers. The piazza's controversial glory shines through in a splendid spread of photographs in Jencks's *Architecture Today* (1980: 118–21) that document Charles Moore's attempt to restage an Italian baroque *corso*, a promenade area, with gusto. A collaboration with Perez Associates and the Urban Innovations Group of New Orleans, it was intended as a celebration of the city's Italian heritage in a series of historical signs that were, above all, designed to lend enchantment to a public place. One could stroll through arcades of ochre-colored columns with Corinthian capitals

fashioned of chrome or stainless steel, or linger in an alcove where Doric and Corinthian columns had necks of neon lighting. The entrance was a "pergola" modeled in white metal tubes, a "drawing" in space of a Greek temple.

In his obituary on Charles Moore in 1993, *New York Times* architectural critic Herbert Muschamp noted that the piazza enlarged the traditional orders of classical architecture with "delicatessen order," citing Moore's playful allusion to a planned restaurant (Dec. 17, 1993). Moore's architectural pastiche was indeed an agglomeration of visual "delicatessen," of solemn and ironic citations and trivial pursuits that came together as illusionistic play and playful narrative about the persistence of a historical memory. The provocative project influenced other postmodern builders, many of them less historically minded than the pasticheur of New Orleans. The architects of the Forum Shop complex in Caesar's Palace Mall, Las Vegas, may be indebted to Moore and his camp style, but they delivered a kitschy travesty of a flamboyant pastiche, a money-making scheme designed to appeal to the typical Vegas shopper. As Aaron Betsky wrote when this simulacrum opened in 1992, "Your typical Roman via where the sun sets and rises on an electronically controlled cycle, continually bathing acres of faux finishes in rosy hues. Animatronic robots welcome you with a burst of lasers, and a rococo version of the Fountain of the Four Rivers [Bernini] drowns out the sound of nearby slots. History repeats itself here neither as farce nor as tragedy, but as themed environment" (cited in Huxtable 1997).

In his later buildings, Moore, who was a prolific theorist for his diverse designs, continued his anti-conventional stance, but his quotation style was less exuberant, as in the Alumni Building at the University of California, Irvine, with its baroque facade in monochrome pink surfaces. A social housing project in Berlin catalogues different types of historical windows all on one wall, as if the illusionistic drawings of old architectural source books came alive in concrete.

### Classic Goes Pop

#### James Stirling
*Neue Staatsgalerie, Stuttgart, 1977–84*

An annex to an existing nineteenth-century museum structure, James Stirling's Neue Staatsgalerie made history as one of the most ingenious expressions of architectural postmodernism; yet it, too, was initially embroiled in controversy, especially in the German press. In the fifteen years since, the "Zitatenmuseum" (museum of quotations) has given pleasure to a most varied public. The museum exemplifies the blending of classical serenity with mod-

ernist design and gaudy elements borrowed from pop art. Stirling's use of travertine stone and sandstone as his main building material creates a subtle interplay of beige and light-brown shades—"quiet grandeur," indeed. In a colosseum-like atrium with Roman arches, eighteenth-and nineteenth-century neo-classical statuary are lined up in classical fashion; visitors enter through a massive portal with Doric columns, reminiscent of the "Lion's Gate" at Mycenae (1250 B.C.E.) until the bright red modern steel door comes into view. On terraces and in other parts of the museum, the exquisite stonework is trimmed in shocking pink and blue metal tubing that serves as handrails. The vibrant polychromy, Jencks claims, fits in with the Day-Glo hair and anoraks of the young (Jencks 1986: 19). Stirling's formally unorthodox, surprisingly user-friendly museum ranks for the architectural critic among the best achievements of postmodernism, since it uses, like Venturi, Hollein, Moore, Stern, and Graves, both "popular *and* elitist signs." This Jencks calls "double-coding," his essential definition of postmodernism first coined in the 1977 *The Language of Post-Modern Architecture* (5) and adopted by many critical minds outside the architectural community.

Stirling's building is hybrid in other ways as well, which brings to mind a statement by Walter Benjamin: "Allegories are in the realm of thoughts what ruins are in the realm of things" (Benjamin 1977: 178). Stirling quotes the topos of the ruin that was so much a part of the cultural imagination from the sixteenth century to Romanticism. The Stuttgart museum features a ruin-like structure, a broken wall with stones toppling—a narrative element evoking a time past. The pragmatic code identifies the structure as a ventilation outlet for the parking garage. Turning Benjamin's statement around, one might say that the architect has produced a *conceptual* ruin that foregrounds, as a visible allegory, historical reflection.[10] When the museum opened in 1984, just a few years after the critique of architectural postmodernism by Frankfurt School philosopher Jürgen Habermas (see note 10), German journalists spoke of the quotation games of an "overrated" British architect. They could not see a postmodernist's attempt to communicate with users, which modernism rarely did (Sack 1984).

### Classical Columns for Social Housing

RICARDO BOFILL AND TALLER DE ARCHITECTURA
*Les Echelles du Baroque, 1983–86*

The name of this colossal housing project of 272 apartments in the fourteenth arrondissement in Paris is a play on words that tells the story of postmodern historical consciousness. "Echelle" means ladder or hierarchy. The

Spaniard Bofill constructed several Versailles-like housing units in the shape of half-circles, translating the baroque garden facade into glass and steel and adding classical tautness and vertical quasi-columns. It is the latter effect that makes for the textual meaning and historical commentary staged by these buildings; Parisians with modest means can now live in what once symbolized baroque hierarchy—the absolutist court and its political enslavement of its subjects. Bofill's architecture is grand, as if out of spite, in its bold attempt to correct historical injustice. At the same time, this retrospective neo-classicism is decidedly future-oriented; the spaces and majestic entrances to the apartment blocks are rather more suited to driving than to walking (Jencks 1980: 302).

In connection with Ricardo Bofill's "échelles" structures (also in Marne-la-Vallée), the idea of "the inhabited column" returned. In 1922, the Austrian modernist Adolf Loos ("Ornament and Crime") entered a competition to design a *Chicago Tribune* tower with a submission that featured, atop a lower structure, a Doric column to house the editorial offices. It is assumed that the residential column was meant to symbolize the "column" as the basic textual element of newspaper making. While Bofill reinvented the inhabited column as social housing, another architect, Robert Stern, presented his design for a *Chicago Tribune* column as an homage to Adolf Loos, ironically entitled "Late Entry into the Chicago Tribune Tower Competition" (1982, Chicago Art Institute). The play of quotations points to the fact that the architectural process over time is as intertextual as the structure of artistic production in the other arts.

### Classicism, Minimalism, Art Deco

MICHAEL GRAVES

*Humana Building, Louisville, 1982–85*

Charles Jencks, who has featured the work of Michael Graves on the covers of several of his titles, considers "The Portland" (The Portland Public Services Building, 1980–82) to be the first major monument of postmodernism (Jencks 1984: 7). The decision to discuss the slightly later Humana Building here has to do with knowing the structure *in situ;* it, too, is often featured by Jencks and others as representative of Graves's postmodern phase. Many observers have remarked on the classicism that most of the Princeton architect's buildings exude without actually citing classical emblems. Indeed, the appearance of the classical is pastiched together.

Departing from the blocky cube shape of "The Portland," Graves revives the art deco skyscraper of the 1920s in the Humana Building (fig. 8). The structure appears as one tall *exercice de style,* a showpiece of architectural cita-

Fig. 8. Michael Graves,
*Humana Headquarters,*
Louisville, Kentucky,
1982–86. Courtesy
Humana Inc.

tion rewritten by the temperament of a virtuoso arranger. The ornamentalism in stone is quite unlike the original art deco, in that the decorative effect achieved through the use of various types of exquisite stone is filtered through the modernist use of these materials, especially the aesthetic of Mies van der Rohe. As almost always, Graves's organization of windows is influenced by minimal art, a direction in the sixties and seventies that arranged identical squares or other rectangular shapes in series to achieve a Gestalt effect. With Graves, the minimalist arrangement constitutes part of the decorative program. Perhaps no other feature of high-architectural postmodernism has been imitated more in regular building across the country and in design.

The entrance arcade features stunning porphyry columns in relief that carry vessels, very art deco as well as reminiscent of German and Italian neoclassicism (and its sometimes Fascist users). Apart from a Miesean marble

and porphyry interior, the foyer also features a "ruin" motif, somewhat more rhetorical than Stirling's in Stuttgart. The citational range of Graves's building is tremendous; its pastiche quality, an overall blend of the diverse "ingredients," nevertheless precludes any association of the term "eclecticism" in the traditional sense. A powerful personal style holds everything together—"á un seul goût."

～

In the beginning of his *The Language of Post-Modern Architecture*, Charles Jencks uses the term "pastiche" in its traditionally negative sense. He praises Leon Krier's "imaginative reconstruction of Pliny's Villa" for its investigation into the past "without falling into pastiche" (Jencks 1984: 8). Later in the book he coins the expression "knowing pastiche" in connection with "*bricolage* as a technique to knit and sometimes jam the past and present together" (111). The author does not develop his minimal attempt to give the traditional pastiche a facelift, neither here nor in later studies. After all, the bastardization process of "high postmodernism," the massive sell-out of the style set in only a few years after its peak; Jencks may have abandoned the slippery term "pastiche" for fear that it would lump the original innovators together with their imitators.

## Pastiche Design

Design, the artistic genre most closely associated with architectural practice, naturally joined the general postmodern departure from the constraints of high modernism. The development of an alternative style to "classic" modern designs, such as Mies van der Rohe's Barcelona ensemble or Breuer's redefinition of the chair in cantilever steel, was as much a necessity in designer circles as in architecture. But the scale of design—functional and/or decorative objects, furniture, even interiors—differs greatly from that of cost-intensive, massive building structures, so that the associate genre was always able to experiment more freely. Moreover, the rebellious spirit of postmodernism's anti-modernist "language games" gave designers something of a carte blanche for a playfulness structurally not dissimilar to rococo exuberance. For formal inspiration, however, designers looked to Las Vegas and to the creations of the fifties that had inadvertently freed themselves from the functionalist purism of high modernism. The most famous creations of furniture during the postmodern eighties are those of the Memphis group, based in Milan, which was very influential not only in Europe, but in the United States as

well. When *New York Times* contributor Marina Isola describes the work of Ettore Sottsass, a founder of Memphis, she actually characterizes the Memphis experiment and "Radical Design" in general: "Extraordinary combination of colors, irreverent juxtapositions of materials like marble and plastic, an unprecedented element of humor in office furniture and inclusion of a classical vocabulary are hallmarks" (Nov. 10, 1996). Memphis pieces are intertextual, fusing classical modern form with debased modernist shapes and funky materials from the fifties. The layering of historical references, often ironic, makes these constructs pastiches of the postmodern kind. The architects, too, fashioned objects of irony for the interiors of their postmodern-styled architecture, as did Hans Hollein when in 1978 he created a group of hybrid columns-as-palms to function both as ceiling support and as theme for the Austrian Travel Office in Vienna. The Corinthian-style palm subsequently appeared in many variants, from faux deco trees in malls and living rooms, to brass bases for lamps, to candleholders.

The mass of commercial products influenced by postmodern style is often completely devoid of the referential meaning that would constitute the historical dimension of what we have called "postmodern pastiche." A low-priced halogen torchiere at a department store may cite art deco models, but it is merely an affordable revival of a more carefully crafted original. Then again, a "deco lamp" from the San Francisco–based Pottery Barn may be of interest because it appeals to our cinematic memory of a similar light source in Lang's *Metropolis;* i.e., it has a touch of pastiche sophistication. To be sure, quotation and referencing can be found in many postmodern designs that turned away from functionalist form. But unlike the majority of their architect colleagues, ambitious designers did not feel the necessity to make the archive of classical forms the central locus of innovation. High-style jewelry manufacture, for instance, went back to the rich mosaic effect of medieval devotional gem works.

Still, plenty of interiors, be they aesthetically ambitious hair salons, corporate quarters, or discos, feature antique columns styled in Tuscan simplicity or in the other four "orders" described by Palladio in 1570: Doric, Ionic, Corinthian, and Composite. Many of these design efforts succeed because of their creative integration of the classical code into a context of contemporary forms. They may have aspects of pastiche, but they are scarcely in need of going beyond their utilitarian aesthetics. Design is not usually the locus of intellectual charge and cultural criticism as cultivated by an upgraded concept of pastiche in the other arts. Many places and spaces, however, are concretizations of cultural memory and indulge in layering their material presence.

Caffe Bongo in Tokyo, built in 1986 by the British group Nigel Coates

and Nato, dramatically blends classical sculpture on pedestals, a portico of Corinthian columns, a Tintoretto-like oval ceiling painting filled with Japanese swirls, a solar system chandelier, a gallery of non-verbal banners, and a bar in a grid of corten steel T-beams. Publicized internationally by *Architectural Review* (Jan. 1988), this is a pastiche text whose cumulative structure appeals to the cultural associations of both East and West. Its chaotic aesthetic embraces our anxieties—globally. The space signals the advent of "deconstruction," the architectural paradigm that grew in parallel with postmodern architecture, which it succeeded at the turn to the nineties.

Unlike the tormented signs of classical presence in the Tokyo city bar, subdued by a theatre of heterogeneities, the "Antiquity Now" move of high-tech contemporary architecture generated a massive commercial revival of classical motifs in affordable materials and increasingly produced by a global market. Catalog merchants such as Ballard Design started to market copies of classical columns for various functional and decorative purposes in the late eighties—Corinthian capitals hand-cast in plaster to serve as elegant, substantial pedestals for tables, with Mies-derived glass tops or a bas-relief of Athena crafted of reinforced plaster for the knowingly eclectic living rooms of the new sophisticates. The Corinthian-style column suddenly appeared everywhere, whether as a "Corinthian Capitals Shower Curtain" (1997), as costume jewelry, as an attractive paper bag (fig. 9), as an advertising lure for Estée Lauder products, as the logo for a remodeling firm, as black-on-gold wrapping paper, in greeting cards, and on and on. The line between legitimate indulgence, reflective camp sensibility, and plain kitsch tended to be very fine, especially in the case of those fans of the classical who preferred Doric style and ordered the weathered Parthenon bookends that Pottery Barn offered in 1989, or a pair of gold and black miniature columns from Bloomingdale's in 1993 to shake salt and pepper with in memory of antiquity.

Most of these appropriations are just that: imitative transpositions of a classical motif or work of art into a different genre, material, and scale, by no means a new paradigm. To speak of travesty here would underestimate and belittle the benefits of the type of populist didactics that such commercialization of the archive of classical forms entails. Before the modernist concept of originality took hold, the qualitative copy in plaster of Paris of a classical work was something that even museums cherished. The buyers of the new imitations are often acting out of ambivalent impulses—camp irony facing the classical up front in the bathroom, as well as the reverence that prompted postmodern architects to reopen the market of antiquities.

Yet none of these attractive stimuli for our cultural memory are pastiches,

Fig. 9. Corinthian Capital Paper Bag, early 1990s.

either in the traditional sense or in our sense with its notion of a genre to be emancipated. This observation is also applicable to the syndrome of a greatly empowered eclecticism that the language of postmodern architecture left in its wake. When it is imaginative, showing aesthetic sensibility and a sure taste, the result can be highly engaging. In other quarters, such as hotels seeking to impress their customers, the revival of eclecticism has led to a multi-style overkill that is unreflected and undifferentiated. The decorative excess may be a medley of grand proportions, but it does not add up "à un seul goût"; it is clearly below the signifying potential of pastiche, traditional or progressive.

## Short Takes

*Odd Nerdrum* is a Norwegian figurative artist, celebrated in this country by connoisseurs of postmodern figuration. Of all the old masters that inform Nerdrum's unique past-present vision, it is Rembrandt whose works, and self-portraits in particular, the student of Joseph Beuys pastiches with the authority of oversized monochrome abstraction. The paintings shape a mythical,

41

archetypal textuality, often depicting a post-apocalyptic scene, and comment upon contemporary political issues such as the environment (*The Nightguard,* 1985/86; *The Water Protectors,* 1985). When *The Man with the Golden Helmet,* until then Berlin's most famous Rembrandt, was revealed as a fake, Nerdrum painted another of his Rembrandtesque self-portraits, this one featuring the artist nude from the waist down and equipped with an oversize dildo penis (Oslo, Spring 1998). The artist as pasticheur as fake.

*Julie Heffernan* paints still lifes with fruit as territories for other old-masterly pictorial illusionisms. A close look turns peaches and apples into surfaces for miniature portraits and scenes executed with a magnifying glass as in Netherlandic art (*Self-Portrait as Contaminant,* 1995). Often an oval-shaped miniature painting is inserted into an abundant fruit arrangement (citing Jan Brueghel the Elder's flower garlands), with a seemingly idyllic scene that reveals itself as grotesque (*Self-Portrait Confronting the Subject,* 1996). The subject in question—a favorite theory topos of the nineties—is also the theme of pastiches after Velasquez in which the artist masquerades as two infantas (Heffernan 1996).

*Thomas Struth* photographed the interior of the baroque church of San Zaccaria in Venice in such a manner/maniera that the colorful figures in the wall and altar paintings mix seamlessly with the tourists visiting the church. It is a pastiche of "all of humankind" that deconstructs the privilege of the religious code (*San Zaccaria,* 1995, Marx Collection, Hamburger Bahnhof, Berlin).

*Charles Ray* is "so baroque and so modern." That is how Richard Flood, chief curator of the Walker Art Center in Minneapolis, describes the piece Ray fashioned from a fatally wrecked Pontiac AM (*Unpainted Sculpture,* 1997). Every part was recast in Fiberglas and put back together in such a way that now, in the words of Flood, "It's all about disaster, and yet it looks like Bernini's 'Ecstasy of St. Teresa,' with all this shattered material like luxurious folds of cloth . . . so full of death and yet so abstract" (quoted by Steven H. Madoff in the *New York Times,* May 31, 1998).

*Jeff Koons* moved into eighteenth-century rococo: the life-size portrait sculpture *Michael Jackson and Bubbles* (1988, San Francisco MOMA) is made of porcelain-like ceramic and styled in the manner of rococo figurines of the finest porcelain, Meissen, Sèvres, or Ansbacher (fig. 10). Using a much larger scale, Koons borrows their delicate, iridescent surfaces, giving the piece a scintillating and compelling presence. As pastiche that mediates between a feudal decorative style and postmodern pop royalty, the work signifies glamour personified.

Fig. 10. Jeff Koons, *Michael Jackson and Bubbles,* 1988. Porcelain. San
Francisco Museum of Modern Art. Purchased through the Marian and
Bernhard Messenger Fund and restricted funds. Photo: Ben Blackwell.

*Marianne Burgers,* a Dutch sculptor, made a pastiche in honor of the Bar-
celona art nouveau architect Antonio Gaudi by creating a sculpture out of blue
and white Delft tile on ferro-cement in collaboration with the firm Ferrocem
Schiedam. As a humorous Dutch answer to the multicolored Parc Guell ce-
ramics, the piece sits in the garden of the Prinsenhof Museum in Delft, re-
writing Gaudi's sculptural form: the artist chose to make a semi-abstract piece
sculpture that refashions a Parc Guell seat as the lap of the earth mother/
mother earth.

*David Hockney,* who has made a career of artistic self-reflexivity, chose
pastiche as his main strategy for taking on canonical works of modernism. As
the example of his *Harlequin* (1980) shows, which, in a very painterly mode,
turns Picasso's artist figure on his head, Hockney does not produce pastiches
in the traditional sense but essays on art and artists. A British critic who exam-

ined Hockney's reception as Britain's greatest living artist concluded in shock that the painter "who for many is definitive 'of our time' is a pasticheur" (Walker 1981: 34).

*Philip Johnson* played with pastiche in several of the buildings designed during what he later called his "postmodern mode," most prominently in the AT&T tower on Madison Avenue, with its neo–beaux-arts rooftop, an entrance block in memory of Brunelleschi, and modern classicism in the spirit of Mies. Less well known and yet more conspicuous as pastiche is Johnson's homage to Claude-Nicolas Ledoux, the French Enlightenment architect and city planner. The visitor approaching the School of Architecture on the campus of the University of Houston is at first glance puzzled, not sure whether this is a historical building or a postmodern historicist one. Recognizing Johnson's play with pastiche led this visitor to interpret the postmodern historicist gesture in the final analysis as a very modern one, the statement of a high-minded twentieth-century architect on the necessity of utopian architecture and the social commitment of future architects.

*Hearst San Simeon* (Hearst Castle National Park) was for decades considered a mere agglomeration of buildings, interiors, and exterior pleasure grounds, the embodiment of eclecticism run wild. For the second half of the century, our perception of William Randolph Hearst's gigantomachia was shaped by the lens provided by Hollywood's best-ever film (AFI 1998), Orson Welles's masterwork, *Citizen Kane* of 1940. The cinematic San Simeon appears as an ever-growing monumental pile of eclectic rubble, reflecting negatively on the personality of the newspaper tycoon Kane, a.k.a. Randolph Hearst.

Today, in view of the mega-eclecticism that is the unfortunate legacy of a misunderstood and cost-effectively bastardized architectural postmodernism coast to coast—that is, shocked by the decorative hype of hotels—San Simeon is a noble fortress of taste. Coming from San Luis Obispo's fabled Madonna Inn (kitsch incarnate) to San Simeon will do it. The Neptune Pool has a Greek temple facade, caryatid lamp posts, and encircling Bernini-style colonnades—everything to highlight the glowing white marble of four authentic Canova sculptures at the edge of the pool. It is pastiche as faux-sublime, but gorgeous. What saves San Simeon's eclecticism today is the fact that its master collected valuable objects and indulged in beautiful materials, so that even in interiors filled with many styles, such as the Assembly Room, the high quality of the diverse items creates a unity of exquisitely crafted materiality.

# CINEMATIC PASTICHE

# 3

In the last two decades of the twentieth century, the cinematic medium experienced in its most ambitious statements a formal change that, although not as incisive as the change from silent to sound film, should nevertheless bring about a distinctly different aesthetic from that of earlier periods of feature film production. It marks a departure from what we have come to consider, *mutatis mutandis*, the "classical" Hollywood film, an artistic and commercial practice with and against which other cinemas have defined their identity. "Classical" in this context implies the development of a typological canon of medium-defining structures that became a standard for making films the world over. The ideal Hollywood format consisted of a visual narrative that created as fully as possible the illusion of reality on the screen, an illusion in which the viewer remained caught up from beginning to end. Continuity editing rendered all junctures invisible, which resulted in a tight, self-absorbed work that did not refer to itself as medium or constructed artifice.

When Bertolt Brecht in 1926 adapted from the Russian formalist Victor Shklovsky the device of "making strange" (*priem ostranenie*) for his theory and practice of the theatre, he could not have anticipated that his *Verfremdungs-effekt* or "V-Effekt" (V-effect), best translated as "defamiliarization effect," would attract the attention of politicized filmmakers and *auteurs* such as Jean-Luc Godard and the practitioners of a New German Cinema.[1] The deployment of the V-effect, all those strategies that make transparent the dream-factory tools of the traditional narrative film, served to break up its autonomy to reveal the constructedness of its representations.

The genre of comedy had permitted early versions of defamiliarization effects, as when Bob Hope addressed the audience at the end of *Road to Utopia* (1945): "As far as I am concerned, this picture is over right now." There are, of course, numerous other instances of cinematic self-reflexivity in

Hollywood-style films that do not essentially challenge the dominant code. This changed when V-effect aesthetics were embraced in a major way by the makers of a "new" and "new-new" Hollywood film—Lynch, Tarantino, et al. —who were influenced by the more unconventional idioms of European cinema, by Godard and by German filmmakers such as Fassbinder and Herzog. The staging of cinematic self-reflexivity, instead of straightforward, unmitigated realism that did not question its underlying assumptions, became an avant-garde activity for a new generation of directors in independent film quarters and in Hollywood.

With the medium's coming of age, self-reflexivity meant above all quoting the tradition and rewriting it (which old hands in the "industry" consider fraudulent; Everitt 1997: 13). Cinematic pastiche projects itself as artistically ambitious, certainly beginning with Ridley Scott's *Blade Runner,* in which one of the architectural structures of Fritz Lang's *Metropolis* is grafted onto an apocalyptic L.A. cityscape. Pastiche structuration in many contemporary films goes beyond mere quotation to comprise a complex medley and layering of different styles and motifs. As opposed to the ideal of a stylistically unified product typical of the Hollywood tradition, it is cinematic impurity that is pursued with a vengeance. If Hollywood streamlined filmic narrative into a most captivating illusion on the screen, Tarantino dissolves the customary linearity of the narrative, Lynch opens *Blue Velvet* with idyllic frames to denounce same as a simulacrum, and British filmmakers merge film with painting to create cultural critique as double visuality.

Pastiche structures can be seen as constitutive of postmodern film, movies that share their stylistics and ideological criticism with postmodern art, literature, and general critical theory. The five case studies selected to introduce this discussion of cinematic pastiche belong to two distinctive groups with overlapping features. Three of the examples are *noir* pastiches; that is, they belong to the postmodern revival of *film noir*—in subdued color or color stock developed toward black-and-white. *Blade Runner, Wings of Desire,* and *Zentropa* have in common a strong dystopian feel that dialectically calls forth its utopian counterpart. The remaining case studies, on Jarman's *Caravaggio* and Greenaway's *The Cook, the Thief, His Wife and Her Lover,* share with the first group the practice of quotation and appropriation as well as filmic reflexivity as critique, but feature a sensuous and flamboyant visual style quite unlike the style of the neo-*noir* examples. The catalogue, titled "Short Takes," addresses additional cinematic pastiches with a brief description.

## *Pastiche Noir*

### Ridley Scott, *Blade Runner* (U.S.A., 1982)

Ridley Scott's *Blade Runner* is the film that first provoked a discussion of pastiche and postmodernism in cinema. In a brilliant essay in *October*, Giuliana Bruno uses the concept to describe the dystopian aspects of the film, which for her represents "postindustrial decay" as the postmodern condition. Pastiche here is the aesthetics of decay and of disintegration. "With pastiche there is an effacement of key boundaries and separations, a process of erosion of distinctions. Pastiche is intended as aesthetics of quotations pushed to the limit: it is an incorporation of forms, an imitation of dead styles deprived of any satirical impulse" (Bruno 1987: 62). This last argument paraphrases Fredric Jameson's negative assessment of pastiche which served as a rallying point for our enterprise (see the Introduction); throughout her article, Bruno acknowledges her debt to Jameson.

Bruno reads *Blade Runner* as a representation of the system of waste and recycling that marks an accelerated postindustrialism; pastiche is but a semiotics of recycling. "The disconnected temporality of the replicants and the pastiche city are all an effect of a postmodern, postindustrial condition: wearing out, waste" (65). Engaging two high-profile theorists of architectural postmodernism, Robert Venturi (1966) and Charles Jencks (1977/1984), Bruno describes the "logic of pastiche" as a hybrid conglomeration that can feature ugliness, decay, banality, and rampant stylistic eclecticism in search of a new synthesis. In the environment of Bruno's argument, this description reads as a negative assessment of postmodern architectural pastiche which misrepresents Venturi's positive concept of "messy vitality" (to counter the right-angle purism of international functionalism) as well as a more general position by Jencks on pastiche.

For observers of postmodern architecture in the seventies and eighties, Jencks's observation does not necessarily read negatively, as it does for Bruno. As in the case of Jameson's rejection of postmodernism from a neo-Marxist perspective, for Bruno the concept of pastiche also serves to denounce the aesthetics of postmodernism. "Pastiche and the exhibitionism of the visual celebrate the dominance of representation and the effacement of the referent in the era of postindustrialism" (67). This is precisely where our argument begins.

At the time of Bruno's writing, in the mid-eighties, Ridley Scott's film appeared as a singular work, unique in its formal features, which allowed those

features to be dismissed as mere "excess of scenography." Thus Bruno sees in "every relation in the narrative space . . . an exhibitionism rather than an aesthetics of the visual" (67). Neither Greenaway's *The Cook, the Thief* (1989) nor Lars von Trier's *Zentropa* (1991), to be discussed below, had yet been made; nor had a host of other films that we now clearly discern as postmodern in form. Today there are so many examples of works that redefine narrative space in film in conscious opposition to the practices of a Hollywood-type narrative cinema that those interested in innovative filmmaking cannot but direct their attention to the new formal appearance of cinematic art. It becomes much more difficult now to subsume pastiche forms under an all-embracing Jamesonian critique of a postmodern culture that symbolizes little more than the evils of a late-capitalist society.

Although Bruno makes productive use of Baudrillard's theory of the simulacrum, especially in her discussion of the "replicants"—that is, she employs the most avant-garde type of post-Marxist critical theory available in the mid-eighties in American academia—her assessment of the form of *Blade Runner* remains within the Marxist code, barring formal innovation and an orientation to form in the aesthetically inclined recipient in general. Scott's film became a cult movie among the artistic avant-garde, in part because of its unusual visual appeal, an appeal, that was not registered among the cognoscenti first and foremost as a semiotics of cultural pessimism. Thus, while Bruno's will remain a historically important analysis, the following reflections tease out aspects of form that, given the dialectic of blindness and insight, she "overlooked."

As shown in the discussion of pastiche structuration in painting and sculpture, the postmodern variant of this once notorious mode of expression offers considerable critical potential. It is capable of an entirely new complexity in conveying meaning, and is by no means mere formalist play. Take the first and second images that we see in *Blade Runner*. The entire frame consists of an eye, and in that the frame is already double-coded. For one, the eye refers to Vertov's camera eye, both in its association with the concreteness of the (Zeiss) lens and as a sign of filmic self-reflexivity. Scott's frame also evokes René Magritte's famous painting in the Museum of Modern Art, *The False Mirror* (1938). The conflation of the two visual references points to the impossibility of "objectivity" in filmic representation. The eye behind the camera is the "false mirror"; that is, there is no value-free representation by a camera eye.

The second image, which lingers in variations for some time, presents the pastiche structure that is prevalent throughout this film. It is a multi-coded

visual semiosis that eschews any definitive message and immerses the viewer in a bewildering web of cultural referentiality. Only in a second or third viewing do the various interacting codes become more discernible. Spectators accustomed to narrative film are likely to associate a Los Angeles burning in 2019; this mimetic code is overlaid by the historical reference to Rome burning and the notion of the decline of the West. This association then leads to the mythical code: leaping flames evoke images of apocalypse. The sudden dramatic flash of a darting flame suggests a Promethean fire. We are dealing with a pastiche of cultural cues that unfold in what is basically one image realized in a sequence of frames. The conflation of the different references brings forth the theme that will intensify throughout the film: a critique of unbridled technological progress.

The critique of technology, of the Promethean principle, is expressed by means of another pastiche mode, namely as a take-off from an earlier work of cinematic science fiction, *Metropolis,* which is itself in part a rewriting of the Faust motif. In Lang's silent classic of 1926, set in the year 2000, the scientist Rotwang is a Dr. Faustus clad in sixteenth-century garb. To the impressive range of technological successes administered by the tycoon Frederson, Rotwang is to add the greatest of all: he is to create a robot in the likeness of a living person, to be used to confuse and mislead the striking workers. Rotwang, the deceiver of humanity in the spirit of science, is pushed to his death in a fight on top of a cathedral.

This last scene is among a number of quotations from *Metropolis* that Ridley Scott pastiches in *Blade Runner.* Dr. Tyrell, the twenty-first-century inventor of "replicants," human-like robots, dies by being pushed from the top of a cathedral by one of his creations. At one point Tyrell wears a Rotwang-type frock-dress; Rotwang's right hand gloved in black leather returns as Tyrell's hand wearing a black leather glove with parts of its fingers missing.

The reference to *Metropolis* is there from the outset: a figure standing in a planning bureau projecting importantly into a future, just as we see Frederson, the "Master of Metropolis" in Lang's film. *Metropolis's* archetypal skyscraper, the often reproduced cardboard tower made by Erich Kettelhut, also appears in *Blade Runner* as a brief quotation. If the architecture of *Metropolis* showed eclecticism in the various locales (functionalist modernism, art deco, the scientist's archaic little house with its high-powered laboratory, catacombs, the Gothic cathedral), the architectural space in *Blade Runner* is exceedingly hybrid, yet in the end appears strangely unified in its overall effect. Skyscrapers look like Maya temples and connote the return to a decorative code in postmodernist architecture. Another marker of architectural post-

modernism, the return to the classical archive, is beautifully staged in Tyrell's quarters as Deckard enters, led there by Rachel. The theatricality of the classical setting may point beyond the "present of the past" program of aesthetic postmodernism to the involvement of the classical heritage in the grand schemes of modern science. The recurring image of the owl that closes one eye or turns away from the camera represents the owl of Minerva, of wisdom that cannot tolerate conspicuously dystopian developments.

So far we have isolated two types of pastiche structuration. One kind appears in the blending of different strands of referential meaning, as in the "Burning Town" complex: pastiche as an overcoding of a visual sequence. The second type involves a more specific and conspicuous intertextuality, in that the new movie quotes and rewrites an earlier work of cinematic art, *Metropolis*, generally considered the first example of the science fiction genre in film. A third type of pastiche structuration in *Blade Runner* shapes the futuristic cityscape as the Other of Western culture. It is pastiched from a multitude of signs that connote socio-existential states. Thus the recurring billboard "Enjoy Coca-Cola" denotes a capitalist consumer culture in a multicultural setting. The soundtrack merging different languages such as Chinese and German reinforces the impression of "Ramble City" (Bruno); more affirmatively, one might hear a multicultural society inhabiting a polyglot space.

The aspect of the pastiched cityscape that is most difficult to assess is the function of the aesthetic quality of its semiotics of decay and displacement. The visual effects often resemble abstract painting and the poor, drab materials of *arte povera*. Since 1982, they have struck those viewers who participate in a sophisticated visual culture, such as the world of art, architecture, and fashion, as being of compelling beauty. The art critic Barbara Rose described the film as a "grabbag of in-jokes" that made references to almost "any kind of high or low art ever done" (1982: 558). The pastiching of all these recycled images and dislocated reality particles was produced by a highly creative team on the Warner Bros. Burbank sets, in particular by designers Syd Mead and Douglas Trumbull, with Jordan Cronenweth as cinematographer.

On one hand, the scenography projects the dark future of an archetypal Western metropolis in the twenty-first century. On the other, a cinematic space of such painterly presence is established that the eye of an aesthetically sensitive viewer is drawn deep into the wealth of visual stimuli. These stimuli may originate in found material, but they are unified by the effect of pastiche as a unifying taste (see chapter 1), thereby producing the strong tactile appeal of the cityscapes. Throughout the film, the city tableaux remain an enigma

that challenges and disturbs the viewer as it fascinates in aesthetic terms. One is always aware—on the level of the narrative—of the charge against destructive technology; it is, however, the double-coding operative in so many scenes of *Blade Runner,* the way the pessimistic message strikingly co-exists with visual beauty, that unsettles viewer reception. For the discourse of dystopian cultural criticism is continually superseded by a visual language that aestheticizes chaos and debris—the postmodern pittoresque. The latter aspects are exhibited as artistic codes rather than mimetic particles of a realistic setting. For instance, the frame in which the replicant played by Daryl Hanna is covered with debris connotes the kind of postminimalist practices performed by Cindy Sherman (see chapter 2) in her early "filmstills," which were created at the time when *Blade Runner* was being made. As Jack Boozer, Jr. observes, "*Blade Runner* is a virtual textbook of self-conscious representational games: multilayered surfaces and points of view, and tricks of 'characterization' and human disguise" (1991: 219).

Critics have stressed the importance of the seemingly ever-present rain in *Blade Runner.* In his review of the "director's cut," Scott's re-issue of his film in 1991, Mike Wilmington says that the rain machine was not necessary to blend all those disparate scenes and images together to suggest a world reaching far beyond the Burbank studios (1992: 17). If we look at the structure of cinematic space with an eye to its pastiche quality, then the rain fulfills the important function of a blending agent, a unifying medium for a curiously sublime dystopia.

*Blade Runner* is a *film noir* in color, a hybrid mode that should become influential for many postmodern works, including those to be discussed. In a classical *film noir,* the narrative usually does not succumb to the expressive effects of the black-and-white cinematography; the notion of a verifiable reality remains at the core of such classics as William Wyler's *Dead End* (1937) and Orson Welles's *Touch of Evil* (1957). The pastiche effects in *Blade Runner* dismiss a clearly discernible narrative direction, thereby foregrounding the philosophical concerns of the film alluded to by the director in interviews. The lack of traditional narrative is precisely why the film was not a popular success. In general, viewers are programmed to see a movie as the closest representation of the real. Interest in the story and identification with the characters are necessary for the pleasurable concretization of the film by those recipients, who consequently tend to follow the story of *Blade Runner*'s replicants closely. The form of this film must strike such viewers as downright weird. Yet it is the conventional and unreflected notion of representation that the

pastiche structuration challenges. Those who catapulted the movie to avant-garde status must have sensed the challenge, which compelled them to return again and again to a work of art only gradually unfolding.

The "exhibitionism" that Bruno sees at work in the visuality of *Blade Runner* functions to express existentialist concern. The film's extravagant and disturbing aesthetics are the visual correlate to the conspicuous word spoken by Deckard, the skeptical detective (Harrison Ford): "Where do we come from? Who are we? Where are we going?" The compelling ontological statement quotes the title of the most famous painting by Paul Gauguin, which he completed in 1897, shortly before his suicide attempt in January of 1898, *D'on venons nous; que sommes nous; où allons nous* (Boston Museum of Fine Arts). The tripartite formulation (which may be older than the painter's title) can be found in many texts and contexts during the last decades of the twentieth century, a shibboleth for any community concerned about the human condition in a geography of nowhere.

Such a reading disputes Bruno's notion that the eclectic, historical pastiche—out of a loss of history and a desire for historicity—is out to redeem history and, according to "the logic of pastiche," to establish a simulacrum of history (Bruno 1987: 74). Postmodern pastiche, recuperating elements of a past, of different pasts, is not about the claim to an authoritative view of history as, for example, Marxism is. It is not of the order of simulacra that Baudrillard sees at work in American popular culture, as in Disneyland. The pastiche form of *Blade Runner* turns the "Anything Goes" reproach to aesthetic postmodernism into its opposite; as cinematic art, it intensely involves us in what Max Ernst called one of his late paintings, *The Contorted Song of the Earth* (1959–60, Menil Family Collection, Houston).

Ridley Scott's stimulating "empire of signs" (to quote Barthes's study in enigmatic semiotics) remained a cult movie for an art house audience, which may have prompted the director to return to a more conventional visual style, as he did in *Thelma and Louise* and later films. The experiment of 1982, however, would exert its mark on numerous younger filmmakers, the Danish director Lars von Trier among them. Before we approach his *Zentropa* (1992), Wim Wenders's *Wings of Desire* of 1987 may exemplify our notion of postmodern film as poetically ambitious amalgam.

### Wim Wenders, *Wings of Desire* (Germany/France, 1987)
#### Script: Peter Handke, Wim Wenders

In *Wings of Desire* ("Himmel über Berlin") director Wim Wenders introduces a most unusual camera-eye perspective on the complexities of today's

society: angels in human shape observe contemporary consciousness and enter its many different manifestations at will. The work is as overcoded as *Blade Runner*, with its meanings and references speeding past in clusters. For the first 45 minutes, the movie is but an "astral projection" (Hoberman 1988) without any narrative but the airborne journeys of the angels, their sightings and insights into life on earth, with pre-unification West Berlin as its urban exemplar. Even when, later, cinematic presence is created narratively, action codes and referential codes compete in ways that tend to elicit the kind of creative reading on the part of the viewer that Barthes envisioned for what he called the "writerly" text (Barthes 1974: 5).

Generally, the reception of *Wings of Desire* has focused on the mega-questions posed by the film with daring directness: life and how one should live it, identity, happiness, and how to find joy in the simplest of everyday experiences, as Damiel, the angel who desires to become human, reminds us. These and other important themes will be touched upon only in passing in our pursuit of pastiche structuration.

The angel allegory allows Wenders and his co-author of the script, the Austrian writer Peter Handke, to intertwine individual thought processes, emotional states, and cultural memory as a continuum of perspectives, universal emotions, retrospective musings, snippets of history, essays on the Ice Age and on existentialism, and the trapeze artist as a metaphor for art. It is this ubiquitous, proliferating referentiality, often effected through subtle, poeticized allusion, that prompts us to regard *Wings of Desire* as cinematic pastiche.

As in *Blade Runner* and *Caravaggio* (see below), pastiche structuration in Wenders's film is complexly layered and coupled with formal devices that may sometimes only border on pastiche. Thus the simultaneity of interior monologues in voice-over mode that tell of "lives of quiet desperation" (Thoreau), sampled on the city highway or in high-rise apartments, is a classic space montage as it was first created for literature by John Dos Passos in his 1925 novel *Manhattan Transfer*. A device adopted by modernist writers and filmmakers as well as soap opera scenarists, it cannot be regarded as a borrowing in the same sense as the postmodern quotation that abounds in Wenders's film.

Two instances relate to the discursive strand that might be labeled "loss of narrative/loss of knowledge in the information age." An old man named "Homer" appeals to the muses by citing the beginning of the *Odyssey* in his lament about the end of narration, and indeed of literature, and asks, "Where are my heroes?" The *homo narrans*, returning to Berlin from an exile imposed by the Nazis (as did the actor who plays him, Curt Bois), figures as an allegory of the end of literature. The theme is continued by the presence of the Homer

figure in the "library," which appears as the last fortress of the vast tradition of knowledge that shaped Western thought. An angel's eye—the camera's eye— glides over a book on a reading table and caresses its title: *Das Ende einer Welt* (The End of a World). Jürgen Kieper's spheric music celebrates the eternal flow of knowledge and thought transmitted by books, and to a degree counteracts "Homer's" cultural pessimism. Angels are everywhere watching over reading acts. The surreal scenes, ambiguous with their promise and nostalgia, were shot in the (West) Berlin *Staatsbibliothek* ("Stabi"); Wenders and his cameraman Henri Arlekan did a remarkable job of turning the actual, multileveled site into a fictional space that strongly calls forth a short story by Jorge Luis Borges entitled "The Library of Babel":

> The universe (which others call the Library) is composed of indefinite and perhaps infinite number of hexagonal galleries, with vast shafts between, surrounded by very low railings. From any of the hexagons one can see, interminably, the upper and lower floors. . . . Also through here passes a spiral stairway. (Borges 1964: 51)

Several elements of Borges's absurdly ordered labyrinth of knowledge are indeed part of the Stabi, in particular the spiral staircase; the name Borges is mentioned in passing. If we were dealing here with a conventional, openly declared adaptation of a literary text for the screen, the transposition of the textual vision of the author Borges into the cinematic medium could hardly be called a pastiche. It is the undeclared allusion and the loose visualization of the borrowing that give the library episodes in *Wings* their pastiche flavor.

The film opens with a stunning rendering of Agnes Varda's notion of *cinécriture*, film as writing, given a most literal sense by Handke/Wenders.[2] We see a hand writing as a male voice recites "Als das Kind Kind war . . ." (when the child was a child . . . ). Handke, Rilke-inspired as so often, introduces the theme of childhood as the ideal state of completeness. From the dissolve emerges a close-up of a human eye, a recent convention of avant-garde filmmaking, which here, too, refers to the famous camera eye of Vertov and Ruttmann provenience. As the angels Cassiel and Damiel take their positions as observers who cannot be seen or heard (except by children), their allegorical status as intervening and recording agents functions, at least temporarily, as the eye of the camera. As with *Blade Runner*, the close-up of the eye can also be read as an allusion to the Magritte painting *The False Mirror* (1938), suggesting that this eye is not a mirror of reality, but that all seeing is understanding, emanating from an informed and constructed state of consciousness. This

eye then marks not only the celestial distance of the angelic observers but also the subjective vision of the filmmaker producing the object film.

Among the many instances of filmic self-reflexivity in *Wings*, one stands out as an unusual act of pastiche. One narrative strand features Peter Falk as a former angel, playing himself in a movie about a concentration camp. The director is "played" by Wim Wenders. In real life, Wenders has not been able to make a feature film about this darkest period in German history, while non-Germans have. Wenders, who was born in 1945, admits to his inability to confront this awesome task and the impossibility of coming to grips with the past through his art. He resorts to the fabrication of a simulacrum in order to make the impasse visible. In effect, the film within the film comes across as a pastiche of the "real" movies or documentaries on the Holocaust. It is pastiche in the sense of mediocre imitation, which perfectly illustrates the filmmaker's quasi-indictment of himself as someone outside history.

Most of the quotations that contribute to the unique atmospheric production of meaning in *Wings* are less problematic and more engaging than the above instance. Walter Ruttmann's montage film *Berlin—Sinfonie einer Großstadt* (1927) is an active intertext throughout. Another allusion to a classic movie from the silent era occurs at the close of *Wings*. It is so enigmatic that it has puzzled most viewers and critics, one of whom dismissed the segment in which it occurs as "brightly colored awfulness" (Scheib 1990: 11). Admittedly, the final love scene is a tour de force in overcoding. In the notorious sequence at the bar adjacent to the pseudo-religious rock orgy, Damiel, the angel turned human, is offering wine in a large, bowl-like glass to Marion, the object of his angelic desire. The way he holds it in both elicits an association with a scene in Fritz Lang's *Siegfried*, part I of *Die Nibelungen* of 1924, in which Kriemhild welcomes the hero Siegfried to the court of Burgundy. Wenders rewrites her gesture—also reminiscent of Isolde offering, unwittingly, the love potion to Tristan—as feminist, in that the male now offers the potion in celebration of the female. Rewritten, the archaic, festive ritual from Germanic mythology sets the stage for the most intricate pastiche feature in *Wings of Desire*.

Marion's address to Damiel at the bar is nothing less than an attempt by Handke and Wenders to make a strong, affirmative statement on love and heterosexual union after innumerable cinematic happy endings seem to have made it impossible to do so. Writer and director squarely address the arbitrariness and coincidental nature of love encounters and demand that the affirmation of love be a decision, like an existential leap. They posit unconditional

acceptance of the universal story that is man and woman. "We are sitting on the place of the people, and the whole place is full of people who want the same as we do."[3] Marion goes on to claim that what is happening here and now is "verbindlich" (binding), and this, too, she speaks directly into the camera, thereby addressing the spectators. She emphatically communicates to the audience that she is finally "einsam," which does not translate, as the subtitles claim, as "lonely." Rather, her enthusiastic embrace of this state is to be read in a Derridean manner as "ein-sam" and refers to the "oneness" she experiences with regard to her own identity in the new, shared bliss ("gemeinsame Seligkeit"). A dictum attributed to Hegel, "Liebe ist Selbstsein im Anderen" (Love means to be oneself in the other), might serve to explain Marion's stance.

Christian Rogowski reads this disturbingly unconventional segment as "an attempt to create such a *Platz,* a utopian space in which the vision of human fulfillment can be shared with the audience" (Rogowski 1992: 558). We see yet another motivation at work in this scene. In order to avoid the sentimentality that love material tends to lapse into, writer and director resorted to a highly stylized rhetorical mode; indeed, one might speak of a postmodern use of *genus grande.* Originally a mode of classical oratory featuring a heavy use of rhetorical figures to excite emotions and encourage noble ideas, *genus grande* became a "grand" style in the baroque age across Europe.[4] Known variously as Gongorism and Marinism—after the mannerist styles of the poets Gongora and Marino—it was employed in high tragedy, while the simpler *genus medium* was the more common speech of comedy.

The turn to baroque theatricality is, as we have seen with respect to architecture and painting, very much a part of postmodern aesthetics. Handke and Wenders make use of baroque high-style artifice in an intriguing project of double-coding. On one hand, this move serves to defamiliarize the conventions of romance in the movies; on the other hand, the deliberate artificiality borrows the seriousness of baroque tragedy. As an attempt to both deconstruct conventional representation of declarations of love and at the same time emphatically affirm the concept of love, the much-misunderstood scene is certainly artistically ambitious. As a pastiche of a certain gesture in *Siegfried* and, more prominently, of baroque rhetorical grandeur, the scene provokes the viewer with its overcoded closure.

Furthermore, the rhetorical stance suggests a certain similarity to Umberto Eco's suggestion of how to cope with declarations of love in an age saturated with testimony in verbal and visual form. "I think of the postmodern attitude as that of a man who loves a very cultivated woman and knows he cannot say to her, 'I love you madly,' because he knows that she knows (and

that she knows that he knows) that these words have already been written by Barbara Cartland" (Eco 1984: 67–68). Eco suggests that the courting ritual of the male be one of ironic double-coding: "'As Barbara Cartland would put it, I love you madly.'" In Eco's view, "he" has avoided "false innocence" and made an authentic point nevertheless. Handke and Wenders also attempt a distancing from the "used-upness" of the language of emotion so central to romantic love. Structurally, their choice to rescue authenticity of feeling in language and gesture may be similar, for instance with regard to the postmodern device of double-coding, but instead of the ironic stance embraced by Umberto Eco, they opt for a purposely conceited, high style, programmed to differ drastically from the conventional, the expected.

The pastiche structuration that shapes so much of the form-content confluence of *Wings of Desire* in turn became the source of numerous second-degree pastiches in music video and television production. Curiously, they follow the development from high art to low that was typical of the traditional pastiche. *Touched by an Angel*, a CBS series that began in the 1990s, adopted the crucial structural innovation of *Wings*, the representation of the angelic principle in the form of humans in civilian clothes. In the work by Wenders and Handke, this device generates the central allegory of the film: it is through an alien lens from above and afar that the human condition is visited, a perspective that is meant to instill in viewers a new humility with regard to life on earth and a consciously archaic joy of living. *Touched by an Angel* is not abstract enough to enact this allegorical message in a major way; the series is first and foremost a soap opera.

A number of somber discourses in Wenders's film—the aforementioned space montage, Homer's lament, and the sorrow of the angel Cassiel, who tries in vain to prevent a suicide—fueled the music video "Everything Hurts," a parody of *Wings of Desire* produced in 1992 by the rock band REM. The motif of *Weltschmerz*, to which "Everything Hurts" alludes, has been associated with the German temperament ever since Goethe's *The Sorrows of Young Werther* (1774).

When does pastiche cross the line to parody or even travesty? Critics writing on the most obvious pastiche of *Wings* yet, the film *City of Angels*, released in 1998, claim that Brad Silberling's movie "travesties" Wenders's and Handke's film by distorting its central premise (Schickel 1998: 81). The initially attractive idea of retranslating the metaphor of "Los Angeles" into the literalness of a concrete angelic presence obliterates, as did the television series, the central message of *Wings*—the importance of enjoying life at its simplest, of finding happiness in the "flux of things."

We are reminded of the eighteenth-century critique of literary pastiche by the theoretician Marmontel (see chapter 1), for whom imitation of a great poet served a noble purpose, whereas pastiche merely engaged some superficial aspects of a copied work. Such superficial affinity characterizes the pastiches made of *Wings of Desire*, whereas the Wenders film itself represents precisely the redefinition of the genre, an intellectually and artistically interactive postmodern pastiche.

### Lars von Trier, *Zentropa* (Danish-French-German-Swedish Co-production, 1991)

Before we turn to the optical riches of two British films that offer a contrastive paradigm of cinematic postmodernism, one more example of *pastiche noir* warrants discussion. Lars von Trier's *Zentropa*, known in much of Europe as *Europa*, is a nightmarish journey that takes place mostly at night, a topos of the classical *film noir* made in the era of black-and-white cinematography. The typical voice-over mode of the genre—a detective's narration—is here restaged as an act of hypnosis; the voice of Max von Sydow, Ingmar Bergman's star actor, mesmerizingly addresses both the viewer and the anti-hero soon to appear. The voice commands Kessler and the audience to gaze and to go on gazing, then to "go deeper"—a meta-narrative comment on film as trance-inducing and dream machine. On the diegetic level, the mesmerizing sequence identifies the journey that Kessler and the audience are about to begin as an experience both real and unreal, one in which reality keeps slipping into surreality, a journey "through the German night."

The fact that the young American Leopold Kessler ventures into 1945 Germany as a *sleeping* car conductor (my emphasis) reinforces connotations of processes of the unconscious. Throughout the movie, the temporal referent is underdefined, which is congruent with Freud's well-known dictum that the unconscious knows no time. During one of his searching flights through the train, Kessler suddenly comes across a compartment full of emaciated figures reminiscent of wagons with victims destined for (or perhaps emerging from) a concentration camp. Such a reading of the scene is also suggested by its contiguity to Kessler's despairing exclamation: "I don't want this train to go to Munich, Frankfurt, or fucking Auschwitz."

The scene is a quotation from Edward Dimytrik's *The Young Lions* (1958, with Brando) and is part of the Kafkaesque code that forges the film's mood, mostly through pastiches on themes from *The Trial*. For example, Kessler's sudden confrontation with the previously invisible but now shockingly inhabited compartment is structurally related to an enigmatic episode in Kafka's text. In the chapter "The Whipper," the character named K. stumbles upon a

closet ("Rumpelkammer") in the bank and witnesses his guards being flogged by a whipper. When he returns the next day, he finds the drama (of sadomasochist sexuality) unchanged from the day before, suspended, as it were, in a "dynamic still" (Cohn 1971: 27). In *Zentropa*, too, time is arrested, irrational; what Kessler sees in a fleeting moment of shock may appear to him, and certainly to von Trier's audience, as an eruption of the repressed memory of the Holocaust.

More strikingly, another theme from Kafka's novel surfaces as pastiche. Lars von Trier, made up to look like Bertolt Brecht, is "the Jew" who visits the owner of the Zentropa railroad to collect a questionnaire about the Nazi past of Max Hartmann. The "trial" of Hartmann is fake, a de-Nazification that belies his Nazi past, which prompts him to commit suicide. In *The Trial*, K. is challenged by an unrevealed authority to come forth with a truly authentic account of himself. He fails to do so and is "sentenced" to die a violent death.

Typical of Kafka's narratives is a surreal textuality in which the ordinary slips seamlessly into the extraordinary. In von Trier's film, the anti-hero Kessler is supposed to be preparing for several examinations in connection with his apprenticeship at the railroad company. He is continually chased by the two examiners (see K.'s pair of guardians). He is urged to prepare for these tests in the midst of the dramatic events in which he is embroiled—his marriage to an ex-and neo-Nazi, his collaboration with the dubious "werewolves," his attempt to free himself. If Hartmann's "trial" has a tragic aspect in the context of his unrepenting son and daughter, the exceedingly banal examinations to which Kessler is subjected are hilariously grotesque. "Your problem is not important," Kessler, in real trouble, screams at his examiners, reminding readers of *The Trial* of a moment in the cathedral when the chaplain admonishes K.: "Forget such irrelevancies" (Kafka 1998: 213).

Leo Kessler (Jean-Marc Barr) is Kafka's semiotic man, like K. always deciphering, with an angst of Kierkegaardian proportions. As the work of a Danish Jew of the post–World War II generation, the film makes sense as an allegory of a very specific Danish anxiety at the beginning of the nineties, concerning Denmark's position in a united Europe. It is significant that Lars von Trier called his film *Europa*.[5] The imagined werewolves, those slick, left-over Nazis, are figurations of the Danish nation's fear that a newly united Germany (1990) would once again take the lead in Europe and send its neighbors into another "German night." (After considerable resistance on the part of its populace, Denmark did join the European Union in 1993.)

To see allegorically, to perceive one thing through another, is an intertextual act that is reinforced in von Trier's work through the numerous bor-

rowings from film history and the cinematic vocabulary. For *Time*'s Richard Corliss, *Zentropa* is a "hallucinogenic remake of *The Third Man*" (June 8, 1992); others see it as a cross between *Blade Runner* and Terry Gilliam's *Brazil*. One could easily add *Wings of Desire* to the cinematic memory behind the visual style of *Zentropa*. Self-reflexivity is close to *noir* sensibility, but quotation is not limited to masterworks of the genre. In a virtuoso fashion, the Danish director also amalgamates otherwise discrete devices of the cinematic medium such as high-angle shots (German expressionist film via Welles *noir*), superimposition, surrealist object close-ups, stunning rear projection, and the hybrid beauty of color stock driven toward black-and-white, with sporadic color frames as a defamiliarization effect. Simultaneous color/non-color coding was used by a number of innovative directors in the eighties, including Ridley Scott and Wim Wenders; after *Zentropa*, the device became a convention. Like Scott in *Blade Runner*, the Danish director favors a visual style of voluptuous bleakness that both provokes and pleases the eye in its conjuncture of dystopian message and dazzling avant-garde form.

"Echoing Orson Welles by way of David Lynch" was Bob Mandella's *in nuce* description of *Zentropa* when the film was released in the United States (NPR, Aug. 11, 1992). In addition to the recognizable Kafka pastiche, there is the engaging *noir*-absurd atmosphere that seems to feed on so many movie classics. Perhaps even inspired by *Blade Runner*, *Zentropa* has its own *Metropolis* pastiche, a grafting of Lang's machine "moloch" and Babel allegory onto a grand inauguration ceremony for one of Zentropa's trains. As for Lynch, Leopold Kessler does bear a striking resemblance to Lynch's young, wide-eyed, stumbling detective in *Blue Velvet;* at the same time, von Trier's K. and the Kafkaesque texture are the director's homage to a great twentieth-century writer and a statement of affinity. The hybrid visual style of *Zentropa*, its blend of self-consciously selected monuments in the film medium and other effects, paradoxically creates the unitary sensibility typical of pastiche. The reaction of an early reviewer is not far off: "The star is the atmosphere" (Hal Hinson, NPR, Aug. 11, 1992).

## Double Visuality: The Presence of Painting in Film

### Derek Jarman, *Caravaggio* (Britain, 1986)

Painters such as Carlo Maria Mariani, as some believe, use pastiche to reposition the homosexual artist in a history of art that, by tradition, has tended to ignore gender aspects of artistic identity. At the very moment in the mid-eighties when Mariani's *La Mano* could be seen on T-shirts from an

exhibition called "Second Sight: Exploring the Future of the Past" at the San Francisco Museum of Modern Art, the British filmmaker Derek Jarman attempted to rewrite the history of Western art and literature by means of a cinema whose aesthetic fervor and force of innovation would advance the cause of gay rights in Britain and beyond. Indeed, as one critic remarked in his obituary on Jarman, who died of AIDS in 1994, the filmmaker sought to construct a "grand transhistorical sequence of homosexuality from Plato onward by way of Michelangelo" (Watney 1994: 84). Whatever function the politics of legitimizing homosexual identity may have had in Jarman's films, be it *Sebastiane* (1976), *Edward II* (1991), or *Wittgenstein* (1992), the director's activist stance clearly was a major force in the development of his unconventional visual style.

Jarman, who studied painting at the Slade School of Art in London, was a pasticher of the first order. With *Caravaggio*, his exuberantly hybrid style eventually reached an international public, fascinating all who trace postmodern form in film. Jarman's visualization of the life of the Italian baroque artist is an homage both to painting and to gay culture, priorities that were intensely embraced by the artist, a central figure in the English gay liberation movement. The *enfant terrible* Caravaggio seemed a most suitable subject to the *enfant terrible* Jarman, worthy of what would become a seven-year labor of love. The book about the making of the film tells of the extensive troubles and setbacks that Jarman faced until finally the film was produced by the British Film Institute, with the modest budget typical of cultural sponsorship.[6]

Jarman's thorough research into the life of Michelangelo Merisi Caravaggio, a life spent on the fringes of high society and in the entanglements of lowly brawls, paid off in the end. Although he immersed himself in the early Italian and German sources on Caravaggio, the director did not aim at art-historical accuracy in the film. As in other famous cinematic biographies of painters, Jarman sought to establish a narrative connection between the art and the life, but he accomplished this in a very different fashion than had previous examples of the genre.

*Caravaggio* is a compelling and compellingly beautiful portrait of genius as problematic existence, specifically the artist as murderer.[7] (Caravaggio is said to have murdered one Ranuccio Thomasoni in 1606 and had to flee from Rome.) In his writing, Jarman is obsessed with this idea of the artist-murderer; the translation of the ultimate misfit in society may metaphorically reflect the flamboyantly interventionist stance of the artist Derek Jarman. "Directing with Caravaggio's knife" is the caption under a photograph of Jarman in the book accompanying the film (Jarman 1986: 136). The words inscribed

on the cinematic prop representing the historical knife of the painter are "no hope, no fear," a motto now imbued with our awareness of AIDS and read as the filmmaker's anticipation of a fate that would be his, too. (Jarman tested positive for HIV at the end of 1986.)

Using a convention of analytical drama, Jarman begins his film with the death of the painter in the fishing village of Porto d'Ercole in July 1610, then proceeds to unravel the life of Michelangelo Merisi da Caravaggio in extended flashbacks.

Caravaggio's revolutionary use of light and dark, his *chiaroscuro* style in the service of a new realism, attracted Jarman, who perceived it as an origin of cinematic lighting.[8] A first level of pastiche structuration can be found in the intermedial juncture of painting and film. We see Caravaggio's most famous paintings—following attributions by recent art history—created before our eyes as the models pose for the artist. Painting turns into cinematic narrative: we see the making of *The Concert of Youth* (c. 1595, Metropolitan Museum of Art), *The Martyrdom of St. Matthew* (1599–1600, Contarelli Chapel, Rome), *Death of the Virgin* (1605–1606, Louvre), and other works (see below), while at the same time the strenuous task of being an artist's model is realistically highlighted.

The act of painting and the presence of paintings, including glimpses of finished work, such as the early *Head of Medusa* (c. 1569, Uffizi), determine the film's visual flow so strongly that the painterly often displaces plot development. Jarman wrote, "I have tried to create every aspect of the film in the ambience of the paintings" (Jarman 1986: 94). Such empathy extended to the sets, which in many scenes consist of expanses of modernist painterly abstraction that double as an economizing measure not dissimilar to the conditions in 1919 that gave rise to the cubo-expressionist style of Robert Wiene's *The Cabinet of Dr. Caligari*. (Because of the shortage of electricity after World War I, shadows and other light-dark modulations were incorporated into the abstractly painted sets of the 1919 classic.)

Jarman indirectly acknowledged his debt to Pasolini when he mused in his work-in-progress diary *Dancing Ledge*, "Had Caravaggio been reincarnated in this century it would have been as a filmmaker, Pasolini" (Jarman 1993: 10). In the course of his homage to Pasolini, Jarman briefly mentions a little-known short by the Italian director entitled *Ricotta* (1962), which appears to have been a considerable influence on the shape of *Caravaggio*. In *Ricotta*, a (fictive) Hollywood team films the story of the passion of Christ in a barren Italian landscape using local, poverty-stricken extras. For the climactic scene, the Marxist and art lover Pasolini re-created the dramatic *Descent from*

*the Cross* by the mannerist painter Rosso Fiorentino (1521, Volterra), with Jesus being played by an extra who dies of hunger on the cross during the shooting. The stark, albeit highly aestheticized, social critique may have shown Jarman the subversive potential of the cinematic use of painting. (The director of *Caravaggio* reproduces Pasolini's quotation of the Rosso painting on page 23 of *Dancing Ledge*.)

Dissolving the medium of painting into cinematic flow, a time-art, represents the typical postmodern conflation of different art forms. André Bazin, in his chapter "Painting and Cinema," remarks that painting "takes on the spatial properties of cinema and becomes part of that 'picturable' world that lies beyond it on all sides" (Bazin 1967: 166). Bazin talked about the representation of paintings in cinematic frames; the dissolve—as in *Caravaggio*—of the static art object into the transitory time flow of cinematic movement represents a more radical amalgamation of painting and film. The painterly film becomes a pastiche of the old-masterly art of the baroque painter Caravaggio.

Another variant of pastiche structuration is the hybrid style of many of the scenes set around 1600, which lets them appear as both past and present, thereby appealing to our contemporary consciousness. Caravaggio's dumb assistant Jerusaleme could pass for an artist at the end of the twentieth century with regard to his clothing and hairstyle, and at the same time he fits our image of someone from the turn of the seventeenth century. Lena looks like a muse who inhabits both baroque Rome and London's contemporary avant-garde scene. The sets are sufficiently abstract as to suggest a timeless space.

The fusion of horizons is not limited to visual signs but is reinforced on the level of speech acts. When "Michele" Caravaggio (Nigel Terry) is shown in his studio next to his work *Boy with a Basket of Fruit*, crowning himself with the vine leaves of his *Bacchus* paintings—in Jarman's view, all self-portraits[9]—the voice-over musings of Caravaggio echo the temperament of the modern-day visual artist Jarman:

> I built my world as Divine Mystery, found the god in the wine, and took him to my heart—I painted myself as Bacchus and took on his fate, a wild orgiastic dismemberment. I raise this fragile glass and drink to you, my audience. "Man's character is his fate." (Jarman 1986: 21)

The picture titled *Bacchus Malato* (Sick Bacchus) (1593–94, Galleria Borghese; fig. 11) takes on a signature role in the hermeneutics of homosexual culture. The gracious appeal and fragility of the figure were, in Jarman's eyes, to be interpreted as a self-portrait of the painter that lent credence to his homosexuality, an identity important for the director's project.

Fig. 11. Caravaggio, *Sick Bacchus*, 1593–94. Courtesy Galleria Borghese, Rome.

Furthermore, one senses a definite linkage between the circumstances and politics of an artist's life under the patronage of mighty cardinals at the turn of the seventeenth century and the eventful bohemian life of today, be it on the level of verbal or visual expression. When Cardinal Del Monte, an enlightened Medici, in whose palace Caravaggio has a cellar studio, steps into that space one night to inspect the props for *The Repentant Magdalene* (c. 1595, Detroit Art Institute), he delivers a timeless monologue about art (whereas some of his other comments are strictly modern):

> The painter restrains the burning action of light; he separates the sky from the earth, the ash from the sublimate. (Jarman 1986: 101)

The viewer associates the discourse on elusive subjects such as art with the timeless status of the "classics"; thus, such a statement functions as bridge to an audience far removed from a centuries-old masterwork and its environment.

Of a different order is the presence of modern slang in the film, expressions such as "fucking brilliant" (Ranuccio to Michele) and "the most successful fucking disaster" (about painting). De-historicized speech and the motorcycle noise in the background infuse the historical narrative with a contemporary feel, thereby contributing to the pastiche structuration on the level of the visual. One of the key scenes for our analysis is a dinner given by Cardinal Del Monte for the Marchese Vincenzo Giustiniani, the richest man in Rome. The Marchese uses a golden pocket calculator throughout the meal, which is catered by elegant modern waiters in white gloves overseen by a senior butler in a tuxedo (fig. 12). This anachronistic gesture signifies the ever-present reality of financiers such as Cardinal Del Monte's guest. Likewise, the men in black leather coats at Lena's deathbed recall members of authoritarian agencies in modernity. For Harlan Kennedy, the "time-slip incongruities (motorbikes, pocket calculators, Italian neorealist clothes)" are testimony to Jarman's zest for iconoclasm that "holds history upside down by the ankles and shakes out all the small change" (Kennedy 1993: 33).

The "party" scene provides the longest sequence involving anachronistic juxtaposition. Vincenzo Giustiniani has invited guests to celebrate *Profane Love,* a painting he has just acquired from Caravaggio. In real life it is the work housed in the Berlin Staatliche Museen (Gemäldegalerie) entitled *Amor als Sieger* or *Amor Victorious* and dated 1601–1602 (fig. 13). The picture is an allegory of *Amor vincit omnia*—Love conquers all—and shows an adolescent male as a winged *putto* who tramples over "Art and Culture," as Jarman—with a wink to Clement Greenberg—describes the array of tossed instruments and

Fig. 12. Cardinal Del
Monte and Marchese
Giustiniani at Dinner.

Fig. 13. Caravaggio,
*Amor Victorius*,
1601–1602. Staatliche
Museen Berlin,
Gemäldegalerie. Photo:
Jörg P. Anders.

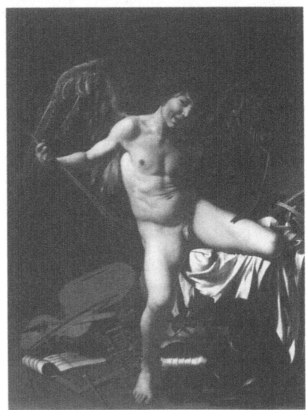

objects dominated by the homoerotic appeal of the nude figure (Jarman 1986: 75).

The party is an exuberant dramatization of "Love conquers all" as the central theme of gay culture, and the time-slips enforce such a claim to universality and perennial relevance. A group of young men who seem to have just emerged from a 1980s neo-expressionist painting by German artist Rainer Fetting hit the scene—highly styled figures exuding a camp theatricality. Jazz is being played at this feast of baroque visual effects—baroque in a typological sense, not as a historical period. An exuberance prevails that thrives on the experience of the absurd.

Pastiche as anachronistic amalgam is likewise highlighted in the scene of Baglione's death, depicted as a quotation of David's famous painting of 1793, *The Death of Marat* (Brussels). Baglione (1571–1644) was an artist and a reputable art historian whom Jarman chose to portray as Caravaggio's fierce competitor and vicious critic. Sitting in the bathtub, Jarman as Baglione nervously thumbs through the beautiful spread of Caravaggio reproductions in the July 1985 issue of the German journal *Pan*. He speaks and types out on a Royal manual typewriter (fig. 14) slanderous comments on Caravaggio's painting to alert those "who love art to this poison that seeps into our Renaissance, as insidious as the dark shadows that permeate his painting, cloaking his ignorance and depravity" (Jarman 1986: 35). Not only does the director offer the yoking of the Then and Now—the early-seventeenth-century art critic writing on a typewriter and reading a magazine from the 1980s—but the anachronistic juxtaposition is also embedded in a full-fledged pictorial quotation with high recognition value, involving not only the art itself but also its reference to the French Revolution. The interpretation of the scene by the educated viewer is likely to be ambiguous. For what might connect the tragic death of the eighteenth-century revolutionary Marat with the unfavorably portrayed Baglione?

The hilarious pastiche elicits a most vexed response, and of all the viewer-distancing devices in the film, this is probably the most challenging. To be sure, the camera as the director's eye moves freely back and forth in time, analogous to the activity of our cultural memory, and it is an aesthetics of paradox that drives the pastiche style of the film. As Vincenzo Giustiniani comments congenially, "The most incompatible subjects make the best friends," which may remind us of the mannerist figure of *discordia concors*, the joining of opposites. Still, the degree of overcoding in those Baglione-Marat frames frustrates the interpretive efforts of viewers who refuse to see only a play of quotations.[10]

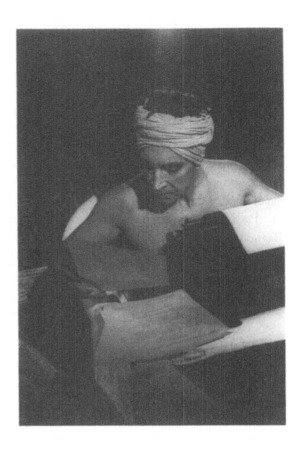

Fig. 14. Derek Jarman as
Baglione.

The quoting, or "stealing," of David's painting also illustrates the credo
of Jarman's *Caravaggio* that "Mercury invented art, an act of theft." Theft, as
the reader may recall, was the impetus of the original pasticcio that established
its lowly reputation. Theft in the postmodern arts, on the other hand, is a
critical and intellectual operation of the contemporary consciousness. In the
presence of a problematized relationship to history and the writing of history,
the creative appropriation of the past, the imaginative theft of the past, is here,
as elsewhere, a sign of the impasse. Jarman stole Caravaggio and made the
painter accessible to thousands of twentieth-century viewers who might oth-
erwise never have cared for baroque art.

Not only does the film heighten aesthetic sensibility in the open-minded
viewer, but it also seems to have pointed a number of artists in the direction

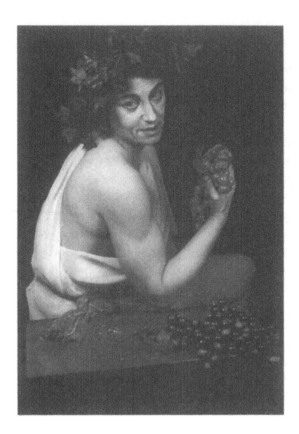

Fig. 15. Cindy Sherman,
*Untitled No. 224,* 1990.
C-print photograph.
Courtesy the artist and
Metro Pictures, New York.

of Caravaggio's painting within the paradigm in postmodern fine arts called "appropriation art." The New York painter Stone Roberts goes back to Caravaggio's early still lifes and takes his quotation through Cézanne into the referential realism seen in much postmodern art.[11] Cindy Sherman acts upon Jarman's interpretation of the *Bacchino Malato* when she appropriates both Caravaggio's painting and Jarman's empathetic identification to produce a visual essay on gender and art, as do other of her "historical portraits" in an unconventional practice of the photographic medium. In her piece *Untitled No. 224* of 1990 (fig. 15), Sherman is seen propped up as Caravaggio's *Sick Bacchus,* a pastiche that aims at effacing the difference between the baroque and the contemporary artist and, more importantly, between male and female.[12]

# PASTICHE

**Peter Greenaway, *The Cook, the Thief, His Wife and Her Lover* (Britain, 1989)**

If this extraordinary cinematic statement by the British director signifies as an "erotics of form," as Charles Hagen holds (1990: 72), then the flamboyant pastiche character of the film is in large measure responsible for this impression. The excess of form is, however, heavily encoded with powerful socio-political content; the conspicuous disjuncture of exuberant form and acerbic cultural critique lets us see postmodern pastiche as a function of emancipatory aesthetics. Not surprisingly, then, it is the film's lush visuality and extravagant stylization that create the semiotic framework for that critique.

The general reception of the movie contradicts such a reading. Many viewers, as well as many reviewers, were alienated by the numerous violent events, and in particular by the final scene staging cannibalism as grand spectacle. (This resulted in an X rating, which Miramax, the distributor, fought in vain.) Most spectators see the film in the mimetic terms by which conventional cinematic works abide. Television likewise tends to allow little else but straightforward realism, and the horizon of expectation of the typical viewer is shaped accordingly. Greenaway's visual text is gaudy at best, if seen conventionally; it is above all the filmmaker's blatant embrace of an allegorical mode for the cinematic medium, one of several devices to emancipate film from being "illustrated text" (Greenaway 1997), that accounts for the status of *The Cook, the Thief* as a masterwork.

Greenaway encodes the pastiche character of his work from the outset, beginning with the title itself. The cook stirs everything together for gourmets, and "thief" is—in the context of the playful self-referentiality of the title—another name for the pasticher. The central locale of *The Cook, the Thief* is a gourmet restaurant named "Le Hollandais," located in a surreal space, a loft in a generic commercial district (of London, perhaps). The film's imagery continually switches between a *locus amoenus* and a *locus terribilis*, to use the baroque topoi "idyllic place" and "terrible place," as befitting Greenaway's commitment to baroque rhetorical figuration. The postmodern baroque interior of the restaurant is populated with hybrid figures who seem to emerge from a seventeenth-/eighteenth-century underworld as contemporary noble punks, in congenial costumes by Paris designer Jean-Paul Gaultier. The fusion of horizons, a mannerist/baroque past and contemporary camp style, is structurally similar to the yoking of past and present seen in *Caravaggio*.

This practice of conflation and stylization *nolens volens* turns narrative into abstract paradigm, into a tale of oppressor and oppressed, of abuser and abused, of "the honest man" (Michael, the bookish lover) and the utopy of

revolt against domination (Michael reading Pascal Astruc-Latelle's *The French Revolution*). Shakespeare's villainous Timon of Athens and his men are the likely models for Albert Spica and his gang; the director's appreciation of Jacobean drama and its horror repertoire is well-known. Yet Greenaway's "thief" can also be seen as a monumentally inflated Mackie Messer. It may be remembered that Bertolt Brecht's and Kurt Weill's *The Threepenny Opera* of 1927 is a play with music about a capitalist thief based on John Gay's *Beggar's Opera* (1728).

The Brechtian intertext is visible in a number of ways. There are the cronies surrounding their boss, shady characters all. They bring their chief stolen silver, as do their counterparts in *The Threepenny Opera.* MacHeath and Spica share a predilection for bourgeois pretension; they continually admonish their subordinates to behave. Spica is a gourmet, a sexual pervert, and knowledgeable about the opposition of "literal" vs. "metaphorical" meaning; that is, he is a dialectical Brechtian character. Greenaway is not interested in conventional character development; the color coding of Georgina according to the space she moves in also serves to undermine realistic characterization.

A neon sign reading "Luna" (Italian for moon) that appears in the vaguely defined loading-unloading area outside the restaurant has been interpreted as an allusion to Bertolucci's film with the same title (Van Wert 1990–91: 45). In the context of the Brechtian presence in the film, the sign more likely refers to the song "Moon over Soho" in *The Threepenny Opera,* a cynical, albeit nostalgic, dismissal of romantic love. (It is into the dark void of this off-space— raw studio space—that the lovers are dismissed; see below.) The "Luna" sign also mimics the typical Brechtian anti-illusionistic prop deployed as a V-effect to distance the viewer from the action. Such a reading would then bear on the meaning of the second sign, which for a moment lights up the darkness outside the richly decorated pomp of the restaurant: "Aspic." On a first, rhetorical level, the verbal sign is an anagram of the "thief's" name, Spica. On the level of artistic auto-reflexivity, the display of "Aspic" continues the self-referential playfulness of the title, *The Cook, the Thief, His Wife and Her Lover,* in that it points to the director's cinematic conflation of historical and contemporary stylistic ingredients—aspic as a synonym for the original pasticcio, the hodge-podge paté, as cold delicacy.

With the Brechtian intertext in mind, the often naturalistically crude depiction of violence in Greenaway's film reads all the more as artifice, as exemplum intended to demonstrate the dire consequences of man's power plays far from the realm of *Books Unlimited,* the spiritual realm that is Michael's. The caring lover of Georgina, the "thief's" abused wife, is murdered by Spica and

his men by being force-fed books. The brutal attack on books, that is, on writing, stages allegorically the anti-intellectualism of "thieves," of persons concerned only with material possessions and power over others, including the object "wife." As Albert Spica comments to Georgina (a superbly sovereign Helen Mirren), "You are my property" (Greenaway 1989: 29).

The killing of Michael (Alan Howard), the severe physical attack on the young kitchen boy Pup, the piercing of a woman's cheek with a fork, not to mention the many verbal insults uttered by Spica (brilliantly played by Michael Gambon)—these scenes brim with vulgarity and gaudiness, while their theatrical settings provide for a high degree of stylization. Hybridity and visual paradox were typical scenic practice on the artistically ambitious stages of Europe in the eighties, where the style came to be considered a fitting expression for Antonin Artaud's theory of a "Theatre of Cruelty." For the surrealist Artaud, the stage should transfigure and exalt the viewer by aggressively involving the senses, by transgressing the ordinary limits of art and speech. The theatre should provide the spectator with "truthful precipitates of dreams, in which his taste for crime, his erotic obsessions, his savagery, his fantasies, his utopian sense of life and of things, even his cannibalism, pour out" (Artaud 1976: 245). The many productions deploying Artaudian shock effects, among them Jacobean revivals such as John Webster's *The Duchess of Malfi*, may have influenced Greenaway's theatrical idiom.

Certainly the director connects to the surrealist elements and to the unconventionality of European performance practices of the last twenty-five years, a tradition that owes much to the theatre of the absurd. Like surrealism, the theatre and literature of the absurd thrived on allegorical representation, which postmodernism picked up with a vengeance. Only if a scene such as the bookseller being stuffed to death with books is concretized by the viewer on an *allegorical* level does it make cinematic sense. Likewise, the monstrous grotesque at the conclusion, when Georgina as a Black Bride, revolver in hand, commands Spica to eat his victim, her lover, must be recognized as the most powerful allegory of the film for it to succeed. Greenaway's rhetoric of pomp and circumstance strives to develop an attitude of aesthetic distancing in the viewer through defamiliarization. Thus the presentation of Michael's dead body to Spica by the restaurant's staff and guests recalls the grand spectacle of mannerist feasts, when pigs and fowl were outfitted with the ornate gesture now bestowed on the state funeral for the intellectual. Only as allegorical discourse does such excess of form produce meaning of relevance. Six decades after Brecht's theatrical coup, the cannibalist scene in *The Cook, the Thief* is a flamboyant dramatization of the inhuman aspects of capitalism. (In inter-

views after the movie came out, the director acknowledged an anti-Thatcher sentiment.)

Greenaway's film is ostentatiously one for the eye, its visual language daring in its high degree of stylization and double-coded nature as visual extravaganza and powerful sociopolitical message. Undeniably, there is an "erotics of form" at work, particularly with regard to the extensive pastiche of mannerist and baroque paintings that Greenaway the painter and sometime museum curator displays in the film.[13] "Le Hollandais," the name of the restaurant, serves as the theme for the director's cinematic exhibition of Netherlandic art that had structured two earlier films. In his 1982 work *The Draftsman's Contract*, a reflection on art, artist, and a public hostile to both, Greenaway cites Vermeer and Jan van Eyck, and features a Dutchman right out of Rembrandt's *Sampling Officials of the Drapers' Guild* (1661). The homage to Jan Vermeer takes an intriguing turn in *A Zed and Two Noughts* (1985), where the (historical) Vermeer forger Van Meegeren appears as the artist in *Allegory of Painting* (1665, Vienna), who may also be Greenaway, a kind of faker of Vermeer (Lawrence 1997: 88). In *Writing to Vermeer*, an opera created with the composer Louis Andriessen and premiered in Amsterdam in 1999, Vermeer's women leave his paintings and take to the stage.

The centerpiece of the extensive and varied appropriation of visual art in *The Cook, the Thief* is a large painting whose perpetual presence as backdrop to the table of thieves makes it a locus of intertextual meaning. It is Frans Hals's *Banquet of the Officers of the St. George Civic Guard* of 1616, which shows one of the civic militia groups of Haarlem engaged in feasting and posing (fig. 16). In the Frans Halsmuseum of Haarlem, a city so rich in the seventeenth century that it became a booming art center, the painting is but one of a series of group portraits to which Hals often adds a self-portrait on the side.

The museum commentary on the portraits of various civic guards and the specific Hals painting "borrowed" for the film (Dutch title: *MaeltijD v. Officieren van de St. Joris Doelen*) details the main functions of the civic guards: maintenance of public order, defense of the city, and service at ceremonial occasions. While every male resident between the ages of 18 and 60 was supposed to serve guard duty, in reality only well-to-do residents did so, paying for their weapons themselves. At the end of their three-year service, the officers had their group portrait painted, which was then hung in the shooting galleries where they convened.

The loose and painterly execution of the group portraits by Hals betrays their programmatic order; the hierarchy of rank is always indicated by the seating arrangement, with the captain in the foreground. Furthermore, most

Fig. 16. Frans Hals, *Banquet of the Officers of the St. George Civic Guard,*
1616. Courtesy Frans Halsmuseum, Haarlem. Photo: Tom Haartsen.

positions were controlled by a few rich families, many of whom were related.
In his brilliant account of Dutch culture in the Golden Age, *The Embar-
rassment of Riches,* Simon Schama reproduces and discusses—with the help of
the art historians Seymour Slive and Alois Riegl—the very militia picture
Greenaway chooses as backdrop for his demimonde characters (Schama 1987:
181). The cultural historian stresses—with Riegl—the balance of fraternity
and station, even democratic openness in the group portrait(s). Does Greena-
way want to contrast his boasting thieves with the healthy self-confidence of
the wealthy Dutch burgher? Surely the intertextual link is not limited to the
cult of feasting that the two gatherings, pictorial and cinematic, have in com-
mon. Indeed, our reading of the film would suggest an evolutionary link be-
tween the emerging and as yet relatively harmless capitalism of the seven-
teenth century and the aggressive structures of late capitalism personified by
Spica and Co.[14]

Not all the borrowings that make up the painterly code are of a political
nature. Many of the voluptuous shots of food on tables and in the kitchen
areas are a cinematic homage to the Netherlandic genre of still life painting.
Sacha Vierny's camera caresses these pastiches consisting of food arrange-
ments, inspired, perhaps, by the works of Abraham van Beyeren and Jan Da-

vidsz de Heem's and their staple compositions of *Still Life with Fruit and Lobster*.[15] In the spirit of this study's last chapter, one might point out that the sensuous, painterly table settings in "Le Hollandais," along with the restaurant's baroque red decor, in turn inspired a second-order pastiche. In their suggestions for the festive season of 1996, the designers for Saks Fifth Avenue cited the film's sumptuous table culture in the department store's Folio catalog.

The expulsion of the lovers from their Eden, the *locus amoenus* of the pure-white bathroom area and the lavish food/sex spaces in the cook's domain, constitutes one of the more morbid scenes of the film. As a nude couple, Georgina and Michael must flee the restaurant, and here Greenaway plays with the (predominantly Italian) iconography of Adam and Eve being expelled from paradise, alluding to depictions from Masaccio to Michelangelo.[16] Their nakedness is exposed to huge animal cadavers in the delivery truck, which creates a fantastic synaesthetic effect in that the visual display of decaying meat stinks before our eyes as we see the lovers suffer. Art historians were quick to recognize that the cadaver setting quotes a famous example of Northern mannerism, Pieter Aertsen's *Meat Stall* of 1551 (Uppsala).

The stuffing-to-death of the bookseller with books appears as the tragic counterpart to the well-known metonymic portrait of a bibliophile by the Italian mannerist Giuseppe Arcimboldo, who worked in sixteenth-century Prague. *The Bibliophile* (private collection) is literally constructed of books; on posters the pictorial conceit effectively advertises the products of publishers. Lastly, the death of our unfortunate book lover is shot in a mannerist perspective reminiscent of pictures such as Annibale Carracci's *Corpse of Christ* (c. 1600, Stuttgart), pointing to the literate, "the honest man," as a Christ figure.

The archive of mannerist and baroque painting is so vast that different viewers associate different works with a particular scene, especially since direct quotation such as that of the Frans Hals painting is relatively rare. Rather, one might describe the film as generously infused with the (mostly Northern) visual tradition of the sixteenth and seventeenth centuries. As Jarman claims Caravaggio's *chiaroscuro* for the development of cinema, so does the fusion of film and painting for Greenaway render an interesting historical twist. The *camera obscura*, predecessor to the photographic medium, he claims, is known to have existed in Delft in 1650 (Greenaway 1997).

In the majority of scenes borrowing from art, the painterly code works to foreground the allegorical charge of the narrative, which alone is able to establish the artistic seriousness of the film. Admittedly, the extensive practice of visual quotation and allegorical statements depends upon an "Aha" reception

for the pleasure of recognition, whereas its absence may frustrate the viewer. We used to speak of the *poeta doctus,* the creative writer as scholar. Greenaway's work challenges us to talk of the scholar-filmmaker who produces what might be called *cinema erudita,* erudite cinema. To syncretize the Western visual tradition by creating a confluence of old-masterly painting and filmic modality actually carries the potential of promoting cultural literacy in a spectacular fashion, one that thrives in healthy contrast to pedagogical programs and to the positivist discourses of our digital culture.

Contributing to the pastiche nature of *The Cook, the Thief*'s visual code is the intentionally eclectic music by Michael Nyman. It bears little resemblance to conventional film music, commanding considerable autonomy as it adds a high degree of structure to numerous scenes. Nyman conflates medieval monophonic music (filtered through Orff), sixteenth-/seventeenth-century traditions (some Vivaldi), and contemporary minimalism. The most striking borrowing is the repeated performance of a boy soprano (Paul Chapman) as the kitchen boy Pup, who emphatically lends a sixteenth-century feel to a twentieth-century score. The term *Gesamtkunstwerk* has been applied to *The Cook, the Thief* on the basis that several arts are joined together to form a total work of art (Van Wert 1990–91: 43). In spirit, however, the film is closer to Robert Wilson's deconstructed *Gesamtkunstwerk* (see chapter 5) than to Wagner's project. Like Wilson, Greenaway is not concerned with the employment of a wholesome union of the arts, but rather with a productive tension between visuality, sound, and narrative. The way that "Nyman's score and Vierny's camera play off each other" (Van Wert 1990: 49) may exemplify the interarts dynamics in the film.

They result in an ever-present critical edge within the quasi-operatic glamour of *The Cook, the Thief* and allow for the film's multi-layered pastiche to function as cultural critique. The absurd, Dada-like pattern with which Georgina ridicules Spica's stereotyping of Michael as Jewish:

> "He's Jewish, I think he comes from Ethiopia. His mother is a Roman Catholic . . . he's been in prison in South Africa. He's black as the ace of spades and he probably drinks his own pee!" (Greenaway 1989: 47)

could not be imagined to be part of the Greenaway production that followed. In *Prospero's Books* of 1991, based on Shakespeare's *The Tempest,* the intertextual eye of the director engages a multitude of painterly references (mostly to the baroque tradition) for sumptuous tableaux that overwhelm the viewer with their overabundance of nude figures. Greenaway's penchant for mannerist

conceits structures his cinematic text: the effect created by this particular visual excess is such that the spectator finally hears only John Gielgud speaking Shakespeare. The optical dimension fades before the poetic word, and it is Prospero's books that alone have real presence.

In comparison to the later film, the tautness and aesthetic economy of *The Cook, the Thief, His Wife and Her Lover* are striking. Furthermore, the subtle figuration of the director's alter ego in the character of Richard, the French cook (Richard Bohringer), adds yet another level to the artistic self-reflexivity of the work: the artist as a voyeur who orchestrates scenarios for the lovers while plucking, with serene passion, the feathers of a goose. Despite the director's erudition, it is unlikely that this scene alludes to the French notion of pastiche as taking only the "feathers" from an admired masterwork, that is, only its superficial effects (see chapter 1). The play of feathers surrounding Richard creates an ethereal, magical image, a metaphor of the imagination, a survival kit for a problematic reality.[17]

## Short Takes

### David Lynch, *Blue Velvet* (1986)

*Blue Velvet* is a fascinating patchwork of textual and visual quotations that jell into surreal spectacle. The real, i.e., the supposedly harmonious life in Lumberton, is dismantled as the repressed. A human ear found by Jeffrey is the enigma that moves the plot. As visual arts code, the image connotes van Gogh's plight and Bunuel's *Un Chien Andalou* (close-up of insects crawling in the ear); in the psychoanalytic code of the film, the ear is a vulva that prefigures Jeffrey's upcoming entanglement.[18] E. T. A. Hoffmann's story "The Sandman," used by Freud to explicate the uncanny, is the major intertext in Lynch's movie. Sadean and masochist sexuality are shown to be the dark underside of sunny surfaces.

Like Jarman and Greenaway, David Lynch has a background in the plastic arts, and he knows how to use borrowings from art to heighten his cinematic narrative. Edward Hopper's paintings are a continued presence, especially in and around the Deep River apartments—the unconscious—where Dorothy lives. The name Dorothy is borrowed from *The Wizard of Oz;* when the masochistic singer emerges naked from a house at night, the allusion is to a painting by Paul Georges, *Return of the Muse* (1969–70). Jeffrey's initiation into this "strange world" of sex and crime makes him and the audience into semioticians deciphering a humanity in trouble.

### Ulrike Ottinger, *Joan d'Arc of Mongolia* (1989)

Stylistic and formal hybridity mark *Joan d'Arc of Mongolia* by the German feminist filmmaker Ulrike Ottinger. One of the film's narrative strands is a quasi-scholarly ethnological essay on Mongolia and its image in the West over two centuries. The main story concerns how Western tourists attempt to encounter the nomadic culture that they will celebrate as a metaphor for the blurring of gender boundaries. It is the lengthy train ride aboard the Trans-Siberian railroad that produces the most blatant pastiche effects as it hosts a surreal staging of multiculturality and gender hybridity. Ottinger always likes camp effects, but this train scene mixes styles, motifs, fake facades, and fake happy peasants in Russia ("Potemkin's villages"), three vamp-type singers from Georgia, etc. Yiddish, sung and spoken by an American comedian, emerges as a hybrid *lingua franca*.

### Juzo Itami, *Tampopo* (1990)

Much of the dialogue in Juzo Itami's film *Tampopo* seems to center on the topic of how best to cook noodles and noodle soup. If understood allegorically, however, all those questions and suggestions concern problems of aesthetics and art. In the visual register, the film offers a feast of quotations from Hollywood cinema that function as an allegory of the influence of the West on present-day Japan. We see a Japanese John Wayne, a Japanese Italian Mafia beau who could have been in *Godfather I* or in an Italo-Western, and viewers can relive the tunnel ride in *North by Northwest*.

### Steven Soderbergh, *Kafka* (1992)

There are a number of cinematic adaptations of texts by Franz Kafka, among them Orson Welles's *The Trial;* Steve Martin pastiches the central text of Kafka's oeuvre in a scene in *Pennies from Heaven*. Steven Soderbergh's *Kafka* is clearly an homage to the most widely read of all twentieth-century authors writing in German, but it does not focus on a single work. Instead it takes a number of Kafka's novels and short stories, uses motifs and characters, and reassembles them anew in a contemporary revolutionary scenario suggestively placed in a socialist country. Magically, the pastiche brings to the screen what we have come to call the "Kafkaesque" as such: complexly layered figurations of the absurd, of estrangement and anxiety; other themes are the bureaucratic maze, the impenetrable code, and punishment fantasies. For the visual realization of his daring transposition of the Kafka phenomenon, the director borrows from "Dr. Murnau" (briefly referred to in the film), especially cinematic style and motifs from *Nosferatu*.

## Quentin Tarantino, *Pulp Fiction* (1994)

Tarantino's film is already historic, a stroke of genius that is hard to follow. As a typical postmodern work, it is double-coded, appealing to teenagers and intellectuals alike. Its strategies of meaning production can be pictured as a rhizome that extends in multiple directions with respect to genres and motifs: tragedy, grotesque, travesty (Harvey Keitel as Aristotle ordering cartharsis = the cleaning of the blood-soaked car), the function of violence in Artaudian theory, the theatre of the absurd, impersonations of Hollywood stars, and a staging of nostalgia for the 1950s. The displacement of chronological narrative, the choice for anti-mimetic non-linearity, is inspired first and foremost by the influential "structural" film *Last Year in Marienbad* (Resnais), then by tendencies of defamiliarization in recent film.

# LITERARY PASTICHE

4

Among the different art forms that developed over centuries, literature produced the earliest pasticcio/pastiche structures. The antique cento was a patchwork, a poem constructed of individual verses by well-known poets such as Homer and Virgil.[1] Centos were predominantly parodic in intent, as, for instance, the *Gigantomachia* of Hegemon of Thasos in the fifth century B.C.E.; Lukian mentions a "very funny song" consisting of lines by Hesiod, Anacreon, and Pindar. Cento passages such as those in Aristophanes' comedy *The Frogs* (405 B.C.E.) also aimed for seriousness; they functioned as literary satire and critique in their time.

The target of the Latin cento poets was Virgil. To fulfill a wish of the emperor Valentinian (fourth century), the rhetorician Ausonius wrote his "vulgar and nasty *cento nuptialis*" (*Oxford Classical Dictionary*) around 398. A shift occurred in Virgilian cento writing when Proba Falconia, a Roman Christian in the fourth century, used Virgil's style in rewriting available parts of the Old and the New Testaments. Much later, this amalgamation of classical poetry and Christian intention remained influential for the monk Metellus from Tegernsee in Bavaria, who blended eclogues from Virgil's *Bucolica* poems with odes by Horace.

Classical philology does not pay much attention to centos, since the genre is considered an aberration of the canon, which positions it outside a classical notion of art.[2] For our argument, as may have become clear in previous chapters, the structure of the cento is immensely important as the initial paradigm for all other forms of borrowing by artists from the archive of their tradition. The cento is pregnant with the characteristics of the medley type of the pasticcio, the appropriation and imitation of the styles of different artists that returns with very different energy in aesthetic postmodernism, and then, of course, also in literary production as "cento pastiche" (see below). The differently structured homage type of literary pastiche—French, mostly—also links

up with the foundational cento form; in both modes the work of a generally revered author is appropriated by a later writer. Homage (pastiche) and the subtextual anxiety of parody (cento) are—in psychoanalytical terms—not so far apart.

Despite these signs of similarity between the cento form and the modern literary pastiche, all indications are that the latter was introduced into European writing by way of the French encyclopedic discourse on pastiche in painting. The literary theoretician Jean-François Marmontel, writing at the end of the eighteenth century, may well have launched the unusual career of the pastiche genre in French literature. Although critical of pastiche as a mannered imitation of a great poet, Marmontel hailed the homage pastiche of a writer who equaled his model in greatness, a notion of literary pastiche that prefigured Proust's upgrading of the *genre mineur* roughly a century later.

The two-volume *Anthologie du Pastiche,* edited and with commentary by Léon Deffoux and Pierre Dufay in 1926, is evidence for the extraordinary position of pastiche writing in nineteenth- and early-twentieth-century France, unmatched elsewhere in Europe. In the preface to the second volume, the editors state that pastiche is superior to parody and caricature because its subtlety does not rely on coarse effects. A nuance is enough to differentiate the pastiche from the original (Deffoux/Dufay 1926: viii). The editors may have been thinking of high-grade pastiches such as Proust's "Dans un roman de Balzac" (Proust 1919) or his engagement of Flaubert, interactions whose differential quality with regard to the originals is appealing material for the research of Romance literature scholars.[3] Otherwise, these subtle pastiche effects can be perceived only by educated French readers; not knowing the original in all its semiotic richness means not being able to grasp the pastiche effect.

Why the pastiche genre remained underdeveloped in most European literature traditions is a subject perhaps worthy of further inquiry. In the case of literary culture in Germany, it is tempting to advance a theory that might explain the scarcity of pastiches in the German language. The phenomenon of pastiche entered German literary discourse in the early nineteenth century in connection with a shocking revelation. Earlier, around 1771, the young Goethe and his friend Herder were enthusiastic fans of a collection of English songs entitled *Ossian,* whose author was a medieval bard writing in Gaelic— or so they and with them other literati thought.[4] In 1829 Irish scholars discovered that the songs had been falsified by the Scottish writer James Macpherson; because of the slowness of information transfer in those days, Goethe did not learn before his death in 1832 of the grotesque fate of *Ossian,* his favorite

reading at the time of writing *The Sorrows of Young Werther* (1774). He even pastiched—as we would say now—the mood of the *Ossian* songs in this, his first novel.

The revelation of the false claim to authenticity abruptly diminished the virtues of the texts by Macpherson which had so convincingly conflated early, archaic times and the enthused sensibility of the eighteenth century. From the German as well as from the British perspective, *Ossian* could hardly be celebrated as an ingenious pastiche (which it was); it was nothing but a sham. The subjective archaeology of the collection blended a minimum of quasi-authentic sources with fictional texts, resulting in a new poetic unity, "à un seul goût." It is noteworthy that the French consider Macpherson's work a pastiche (Larousse 1982: 7879), whereas German cultural discourse still refers to the affair only with embarrassment.

The *Ossian* shock is perhaps responsible for the minimal attention given to pastiche in German over the decades.[5] Definitions tend to be negative, influenced by the embrace of originality that became a priority with the rise of the autonomous work of art in the eighteenth century and its zenith in modernism, in the visual arts and music more than in the literary domain. Theodor W. Adorno, the Frankfurt School philosopher, joins in the understanding of modernist art as radical self-critique endorsed by the art critic Clement Greenberg and modernist poets such as T. S. Eliot and Gottfried Benn when he condemns the "pastiche or the copy" as the result of slavishly followed norms for artistic production, whereas art must resist those norms. "For art no longer knows other norms than those which form in the logic of their own movement, and which fill a consciousness that respects them, produces them, and changes them again" (Adorno 1967: 14, my trans.).

Adorno addresses art in general, but the narrow understanding of pastiche that he expresses in this passage was likely informed by the lowly status of literary pastiche in the German community of letters. And this status may have to do with the fact that pastiche structures in the visual arts can be recognized independently of national languages, whereas these play a crucial role in the reception process of literary pastiche as it was defined by the French tradition. Pastiche for the French was a quasi-homage to and a coming to grips with an admired writer, Proust's "pastiche volontaire" (as opposed to "pastiche involontaire," the unknowing or indiscriminate imitation of a model).[5] Without knowledge of the style and habitus of the pastiched author, someone from another language culture or not versed in the literary language being imitated will have difficulty recognizing the pastiching of the later writer. The problem, as we shall see, also arises with postmodern pastiches.

What makes contemporary pastiche novels more accessible is their tendency to combine quasi-homage and parodic modes with a sophisticated patchwork of textual styles that resembles the mix-and-match modes we saw in the other arts. However, if one considers the blending operations of the antique cento at the beginning of pastiche history, then the hodgepodge of poetic grafts found in the postmodern fictional text does not appear as radical a stylistic departure as the pastiche form of postmodern film. Literature, one of the early developed arts of the world's high cultures, shows her old age; a variety of pastiche-type forms have passed through her memory. Cinematography is only a century old; pastiche structuration comes with the full force of authentic innovation.

A typological listing and description of selected postmodern texts is a problematic undertaking, since the two basic structures of the literary pastiche, the homage type and the stylistic medley, co-exist in most texts. I will nevertheless consider some works under the heading of "quasi-homage/ rewriting/parody," while a second group is introduced under the heading of "cento pastiche." As mentioned in the Introduction, the comparative arts orientation of this study necessarily implies a certain freedom from performing on the highest level of scholarship in each and all of the arts dealt with. That state of affairs becomes particularly aggravated in this chapter, where the author aims to cite pertinent examples of postmodern pastiches of different literary traditions and is faced with the immense amount of research encircling each case study. Such an endeavor can mean only a partial and specialized approach to the texts chosen.

## Ur-Pastiche

### Jorge Louis Borges, "Pierre Menard autor del Quijote" (1939)
### "Pierre Menard, author of Don Quixote" (1962)

The old age of the literary pastiche entails a spiraling effect of sophistication rarely found in the other arts. A text that clearly departs from, and extends, the Proustian pastiche is Jorge Luis Borges's "Pierre Menard autor del Quijote" of 1939. A homodiegetic narrator attempts to assemble the life-work of the poet-scholar Menard; the eulogy is written in the first person and in the style of an academic appreciation. It frequently, however, gets caught up in the snarls of unintended critique that relativize what has been said. On the intradiegetic level we find the nebulous and unsubstantiated documentation of the life-work of Menard, his known attempt to create an exact copy of the *Don Quixote* of Cervantes.

Jean Franco, in an essay that discusses further pertinent examples, calls the whole text by Borges the "ur-text" of contemporary Latin American pastiche (1990: 97). Franco concentrates on the intradiegetic pastiche only and sees Borges as having written the piece in an effort to surmount the overbearing mastery of Cervantes. Drawing on Bakhtin's notion of double-voicedness in the novel, Franco focuses on the difference in the meaning of words that the reproduction in the twentieth century of a text from 1602 would entail. The pastiche, Menard's reproduction of the Cervantes novel, is seen as drawing attention to the changes in meaning that have occurred in the intervening centuries.

In Jean Franco's reading, it is assumed that Borges tells the story of the pasticheur Pierre Menard. A narratological approach would tend to posit a first-person narrator who is not identical with the author Borges and who is marked by the typical unreliability of homodiegetic tellers in fiction. Thus we learn of Menard's copy of *Don Quixote* through the eyes of someone who celebrates the deceased Pierre Menard as a colleague and an author in highly ambivalent terms. It is someone who can enumerate easily in a positivist fashion. When Menard's Novalis-derived "total identification with a specific author" is described, the narrator talks about it as "subterranean, interminably heroic," and "inconclusive" (Borges 1963: 45). The text is replete with signs that point to Menard's act of re-creation as a phantom phenomenon which in turn suggests more a state of mind than a (fictual) fact. "Shall I confess that I often imagine that he finished it and that I am reading *Don Quixote*—the entire work—as if Menard had conceived it?" (46). "Pierre Menard" is also a story about literary hermeneutics and reading older literature with a contemporary horizon of understanding.

The more the short text is spiked with authentic or seemingly authentic references to other literature and scholarship, the more it acquires an elusive and contradictory textuality. From it emerge strategies for coping with the masterwork (of Cervantes), ranging from the devoted act of copying, to his purported dismissal of the "original" as not "inevitable" (47), to the narrator's preference of Menard's *Don Quixote* as "more subtle" (48). We then see the narrator as a meta-pasticheur, elaborating on the changes Menard made in rewriting Cervantes by employing a new approach to the historical novel. A detailed close-textual analysis would be required to show how the text continually self-destructs, thus making visible the struggle of this team of twentieth-century commentators, the first-person narrator and Menard, to shake off a giant of the literary tradition. The conflict reaches an absurd climax in the juxtaposition of a prominent phrase in Cervantes's *Don Quixote,* Part One,

Chapter Nine, on the "truth of history" with its exact likeness penned by Menard and with the narrator elaborating on the merits of the latter's "version."

Arthur C. Danto, philosopher of art, rightly observes that Cervantes's and Menard's works "are in part constituted by the location in the history of literature as well as by their relationship to their authors. Borges's contribution to the ontology of art is stupendous; you cannot isolate these factors from the work since they penetrate, so to speak, the *essence* of the work" (Danto 1981: 36). In my reading, occasioned by a specific scholarly interest and rooted in its own historical moment, Borges uses the pastiche convention to ridicule the notion that modern rewritings could attain the distant aura of the great work of art that affects us precisely through its otherness and its irrevocable distance from our own contemporary sensibility.

With their conspicuous dissemination and cancellation of meaning, Borges's writings have long held their place within the comparatist canon of postmodern literature. Yet for most pastiche works in languages other than Spanish, Borges's text cannot be called the "ur-text." It is also not likely that Proust's early reformulation of the genre directly influenced the texts under consideration; it influenced the perspective of our study via Denis Hollier's important interpretation (1975), which came about in the same discursive climate as the pastiches to be discussed.

## Pastiche as Homage Deconstructed

### Goethe Pastiches: Modern/Postmodern

One might say that Borges's quasi-homage is written against the Proustean pastiche. The French author called "pastiche volontaire" an exercise for becoming literary, for becoming productive through rigorous interaction with the style and work of an important author and the literary system represented by him. Borges shows pastiche to be totally futile in dealing with the dominance of the great ancestral tradition. Pierre Menard's quest is ridiculous, reasserting merely the lastly unalterable presence of the masterwork for anyone who writes.

Not unlike Cervantes, Goethe continues to instill a certain degree of "anxiety of influence" in contemporary writers. A postmodern sensibility is at work in the exquisitely ironic pastiches written in different tongues that are sampled below. They are "topped," quite literally, by the pastiche act performed by a high-rise constructivist sculpture.

# PASTICHE

### Thomas Bernhard, "Goethe stirbt" (Goethe Dies; 1982)

The novel *Korrektur* (*Correction*) of 1975 by the Austrian writer Thomas Bernhard was hailed by many, especially by Americanists and comparatists, as an exemplary work of postmodern self-reflexivity. Like the Borges story, "Goethe Dies" is a drastic remake of the traditional literary pastiche (Bernhard 1982: 9–10). The latter's major aspect, emulation through creative imitation, is reoriented to achieve the effect of destruction of the author persona. Here, too, a first-person narrator is claiming to be near the "genius" in the time before his death. We do not know who this witness is, but we know and hear about the others around Goethe: Eckermann, Riemer, Kräuter. The pastiche lives from the unidentified narrator imitating the *Gespräche mit Goethe* (Conversations with Goethe) that Johann Peter Eckermann conducted in the last decade of the poet's life. The homage quality inherent in the original Eckermann reflections is converted into total farce. Instead of Eckermann's straightforward presentation, this chronicler gives us Eckermann and the others as courtiers embroiled in jealousies and intrigues. His voice and idiolect show the same obsessive referencing habits that are characteristic of Bernhard's narrators: "Der Genius, so Riemer, soll Kräuter gesagt haben, stand jetzt am Fenster und betrachtete eine vereiste Dahlie im Garten" (The genius, thus Riemer, Kräuter is supposed to have said, now stood at the window and looked at a frozen dahlia in the garden). The mannered style creates much of the atmosphere of hearsay and legend around the "genius," and comes to represent, palpably, the cult around the poet as national hero: "der Größte der Nation und gleichzeitig auch der allergrößte unter allen Deutschen bis heute" (the greatest of the nation and at the same time the most superior among all Germans until today). Goethe is then "quoted" with statements of ridiculous hubris: "Was ich dichtete, ist das Größte gewesen zweifellos, aber auch das, mit welchem ich die deutsche Literatur für ein paar Jahrhunderte gelähmt habe" (What I wrote is no doubt the greatest, but it also paralyzed German literature for a few centuries). This Goethe also claims to have ruined Schiller quite consciously, as well as the national theatre, but trusts that people will not notice it for two hundred years.

Aspects of satire and parody typically tend to accompany the tradition of negative homage paid to an overpowering cultural presence. What makes this piece a postmodern pastiche is its hybridity through anachronistic manipulation. The cause for the chaos in the Goethe house a few days before the poet's death on March 22, 1932, is the master's ardent desire to enjoy the company of Ludwig Wittgenstein. According to the narrator, Goethe constantly cites

and invokes the twentieth-century philosopher and insists that Kräuter, the secretary, depart for England to fetch Wittgenstein, whom Goethe imagines to be at Oxford rather than Cambridge.

The German master poet desires the presence of the Austrian thinker more than a century his junior: by pastiching the anachronistic encounter, Thomas Bernhard attempts to update and correct the cult of the German *Klassik*—and by extension *German* culture—with a most important *Austrian* contribution, a world-renowned Viennese philosopher. "Goethe Dies" is a poetic rebellion against the collapse of Austrian culture into its partner in language.[6]

### Donald Barthelme, "Conversations with Goethe" (1983)

The American postmodern author Donald Barthelme can hardly be similarly disposed to the Goethe phenomenon, which makes his "Conversations with Goethe," originally published in *The New Yorker*, intriguing in a more universal way (Barthelme 1983: 73–76). The piece is, structurally speaking, a more straightforward pastiche of Eckermann's *Conversations with Goethe* than is Bernhard's. It starts out by using an authentic entry date, November 13, 1823, and then invents others in the proximity of those recorded by Eckermann. In keeping with this fictional approach, all the entries are witty distillations of Eckermann's obsession with detail and reverence. The November 13 entry shows most dramatically the parodic distance from the original, which celebrates in a lengthy fashion Goethe's intuition of an earthquake. Barthelme has Eckermann write:

> I was walking home from the theatre with Goethe this evening when we saw a small boy in a plum-colored waistcoat. Youth, Goethe said, is the silky apple butter on the good brown bread of possibility.

Barthelme bluntly substitutes for Eckermann's reverent narrative and quotations of Goethe a kitsch metaphor that reveals in a flash the irreverent attitude produced by an anxiety of influence. All the other fictional entries show the same structure of pastiche as parody; for example, under the date January 11, 1824, we find "Music, Goethe said, is the frozen tapioca in the ice chest of History" (74). Or, in a faked April 7, 1824, report: "Art, Goethe said, is the four percent interest on the municipal bond of life." Goethe is reported to have been very pleased with his remark, and Eckermann now wants to rival his master in abstruse formulation. When Barthelme's Goethe calls critics "the cracked mirror in the grand ballroom of the creative spirit," Eckermann counters that they "were, rather, the extra baggage on the great

cabriolet of conceptual progress." Barthelme has Goethe say: "Ecker-mann, . . . shut up."

The slang touch at the end can be read in several ways. Perhaps the twentieth-century author Barthelme would like to propose that an imitative rivalry is hopeless, that only a dramatic distance from a master writer can produce another. The "shut up" sign belongs to the code of past-present junctures in the language of many postmodern works, as in the already discussed film *Caravaggio* (see chapter 3).

### Milan Kundera, *Immortality* (1990)

In *Immortality* the Czech author Milan Kundera employs various strategies to approach Goethe and the subject of immortality. Much as in Thomas Mann's *Lotte in Weimar*, Kundera lets us see ordinary features of Goethe the man by way of a relationship at the periphery of the poet's life, his relationship with Bettina von Arnim—or, rather, her pursuit of the poet. Kundera adopts what he believes to be Goethe's pared-down notion of immortality, not the religious faith in an immortal soul but a "quite earthly immortality of those who after their death remain in the memory of posterity" (Kundera 1990: 48). Most of these pieces in the second part of *Immortality* can be regarded as empathic fictional biography, sprinkled with essayistic fragments typical of Kundera's prose, here in the service of ruminations on the subject of immortality. But there are some pastiche structures that relate to those described in the chapter on film (and elsewhere).

In segment 4 of *Immortality*, Goethe and Napoleon are framed by a horde of latter-day photographers, and Kundera stages the historical meeting of the two immortals as a present-day summit meeting and media event. In segments 15–17, Hemingway consults Goethe on immortality, and Goethe instructs his twentieth-century colleague that "immortality means eternal trial" (81). For Hemingway this trial is the life he has led, and now, he complains, he is classified and analyzed by professors (82). Kundera uses the imaginary encounter not only as literary satire but to point to the immortal quality of a writer's work as a perennial intertextual force in humanity. "'You know, Johann,' said Hemingway, 'it's a stroke of luck that I can be with you'" (86). To have that literary past, Kundera says, is an existential necessity for writers, including himself.

### Ilya Kabakov, *Looking Up, Reading the Words . . .* (1997)

The neo-constructivist, space-embracing sculpture *Looking Up, Reading the Words . . .* by the Russian artist Ilya Kabakov (fig. 17) is likely to win the

Fig. 17. Ilya Kabakov, *Looking Up, Reading the Words* . . . , 1997. Steel.
Courtesy Landesmuseum Münster. Photo: Roman Mensing/artdoc.de

prize for the most intriguing of postmodern Goethe pastiches. It was first
shown in the summer of 1997 as part of the outdoor exhibition *skulptur. proj-
ekte,* which spread through and surrounded the city of Münster, Germany.
Kabakov's extensive construction is sculpture as text/scripture as sculpture. It
is also a piece of environmental art, in that it forces the viewer to lie down in
a meadow, from which a shaft rises to some height to hold the textual part of
the sculpture. Twenty-two steel beams arranged like lines on a writing pad
hold the letters of the following poetic address:

MEIN LIEBER! DU LIEGST IM GRAS,
DEN KOPF IM NACKEN, UM DICH
HERUM KEINE MENSCHENSEELE, DU
HÖRST NUR DEN WIND UND SCHAUST
HINAUF IN DEN OFFENEN HIMMEL

IN DAS BLAU DORT OBEN, WO DIE
WOLKEN ZIEHEN—DAS IST VIELLEICHT
DAS SCHÖNSTE, WAS DU IM LEBEN
GETAN UND GESEHEN HAST.[7]

The culturally conditioned, horizontally disposed viewer is convinced that this is a quotation by Goethe, from *Werther* in particular, a work much revered in Russia in the past. Indeed, the passage is identified on a paratextual item, an exhibition paper bag, as Goethe's, and it certainly sounds like his lyrical, pantheistic idiom. One hastens to check *Werther* and finds only passages of similarly enthused language. The Russian artist pastiched the German poet of poets by means of feigned quotation to exhibit our image of his textuality.

## The Intertextual Status of the Author

### Christoph Ransmayr, *The Last World* (1988)

Christoph Ransmayr's novel *The Last World* celebrates the past of the literary in a poetic narrative style that could not be further from Kundera's witty essayism, yet Ransmayr shares some basic pastiche moves with his senior colleague. Ransmayr's is an homage to Ovid and his *Metamorphoses*, the collection of 250 transformation sagas that became the most important source for antique mythology in the baroque age. Ovid's opus consisted of found material that was rewritten (Mack 1988: 99), something the ancient author signals in the first lines of his poem: *In nova fert animus mutatas dicere formas corpora* (Forms changed into new bodies). Ransmayr's rewriting of some of the Ovidian myth—for example, a feminist telling of the story of Echo—stands in the tradition of the Proustian pastiche. Cotta, the main character, searches for the classical poet who has been banned. It is a search for the "book"; the novel is a reflection on poetry and life, poetry and sensory perception, literature and politics. The "last world" of the title is often read as a dystopian, apocalyptic sign; above all, it is a code for the poetic as the last resort of humanistic presence in our never-ending media glut.

Metamorphosis, one form out of another, is the principle of all poetic creation. In Ransmayr's novel, the classical code and the contemporary are intertwined in ways that make for an unusually engaging double-codedness. The fictional biography of Ovid and his mythologemes is made transparent for the narration of twentieth-century cultural typologies. A film projectionist shows his wares in the town where the hero Cotta, a writer, searches for Ovid, who has been banned from Rome and is sick, perhaps dead. Ransmayr's palimpsest of the classical in the present is often achieved through the use of

more blatantly anachronistic juxtapositions as they can be discerned in other postmodern artistic endeavors:

> At a signal from the emperor . . . Naso [Ovid] stepped forward that night to a bouquet of shiny microphones . . . he forgot himself and his own fortunes. He stepped up to the microphone without the slightest bow, and simply said: Citizens of Rome. (45)

This unmediated juncture of past and present (Ransmayr's text has others) can be seen as a literary counterpart to the anachronistic scenes in Jarman's *Caravaggio,* for instance, when Vincenzo Giustiniani pulls out his electronic calculator. There, too, the time paradox functions to infuse the past with presentness and contemporary relevance. This idea is hardly new in the ever-active memory of literary discourse, and the early twentieth century abounds with works that give a radically contemporary life to the great dramas of antiquity. (One need only think of the many existentialist adaptions and stagings.) What makes these structures in both film and literature postmodern is the conspicuous, stylized juncture of heterogeneous components.

The fictional biography, the quest for the earlier author as a finding of one's own literary persona, is not a postmodern feature; in fact, Cotta-Ransmayr's search for Ovid is intertextually linked to Hermann Broch's *Death of Virgil,* written in 1945. It is the genre of the fictional biography on the playing field of postmodern styles that produces the new pastiche of homage as a conversation with the literary archive.

### A. S. Byatt, *Possession* (1990)

The Amsterdam comparatist John Neubauer was one of the first scholarly readers of the postmodern novel *Possession,* by A. S. Byatt, to comment—in a paper given in 1991—upon its nature as pastiche, which he sees as "doubly contextualized. The pastiche of the fictional Victorian poetry is to be read in terms of the gradually discovered biographical documents, which reveal a secret love affair between the two poets [Randolph Henry Ash and Christabel LaMotte], and its impact on the scholars [Roland and Maud] of today" (Neubauer 1997: 384–85). There are indeed several layers of pastiche structuration in Byatt's exploration of literary memory as authentic source of literary production and literature as life form. The narrative moves freely in a variety of fiction types: fictional biography, the campus novel as a satire of "theory," the detective novel, the romance genre, the quest. The poetic dialogue between the nineteenth-century writers brings yet another literary type into play, lyric poetry, which asserts itself in extensive segments, breaking the narrative flow.

The figures of Ash and LaMotte are montaged: Ash is Robert Browning, Tennyson, Wordsworth, Goethe; Christabel LaMotte is Christina Rossetti and Emily Dickinson. The romance of the pastiched poet figures is dialectically linked to the teasingly deconstructed relationship of the present-day searchers for the truth of the former.

The young scholars find their postmodern stance already rehearsed by their object of study, Ash. The Victorian feels that the imagination is now living in a "tired world." All fresh knowledge is compromised by "palimpsest on palimpsest," the poet—a mere ventriloquist. Rosemary Lloyd writes, "The way in which language possesses us, together with the ways in which the object of a scholar's study can invade the scholar's subject, and the sexual nature of such possession, is a central feature of A. S. Byatt's 'romance'; . . . it blends intellectual and physical desire, the creation of the word and the creation of the flesh, in a brilliant fusion of pastiche, parody, punning and invention that figures the labyrinthine nature of textual strategies and textual criticism" (Lloyd 1993: 14).

Here Jacques Lacan is pastiched in Maud's attempt at subject criticism:

> the unstable self, the fractured ego. Maud thought, who am I? A matrix for a susurration of texts and codes? It was both a pleasant and an unpleasant idea, this requirement that she think of herself as intermittent and partial. (273)

The feminist theoreticians Hélène Cixous and Luce Irigaray are named and their positions satirized (by Byatt) as they are idolized and kitschified by the acolyte Leonora Stern (265, 342).

Such integration of borrowed material has an anti-mimetic effect on those who know it; this is certainly true for the many brief pastiches of contemporary theory or the bits of intellectual dialogue that seem to lift themselves out of the story. When Roland asks Maud, "Do you never have the sense that our metaphors *eat up* our world? I mean of course everything connects and connects" (275), one eagerly associates it with Lakoff/Johnson's *Metaphors We Live By* (1980), followed by E. M. Forster's "only connect" of *Howard's End* (1910), realizing that the blend of the two allusions renders a mini-pastiche of the semiotic topoi "the body as text" and "the text of the world."

The young scholars' reflections occur in the context of their rewriting and deconstruction of a once well-known ballad by Friedrich Schiller, "The Glove" (Schiller 1902), perhaps not immediately evident to the English Studies community. Equally inaccessible to anyone outside the scholarly terrain of nineteenth- and twentieth-century English literature are the many, often

inconspicuous quotations and rewritings that draw upon this very material. The same can be said of the apparently highly engaging pastiche in Russian modernism, Andrei Bely's *Petersburg* of 1916, whose innumerable allusions to Russian culture go unnoticed by the uninitiated reader. For specialists, the process of deciphering the embedded intertexts and their function for the respective narratives is a fulfilling task, including the recognition, in the case of Byatt, of her play with feigned quotation (Broich 1996: 624).

*Possession* nevertheless does succeed with "regular" sophisticated readers because of its postmodern double-coding; i.e., its narrative surface makes it a highly engaging book for many who know little about literature and critical theory. A reader-critic, however, is caught between the knowing and not knowing of the other code and opts to perceive Byatt's novel as a sort of "texte rumeur," the term derived from "Eau Rumeur," a perfume as a "con-fusion of voices" from the House of Lanvin. *Possession* takes possession of a world of voices and poetic scents from an era long gone, asserting the present of the past, as a phrase by Nathaniel Hawthorne, which serves as prologue, stipulates: "the attempt to connect a bygone time with the very present that is flitting away from us."

Apart from the intergeneric shape of the novel pointed out earlier, the vibrant intertextuality of citations and allusions constitutes the first level of pastiche structuration in Byatt's novel—cento style. A second level is formed by what one might call heavy-duty pastiches, epic poems written in the styles of Browning and other Victorians such as "Mummy Possest," purportedly by Ash. Slim, delicate, and eminently more modern verses are signed by "C. La-Motte." Such material elicits a contemplation concerning the problematic reception of literary pastiche outside its own language culture. In order to optimally read a pastiche, the reader must know the pastiched author and his/her style. How can one assess and aesthetically enjoy the conceit of the successor if one cannot perceive the play of differences vis-à-vis the original? To be a mere visitor in the field of Victorian poetry means to be helpless in trying to assess the pastiche effects exhibited by the contemporary writer.

What can redeem the reception dilemma of those seemingly deprived readers? Curiously, it is precisely these lengthy pastiche poems that convince the reader that he/she is witnessing an immersion into the very realm that seems to be irretrievably moving away from us in our electronic revolution: the realm of the aesthetic, defended with passion, narrated with the urgency of life and death by a postmodern Scheherazade. The "romance" is, above all, about literature.

With its various registers of pastiche structuration, *Possession* participates

in the terminological debate on the postmodern novel. Is it a postmodern work or a "pastiche of postmodern fiction," as Ulrich Broich proposes (1996: 626)? The Munich scholar of English Studies suggests that Byatt's use of the detective novel is grounded in the classical notion that reality can be grasped, and not in the postmodern belief that an assessment of reality or its linguistic representation is impossible. The objectivity of knowledge is likewise not doubted by the two young researchers, Broich asserts.

I would argue that Broich's intricate and challenging thesis collapses two markedly different registers of the postmodern, the discourse of literature and of certain positions in philosophy. Literary postmodernism gains its identity in the typology of stylistic features and forms of signification that scholars of the contemporary novel informally agreed upon two decades ago. Byatt's novel belongs without doubt to the ever-growing pool of metafictional works that exhibit narrative self-reflexivity and foreground intertextuality, i.e., the archive, in various styles, including pastiche. These topoi that govern so much of contemporary fiction should not be unqualifiedly identified with the post-structuralist agenda and its problematization of processes of signification. To posit postmodernism as anti-foundational theory and to associate it with the thought of Derrida, Lyotard, and Rorty, as is frequently done, is complexly tied to the interior dynamics of discourse formations in the field of philosophy. The idea of the postmodern takes very different shape in artistic-critical productions, overlappings not excluded.

To narrate the intertextual status of the author and of literature, as Ransmayr and Byatt do, can be seen as thoroughly postmodern in sensibility even as such an undertaking shuns the skepticisms of deconstruction and the linguistic turn. That the theory parodies in *Possession*, like the one on feminist kitsch alluded to above (265–67) or Ronald's wish to look at something "without layered meaning" (291), mock what passes for postmodern critical discourse does not cancel out the identity of Byatt's meta-poetic "romance" as a prime example of the literary postmodern. Parody, irony, and critique turned poetic prose are part and parcel of that elastic hybrid, the postmodern text. To see A. S. Byatt pastiche these relatively new conventions in *Possession*, as Broich does, ignores the novel's emphatic embrace of postmodern form; it also underestimates the importance of pastiche as a sign for the intertextual status of all writing.

## Cento Pastiche

We have so far considered examples of postmodern pastiches that, given their considerable difference in form and signifying strategies, are of the homage or quasi-homage type—homage to a great literary figure or figures through imitation, dialogical engagement, critical distance, and parody. These works are impure by definition, and as much as one may stress their participation in the intertextual system of literature, one might do well to remember a warning by the Danish scholar Leif Ludwig Albertsen, who had the traditional French-derived notion of literary pastiche in mind: it is not to be mixed up with parody and travesty, because in these genres the author polemically rewrites a model to triumph over it. The writer of an homage pastiche, however, annuls himself in order to be reborn on a higher level (Albertsen 1971: 2).

When we now turn to the corresponding type of literary pastiche whose structure harks back to the antique cento and the pasticcio medley of the sixteenth-century Italian art fringe, we will find that the semantic orientation of the typical cento—parody—is no longer the first priority of the postmodern literary pastiche. The patchwork of quotations and ironic paraphrases from literature and literary theory embedded in the text of *Possession* serve the author's plea for the primacy of literariness. When Umberto Eco resurrected the cento form in a different key, he also shed parodic intent—in order to retrieve allegory for the postmodern novel.

### Umberto Eco, *Il nome della rosa* (1980)
### *The Name of the Rose* (1983)

Much has been written about *The Name of the Rose*, the magnum opus of the scholar-novelist Umberto Eco. First and foremost, it is seen as a semiotic manifesto on a grand scale, as the sum total of the theoretical, historical, and literary imagination of an author whose immense erudition elucidated the signs of our contemporary world for a wider public (especially in Italy). Thirty years of collecting medieval material produced an exemplary postmodern novel that made a new type of dialogue with the past possible, playful and yet intellectually serious. With Eco, double-coding becomes a topos of postmodern narratives. On the level of "story," the text can be read as a thrilling detective novel; on the level of "discourse," the work of fiction reveals itself as an extended philosophical reflection on major ideologies governing the human condition.[8]

The end of the novel provides its not-too-casual readers with keys for

decoding its central themes. In a surprisingly auto-reflexive speech act, the first-person narrator calls the novel a "cento" made from scraps that he, Adso, gathered from the burned library (Eco 1983: 501). "The whole novel is written in borrowed intonations," Eco said in a German interview (Zimmer 1985). It is the weave of diverse master narratives of Western culture, of innumerable quotations and paraphrases verbal and visual, that makes the cento pastiche called *The Name of the Rose.*

To begin with, there is the composite identity of the main characters that foregrounds the presentness of their deep past. William de Baskerville is both William Ockham, a medieval philosopher, and Sherlock Holmes, favorite of semioticians, whereas his associate Adso is modeled after Dr. Watson.[9] Baskerville is further montaged from the "revolutionary" Franciscans Roger Bacon, Robert Grosseteste, and Marsilius of Padua, whose treatise *Defensor pacis* William recites (Mersch 1993: 40f.). Medieval thinker(s) as detective—semiotic man, reader of sign systems and the codes of history. It is well known that Eco celebrated his affinity to Jorge Luis Borges by creating the figure of Jorge of Burgos, the blind seer and aged director of the abbey's library. (Borges headed the Argentinian National Library and became blind with age.)[10] Typical Borges themes, the labyrinth and the library, are central metaphors in *The Name of the Rose;* "the library is a great labyrinth, sign of the labyrinth of the world" (Eco 1983a: 158).

Aspects of the homage pastiche can certainly be found in these figurations; it is, however, the cento or patchwork structuration of the text that participates most importantly in the production of meaning. The blend of seriousness and parody, of quotation, historiography, and fiction, has been called an "intertextual collage" (Mersch 1993: 44). In our eyes the amalgamation of philosophical and theological thought, the archival narrative of the medieval church, of mannerist concetti with contemporary critical theory and the semiotic cult of the detective novel, produces a smooth paté of stylistic unity that is closer to the much-invoked "à un seul goût" of pastiche than to the antiform of collage. Collage connotes a certain disparateness of its parts, with the process of assembling still discernible in the finished product (see chapter 1). The narrative flow in *The Name of the Rose,* however, exerts a strong homogenizing effect on the textuality of the novel, extending even to paradoxical instances and making them part of an overall postmodern feel. It even accommodates deception, a feature associated with the old pasticcio in the visual arts, as when William claims to quote an axiom in Middle High German and attributes it to a monk of Adso's homeland; with Eco we know this author as Ludwig Wittgenstein (Eco 1984: 624f.).

Teresa de Lauretis (1985: 19) reserves the designation "imposing pastiche" for a certain segment of the novel, Adso's dream or vision while listening to "Dies irae" ("Sixth Day, Terce," 426–35). Indeed, this segment displays such an exuberant hodgepodge of visual and verbal signs that the reader's horizon of understanding is challenged throughout. De Lauretis detects Voltaire, Bruegel, Bunuel, and Lyotard, as well as a use of the comic strip, in the ten-page segment;[11] in the eyes of this observer, a rather more complex drama of pastiche effects plays itself out that connects to visual texts earlier in the novel and points ahead to the grand didactic spectacle of the "Seventh Day."

In his *Postscript to the Name of the Rose* of 1984, Eco furnished his readers with photographic reproductions of the visual sources that had inspired him in conceiving the novel, and two early episodes in particular.[12] The first is Adso's admiration of the portal of the church of his Benedictine abbey, modeled after the tympanum of the Romanesque abbey church of St. Pierre at Moissac (Eco 1984: ill. no. 1). The relief represents the apocalyptic vision according to St. John 4:2–8, representing Christ as Majestas Domini and judge of the world. Art-historical analysis shows that Eco blended the iconography of the apocalyptic judgment scene on the monument with biblical text and edited the material using his imagination.[13] The sculpture on the middle portal of the abbey Sainte Madeleine in Vézelay (1125–30) is the model for Adso's experience of the tympanum of the "old church" (ill. no. 3). Its depiction of exotic peoples in sculptural splendor influenced the description of Adso's impression: "From their dress I could recognize the Hebrews, the Cappadocians, the Arabs" (336). Reproductions numbers 5 through 8 in *Postscript* document the substantial inspiration drawn from illuminations in the Spanish apocalypse commentary by Beatus of Liébana (eighth century), edited by Eco in 1973.

Only one of the illustrations in Eco's epilogue relates to the text segment that piques our curiosity about pastiche action in the novel. The procession of the virgins toward the beginning of Adso's vision is modeled after a mosaic in San Vitale, Ravenna, depicting Empress Theodora and her ladies in waiting (ill. no. 10). The procession of the virgins refers to the apocalyptic code exemplified in the earlier descriptions, with a stylistic difference: comic strip bubbles emanate from the virgins' mouths, spelling their names. Then Adso's vision immerses him in a feast that turns out to be a travesty of the tympanum scenes. It is the abbot who is now *majestas domini*, holding a fork for a scepter and calling on a group of holy men as "whoresons"; Jesus as Adam with a tiara (instead of crown) as worn by the girl—or Virgin Mary—in the procession, in his hand "a goblet brimming with pig's blood" (427).

The travesty arrests the act of reading; it is followed by a catalogue of thirty-five configurations, such as "Cain entered dragging a plow, Noah made a triumphal entry rowing the ark, Lazarus on the table, Susanna in the garden" (429). The whole litany turns out to be a recitation of Old Testament narratives as they have populated our cultural memory. The above-mentioned allusion by Teresa de Lauretis to the Netherlandic painter Pieter Bruegel may refer to paintings such as *Children's Games* (1560, Vienna), which has similarly cumulative scenes that satirically depict grown-up figures engaged in childish business. Many of the same biblical figures listed in Adso's dream are subsequently imagined as being involved in a grotesquely excessive feast where they eat that with which they are usually associated: Jesus devours a donkey, Holofernes the head, Jonah the belly, Eve the rib, and so on. Frequent mention is made in the novel of the *Coena Cypriani,* a sign easily mistaken as fictional, yet one that denotes an authentic tract about an excessive biblical feast, with figures from both Testaments and Catholic saints appearing as drunkards and sexual perverts (Veeser 1988: 105–106).

The reversal of conventional signification, especially the displacement of conventional attributes, connotes the topos of the "world upside down" that shapes so many of the strange and often crass happenings in Adso's vision; it will prove to be a major allegory in the novel. The guests at the feast thank the abbot by ripping off his clothes and trampling on his body while he asks not to be tickled. And Adso reaches the lovely valley of the Golden Age by crawling into the vulva of a beauty. A mannerist image such as this calls forth the highly imaginative settings in Hieronymous Bosch's *Garden of Delights* (Prado, c. 1500). Crawling into and looking out of all kinds of fantastic containers is a prominent motif in the large middle panel of Bosch's triptych. That it depicts the Dutch artist's idea of a new earthly paradise corresponds well to our eventual reading of the work of fiction (Musper 1981: 114).

Adso wonders whether he is in paradise or in hell, and such ambiguity corresponds to the ambiguity displayed in the triptych by Bosch, whose title hides the numerous monstrous and grotesque configurations of naked bodies (taboo in the Middle Ages) and bizarre objects. Burning buildings in the right panel symbolize the apocalyptic threat. The "Dies irae" vision of Adso likewise is informed by an "apocalyptical pattern" (470); a burning crypt turns into a kind of hell's kitchen, a "womb, mucous and viscid," brings forth a giant, all-devouring black monster (434). Yet the feast is equally shaped by earthly delights and blasphemies such as the desecration of the Host. The abbot, Jorge, Adso, and the other monks revel in their freedom from the code

that normally binds them firmly into their Christian culture. When read through the theoretical excursus of the last chapter, the passage celebrates laughter as the true "human comedy" that is able to bring about a social reality outside of religious fanaticism as represented by Jorge. The "Dies irae," the idea of a "last judgment," is shown to be no more than a discourse among discourses. As William tells Adso, explaining the dream to him, "We already have so many truths in our possession" (438).

On one level of signification, then, the novel problematizes the encounter of Christian thought with the philosophical disposition of antiquity—and today. The "book" so much desired and chased in *The Name of the Rose* is the lost second part of Aristotle's *Poetics*, which is said to contain a more extensive theory of comedy than the brief mention in the extant first part. Presumably, Eco's novel suggests, it affirmed more strongly the necessity of the ridiculous as a truly human dimension. In Mikhail Bakhtin's theory of the carnivalesque, Aristotle's poetics and the spirit of the *Coena Cypriani* merge to portray laughter and carnival as emancipatory forces (cf. Kellner 1988: 24–25). In a telling passage, Eco lets Jorge appropriate Bakhtin for his negative argument: laughter and carnival may allow a view of the world upside down for a short time (474). But the drunk peasant deceives himself, Jorge argues, when he believes that he has toppled the conditions of domination. The "book" of laughter could potentially legitimize that reversal, Baskerville's hope, Jorge's fear. Confronted with the prospect of Aristotle, Marx, and Bakhtin joining forces, Jorge de Burgos proceeds to eat "the book," i.e., "Aristotle," i.e., pre-Christian Western culture (480).

"The universe of semiosis, that is, the universe of human culture, must be conceived as structured like a labyrinth of the third type," which Eco defines as a "network of interpretants" (Eco 1984: 83). In *Postscript* he likens it to a rhizome, the spatial image of an extending rootstock and popular metaphor introduced by Gilles Deleuze and Félix Guattari, to imply that all paths are connected without ever leading to a center (Eco 1984: 57). Eco's novel exemplifies the unlimited semiosis of human discursivity, which pastiche effects intensify as they are active agents of intertextuality. They may be outrageously playful, as when the biblical archive is plundered and travestied, or when the "lyotardian beast" appears ("the great Lyotard" in the English version, 434), staging the postmodern as medieval phantasma. Pastiche visualizes—to a degree—William of Baskerville's ideal "to make truth laugh" (491), as liberation from an obsession with *one* truth—canonical, authoritarian, unfit for enlightened worldmaking.

# PASTICHE

## A Literary Canon in the Supermarket

**Patrick Süskind, *Das Parfum* (1985)**
*Perfume* (1986)

Patrick Süskind's *Perfume,* a cento pastiche influenced by Eco's novel was published in Switzerland in 1985. Süskind seized upon the structure of double-coding in a far more sensuous mode than did Eco's detective novel, which suffers to a degree from its overwhelming erudition. By contrast, the sensuous textuality of "The Story of a Murderer," the subtitle of Süskind's first novel, lured so many ordinary readers into its sumptuous flow that the book was frequently classified as popular fiction. (For a while the English paperback graced the shelves of American supermarkets.) Furthermore, Eco's substantial scholarly prestige before he published his first novel colored its reception among the educated, whereas Süskind was in the mid-eighties a young and unknown author who had lived in Paris for several years. A reviewer for *Die Zeit* did pick up on the pastiche quality of *Perfume* when he coined the much-quoted phrase "Grenouille plunders dead skins, Süskind dead poets" (Stadelmaier 1985). Since then the story of Grenouille, the murderer of scents, has attracted much scholarly attention as a postmodern pastiche of considerable critical caliber.

Anyone familiar with the canon of German literature finds the same embedded in paraphrases, parodies, or travesties in the thrilling and sweeping telling of the story. Pastiches of Grass's *The Tin Drum,* of Mann's *The Magic Mountain,* of Grimmelshausen, Lenz, Keller, Musil, and numerous others have been sighted by critics such as Judith Ryan (1990). Receptions do vary, since even readers in the same field may associate different "dead authors" with certain passages in the narrative; the horizon of expectation naturally shapes the individual act of interpretation. The following reading foregrounds the Romanticism intertext in Süskind's novel and considers it an encoded essay on the nature and movement of the artistic consciousness.[14]

Like a young poet, Grenouille "devoured everything, everything, sucking it up to him," still without "aesthetic principles governing the olfactory kitchen of his imagination" (43). This phase of chaotic intertextuality and awakening creativity is marked by bizarre endeavors. Then Grenouille finds a scent, and "a hundred thousand odors seemed worthless in the presence of this scent. This one scent was the higher principle, the pattern by which the others must be ordered. It was pure beauty" (49). One may compare: what

attracted Heinrich von Ofterdingen "with great force was a tall, pale blue flower. . . . the most delicious fragrance filled the air. He saw nothing but the blue flower" (Novalis 1964: 17). The flower and its scent that inspire the young poet's "infinite melodies" belong to the allegorical code of Novalis's highly developed reflection on poetry and the poetic as a form of being.

Süskind reverses the ideal union of flower and muse; his poet of scents turns into a spiritualized vampire. He needs to celebrate the "master scent" of the girl ( = corpus of literature) in order to create the "revolutionary" work of art, but at the same time he must eradicate the very beauty whose "essence" was essential for him. Grenouille's murder is an allegory of the "anxiety of influence" that artists experience, as Harold Bloom detected (1973). In short, Süskind's genealogy of the artistic consciousness deconstructs the romantic-idealistic text that has shaped our notion of creativity. The eighteenth-century stylization of the artist into a higher being called genius who would exist above conventional moral standards is revealed as absurd. The pastiche code of the text shows every artist as tied to traditions and to ethical limits that are there to curb the megalomanic roamings of the "monstre sacré."[15]

I discussed above works of fiction that either belong to the quasi-homage and parodic type or are examples of the patchwork type of pastiche, which I named "cento pastiche." As A. S. Byatt's *Possession* showed in particular, the two types can overlap, often in subtle ways. This is true of many other texts, although one can also discern a preference for the cento pastiche on the part of contemporary authors of many tongues. The structure showed itself particularly adaptable to the writing of "critifiction," a hybrid of "theory" and fictional narrative.

## Short Takes

### Tom Stoppard, *Travesties* (1975)

Tom Stoppard's play *Travesties* pastiches the fictional encounter of three historical figures who lived in Zurich during Word War I but never met: Joyce, Lenin, and the Dadaist artist Tristan Tzara. Stoppard makes these three figures into mouthpieces for different approaches to art and literature and the artistic in general: "modernist," Marxist, and the anti-art attitude of Dada. The play then is a poetic formulation of conflicting theories on modern literature, art, and society.

# PASTICHE

### Terry Eagleton, *Saints and Scholars* (1987)

The hybrid text *Saints and Scholars* by the well-known theorist Terry Eagleton uses the same construct as Stoppard: a figural medley leading into a cento-type pastiche that consists of authentic philosophical material and theoretical dialogue. All this is "stirred into" a more or less fictional biography of Nikolai Bakhtin, the elder brother of Mikhail Bakhtin, who knew Ludwig Wittgenstein. The awe-invoking thinking of the philosopher Ludwig Wittgenstein is approached via the marginal perspective of Nikolai. As in the Goethe pastiches (or Stoppard's *Rosenkrantz and Guildenstern Are Dead*), the view of the oblique observer serves as an unconventional lens on the central persona; Eagleton also uses the semi-fictional set-up to experiment with establishing potential links between Wittgenstein and the post-formalism of Mikhail Bakhtin.

### David Lodge, *Small World* (1984)

The campus novel *Small World* by David Lodge pastiches Arthurian romance, the quest, the character Persse as Parzival, poetry by T. S. Eliot, and other pieces of world literature such as Tasso's "Gerusalemme liberata." An ever-present discourse of "theory" is at times impersonated by Morris Zapp as Stanley Fish. The witty cento pastiche became an exemplar for many later academic novels in several languages, mostly weaker than their model.

### Heiner Müller, *Hamletmaschine* (1977)

*Hamletmaschine* is the best-known play by Heiner Müller outside of German-language culture, a crass and poetically powerful rewriting and dismantling of Shakespeare's *Hamlet*. All of Müller's later plays montage Shakespeare, Kleist, Schiller, and other canonical authors to shape a critique of society through juxtaposition and neo-expressionist stylistics. The texts often resemble prose poems that mix quotations from "high" culture with common, everyday phrases. Müller wrote the so-called "Cologne" segment for Robert Wilson's *CIVILwarS* (1984/85), and the two avant-garde artists inspired each other. Heiner Müller, who resided in East Berlin, is today considered by many the most important playwright since Brecht. Shortly before his death in 1995, he completed the play *Germania III*, quotation art at its most intense.

### Roberto Calasso, *The Ruin of Kasch* (1994)

First published in Italy in 1983, Roberto Calasso's *The Ruin of Kasch* is constructed from fragments, citations, digressions, and anecdotes, loosely presented insights into literature, and sometimes lucid observations on history

and politics. The legend of Kasch tells of a society in ruins, for Calasso the origin of literature.

Although Calasso's textual hybrid faintly resembles a cento structuration, it has no homogenizing agents that could bind the heterogeneous matter into a medley pastiche. (Milan Kundera's work escapes the effect of a mere arrangement because of its narrative threads.)

### Julian Barnes, *Flaubert's Parrot* (1984)

The reader not familiar with Flaubert scholarship is unable to discern what in Julian Barnes's meta-fictional text *Flaubert's Parrot* stems from documented biographical knowledge about the author of *Madame Bovary* and what is Barnes's fiction. "Why does the writing make us chase the writer? . . . Why aren't the books enough?" These questions drive a text that pastiches Flaubert's style, especially its realist aspects, as it describes in all technical detail the damage done to the Flaubert statue in Rouen during World War II. It is "pastiche volontaire," to be sure, a departure from Proust's project in a decidedly postmodern vain.

### Avital Ronell's *Crack Wars: Literature, Addiction, Mania* (1992)

No less an homage to Flaubert, Avital Ronell's *Crack Wars*, a cult book among a young generation of campus literati, pastiches bits of literary text, especially from *Madame Bovary*, with types of intellectual commentary and selected topoi of a camp sensibility—all served up in a poetic language pregnant with theory. Derrida's writing as graft, for example in *Glas* (1987), was influential earlier on for this academic comparatist, who has made "para-literature," a hybrid of scholarly criticism and fiction, her mode of production. For Jonathan Culler, Ronell yokes "the slang of pop culture with philosophical analysis, forcing the confrontation of high literature and technology" (Culler 1994).

The list of additional literary or not so literary texts that display pastiche features of various kinds is formidable. Self-reflexivity and active intertextuality, driving forces behind the work of cultural memory, have become a quasi-moral category. The semiotic promiscuity of committed pastiche texts may be an answer in defiance to the phantasmatic virtuality of cyberspace—and perhaps imbue the printed book with the energy to survive.

# PASTICHE CULTURE BEYOND HIGH AND LOW: ADVERTISING NARRATIVES, MTV, PERFORMANCE STYLES

# 5

## Commodity Pastiche: Advertising Narratives

How can a mind critical of the considerable social snarls of turbo-capitalism and a global, often inhuman market engage the aesthetics of pastiche in advertising? In view of the steadily increasing commodification of life at the dawn of the new century, including the "hyperreality" (Baudrillard) of the digital "revolution," how legitimate is an appreciative approach to ambitious fashion photography because it celebrates art by way of pastiche? How do other semi-artistic practices of quotation and "genre-hopping" in upscale popular music and diverse performance modes fare under the scrutiny of cultural sociologists? To be sure, Marxism and its totalized view of socialist politics and art would have nothing to do with such a schizophrenic attitude; even a post-Marxist approach is likely to find the two-tier vision problematic.

Wittgenstein's famous first sentence of his *Tractatus-Logico-Philosophicus* (1921), "Die Welt ist alles was der Fall ist" (The world is all that is the case), is helpful in this individual crisis of legitimation, as are Wittgensteinian "language games" as disseminated by Jean-François Lyotard in his *The Postmodern Condition* (1984: 40). Often used as a synonym for Foucault's notion of discursive practices or Stanley Fish's "interpretative communities," the concept of "language games" seems to suit the treatment of advertising material in aesthetic terms better than the harsh realities of the economic paradigm. Suitable as well for accommodating a critique of postmodern capitalism *and* for simultaneously defending one of its sub-systems is Niklas Luhmann's upgraded version of Max Weber's differentiation of professional specialization in modernity. Coming—more directly—from the systems theory of Talcott Parsons, from structuralism, and from the hybrid of science and hermeneutics called constructivism, Luhmann developed a theory of social systems that might be useful for the task at hand.

Acknowledging and at the same time ignoring the complexity of Luhmann's thought and its formidable output, I will shamelessly isolate what I need: the idea of single systems, to a high degree self-regulating, but complexly linked to other systems. For Luhmann, the central structure that moves systems is *autopoiesis*, a term he borrowed from cognition biologist Humberto Maturana of the University of Chicago. The concept of self-creation of a system, the idea that each system develops its own structures of existence and development, has always appealed to me. As someone who "grew up" in the differing methodologies of two disciplines, art history and literary studies, which led strictly separate discursive lives before the advent of postmodernist border-crossings, I am attracted to Luhmann's basic model (less so to other manifestations of his theory).[1] It allows me to look at the market, at the systemic structure of commercialization, *and* to deal with the aesthetically coded sign system of commercial art in the context of the "language game" of the art world.

~

Throughout the nineties, the scenes of contemporary art—studios, galleries, museum exhibitions, mega-shows such as the German *documenta*—offered problematizations of the concept of art or concretizations of positions in critical theory. On the other hand, museums scored popular successes with exhibitions of Old Masters or nineteenth-century modern painting, Impressionism in particular. Somewhere in this contrastive landscape of art appreciation, a new mini-paradigm occurred. The style artists of visual advertising in print media and their artist photographers became the high priests of the archive of art. By pastiching canonical works, the makers of commercial art exhibited the relevance of high art and at the same time their own visual sophistication.

When Ingres's *La grande odalisque* (Louvre) appears on a label for "Hot Sox" (c. 1990) or lends its eroticized body contour to advertise a vaginal cream, we would call this a citation of high art for the purpose of illustrating a commercial proposition. By contrast, the package cover of Calvin Klein ladies' hosiery (early nineties) takes Ingres's Venus motif much further. A black-and-white photograph of a partially nude model—her lower torso suggestively covered with transparent black hose, her curvilinear back displayed in the odalisque mode—this is indeed a pastiche, and as such a more subtle use of art in the business of selling designer stockings.

Venus-type figures embedded in the history of art lounge on lush sheets; the cover of the July 19, 1993, issue of *The New Yorker* shows them on beach towels (fig. 18). The exquisitely ironic pastiche by the painter/designer Bob

Fig. 18. Bob Knox, Cover Design, *The New Yorker,* July 19, 1993.
Reprinted by permission. Copyright © 1993 by The New Yorker Magazine,
Inc. All Rights Reserved.

Knox features Goya's *Naked Maya* (c. 1800), Rousseau's *The Dream* (1910), Matisse's *Blue Nude* (1907), and a seated female act—generic Renoir. Except for the Goya pastiche, all the motifs are quoted from modernism: in the center, Manet's *Déjeuner sur l'herbe* (the relevant excerpt); below, a neo-classical male act (Picasso); next to it, Gauguin with companion in Tahiti; above, a frontal, somewhat androgynous view of Modigliani's *Reclining Nude from the Back* (1917); and topping the whole sensuous scenario by the sea, a stern Léger figure who holds onto a book. The bodies borrowed from art are immersed in the yellow expanse of the beach, which unifies the mix of quotations into an alluring mood of summer and vacations: "à un seul goût." A pastiche for the sophisticated public of the magazine, and on second glance the clever scheme of an artist to mock the American canon of modernist painting: French, very French.

The trend in fashion photography to restage works of art was largely heralded by *Vogue* in the 1980s, with stunning examples such as an advertisement for Northbeach Leather that pastiched Picasso's *Demoiselles d'Avignon*, draping their nudity in sensuously red leather. In the nineties the fashion pages of the *New York Times* abounded with visual citations of twentieth-century art, co-productions of style artists and photographers. A splendid example, to begin with, is Franciscus Ankoné's sumptuous homage to the art deco designer Erté, shaping a multi-page pictorial presentation of models in French couture evening gowns in his style. Photographed by Serge Lutens, these images are creative transpositions of 1920s graphic art into a related genre (*New York Times Magazine*, Jan. 6, 1996).

Designers, photographers, and style directors today are of a generation that graduated from schools of art and/or design. Most of them were introduced to the history of art, and to contemporary art in particular. Most visit museums and gallery shows and strive to be literate in whatever goes on in the art scene. The commercial art with which they make their living has increasingly become a vehicle used to show to the cognoscenti in their public spheres, and above all to their peers, the visual sophistication behind the banal pragmatics of selling a product. "Imagination cannot be confined"—this line, which headed the dreamy, surreal advertisements for "Johnnie Walker Black Label" in 1996, reads like the credo of the contemporary commercial artist.

The trend toward quotation has spiraled in recent years and is fittingly exemplified in a *New York Times* spread that appeared on June 16, 1996. Photographed by Josef Astor and styled by Robert Bryan, "Stairs and Stripes" is more than a pastiche of quotation and visual rewriting (fig. 19). It tells a narrative befitting an important moment in New York's history of seeing. On the

Fig. 19. Josef Astor, *Stairs and Stripes*, 1996. *New York Times Magazine*, June 16, 1996. Courtesy the artist.

first of two pages, young men display the then fashionable fitted T-shirts whose striped design modified the popular Kenneth Noland pattern of previous years.[2] In streamlined black pants they walk up a functionalist staircase— a pastiche of the Oskar Schlemmer painting *Bauhaustreppe* ("Bauhaus Stairs") of 1932, which for many years hung in the staircase of MOMA, symbolizing the connection between the two institutions. It had been given to the museum in 1940 by Philip Johnson and was showcased in the summer of 1996 in a special exhibition honoring Johnson and the design objects that the former

curator of MOMA's architecture department gave to the museum over the years. The tall, slim, stylish male models walking up the stairs—and coming down an identical staircase on the second page of the spread—seem to honor the tall, slim, stylish architect who turned ninety at that photographic moment in time. In the center of the staircase going up (the Bauhaus reference), a figure is elevated by standing on a sphere, a cosmic shape connoting purity and infinity. "Stairs and Stripes" celebrates the birthday of an artist and a nation.

Philip Johnson is not the only modern architect to be the subject of an homage pastiche, consciously or unconsciously. When Frank Gehry's Guggenheim Museum in Bilbao, Spain, was revealed to a stunned transatlantic public in the fall of 1997, its splendid innovation was honored in an unlikely context and in a most playful manner. The 1997 Christmas catalog from Williams-Sonoma displayed on its cover a cake-like structure formed from piled-up biscuit shapes, photographed in such a way as to simulate the dynamic neo-cubism of Gehry's building.

Advertisements such as the "Bauhaus Stairs" pastiche and the in-joke of the Williams-Sonoma team point to what might be called the "narrative turn" in advertising practices. Before the advent of the advertising narrative pastiched from various codes, the integration of cultural memory was effected by the quoting of a particular work of visual art or the style of an artist. This reduced the slickness and commercial lure that even very accomplished ads often cannot shed. A decade ago, designers-cum-photographers for print media advertisements discovered pictorial surrealism, a direction in modern art that in the days of American high modernism was deemed peripheral. In varieties of postmodern art, surrealism was resurrected in unexpected ways. Pastiches of surrealist paintings and motifs, especially borrowed from the art of René Magritte, have since advertised everything from designer raincoats—men with bowler hats who float in the sky and rain over the page—to a diamond necklace spread on a sled in an arctic landscape, a typical surrealist paradox.

Many of these imaginative appropriations of twentieth-century art, and increasingly from art films, are intertextual, but they are not narrative in the sense of telling a story (which may be the story of various subtexts embedded in what appears at first glance to be merely a tasteful surface). Theirs is a basic pastiche effect—usually quasi-homage borrowing—which is also characteristic of the many attempts to retrieve the classical, medieval, and baroque vocabularies not only in the products themselves but in the visual stylizations of commercial art. An ad for Alitalia airlines that praised its "Magnifica Class" during 1998 shows a comfortable, pragmatic business-class seat in which a

white marble statue of classical beauty lounges voluptuously (Canova's Pauline Borghese). No narrative, but a visual metaphor to be grasped in an instant: the "Magnifica" in her authoritative business frame suggests classical grandeur, rationality, rigor, *and* dionysian pleasure.

That advertisements constructed as visual metaphors of layered meaning can glide easily into mini-narratives does not come unexpected. In the mid-nineties, Giovanni Gastel created an advertisement for Versace watches that works on several levels of intertextual meaning. First of all, the art photographer piled up seven watches in such a way that their luxurious blend of the antique meander pattern and Renaissance ceiling decoration, both revived by Versace, are showcased in an optimal fashion. The face of these postmodern hybrid clockworks features Versace's logo, which pastiches Caravaggio's *Head of Medusa* (c. 1597, Uffizi). As Versace porcelain and other designs show, the fashion artist rewrote the gruesome orginal—all panic and snakes—as an androgynous face at peace. Was it to refer to a meta-gender position on the part of the designer? Compared with Derek Jarman's cinematic Caravaggio pastiche (see chapter 3), Versace's appropriation of the baroque artist is destined to remain within the realm of the decorative arts, which traditionally shun issues.

There is another level of intertextual engagement in the unusual aesthetic sales rhetoric of Gastel's "Versace Watches." The seven mini-art objects are piled up to form an irregular "building"—the telltale advertisement reveals itself as an homage to the architecture of "deconstruction."

Examples of telling tableaux, inspired by the narrative photography of Duane Michals and Nan Goldin, dominate in fashion photography at the turn of the millennium. Constellations of models in shots that simulate moments of a story appear frozen as filmstills but activate the reader's imagination to fill in what might be happening and is not told. The fling with "theory" on the part of some creators of fashion advertisements, however, showed that there are limits to what can be transferred from a discourse formation quite distant from the aims of commercial art.[3]

The narrative turn in advertising came into its own as an innovative strategy in actual texts, namely in the hybrid writings featured in the J. Peterman catalog. The merchant in Lexington, Kentucky, for years advertised its unconventional clothes in an unconventional manner: instead of being photographed, garments and related accessories were illustrated by color drawings, as in the beginning of fashion magazines. What made the catalogs cult objects among fans of postmodern styles in the nineties were the texts that mediated between the literary and the commercial idioms.

The author "J. Peterman" was clearly someone well-versed in English lit-

erature, classical Hollywood cinema of the thirties and forties, foreign art films, and "theory." This was a writer who came of age during the movement of postmodern literature, which, after all, intended to mediate between English and American high literary culture and popular culture. The professor of English Leslie Fiedler intentionally placed his seminal essay "Cross the Border—Close the Gap" in *Playboy* (December 1969; Fiedler 1969/1971). Others supported anti-canonical and carnivalesque modes of the literary text to fit the new high-low cultural paradigm. This, then, is the climate that brought about the hybrid and camp quality of Peterman's prose, which pastiched the heterogeneous discourses of film, literature, and "theory." Because these postmodern pastiches existed outside the library canon, in ephemeral catalogs, a few are quoted at some length:

> WITTGENSTEIN ON TWEED
>
> The best proof that Bertie Russel was a smart cookie is that he thought Ludwig Wittgenstein was smarter.
> Wittgenstein. He was the one who said that the really important things in life can't be said, only shown.
> Is it just an accident that when Wittgenstein showed himself to the world, he almost invariably showed himself in tweed?
> Harris tweed, to be exact.
> He gave away all his money but he didn't give away the tweed.
> It was tweed in Vienna and tweed at Cambridge [ . . . ].
> Harris Tweed Sports Jacket, an inexpressibly good handwoven fabric, substantial and handsome, with two-button front. (J. Peterman Company 1997: 124)

And an example from the offerings for the sophisticated woman:

> MOVIE COAT
>
> As sexy as a raincoat can be.
> The scene at the airport. Ilsa. Bogart. Rain. of course. The sound of a propeller. 1942.
> Notorious. 1946. Cary Grant carries her down the stairs.
> She's wearing the coat. Not only that, she's wearing it over bedclothes.
> Am I wrong?
> Light. Water-repellent. Almost ankle-length. . . . (1996: 55)

Another textlet is entitled "The Archeology of Laughter," alluding to Foucault's unconventional use of the notion of archaeology; or sample this excerpt from "Wired":

> Cities around the world are connecting on the Internet's M-Bone. The Musica Antiqua Köln plays Telemann's Concerto for 3 Oboes in B flat major. The techno-chic drink lattes spiked with framboise in real time. (1996: 38)

111

To be sure, not every piece was witty and "readerly"; there must have been hundreds of them, and an anthology will no doubt be forthcoming. From its inception, the Peterman writing-selling enterprise made it its "philosophy" to depart from corporate culture, as stated at the beginning of each catalog. The unconventional style was, lastly, the expression of an ethos, however rhetorical commercial practice may have made it out to be.

The pastiche textuality of the Peterman catalogs has in turn been imitated, indeed pastiched in the old sense of faked copy, by other merchants. The stylists of the Saks Fifth Avenue Folio catalog are to be commended for their honorable attempt at integrating excerpts from canonical literature into a July 1996 edition featuring "Design for the Home." Thus Coleridge's "Oh, Sleep! It is a gentle thing" advertises a set of rustic sheets on an inviting bed, as does Cervantes' "To withdraw is not to run away." Cicero's "Peace is liberty in tranquility" is used to thematize a fashionable living room or study corner with a faux tiger rug and picture frames in which wild beasts appear domesticated. Last but not least, Shakespeare's job is to give glamour to iridescent summer dessert plates: "Summer's lease hath all too short a date. . . ."

As literature is marginalized in academia, its nobility is in demand elsewhere.

## Pastiche Performance

### Popular Music

Pastiche structuration has been a feature of innovative popular music for more than a decade, registered for the most part under different labels. An exception is the "all-female jazz vocal quartet influenced by the innocence of the 60's girls' group sound" who called themselves "Pastiche" when I encountered them on a Southern California campus around 1990. Given my budding interest in pastiche form in the arts, I felt compelled to establish a file on hybridizing tendencies in contemporary popular music, i.e., to jot down relevant data whenever and wherever I heard music that was described as hybrid. As a lover of "classical music" and thirties swing, I cannot claim to know today's highly pluralistic scene of popular music, a portmanteau label for a vast variety of production of differing artistic merit. What I do know is that the old opposition of high and low culture has been challenged in many quarters by popular music culture, once the vernacular that appealed only to the taste of the masses and to mass consumption.[4]

In the last quarter of the twentieth century, the geography of popular mu-

sic took on global proportions; the most powerful wing of youth culture, it has also become a global village in terms of technologies of dissemination and cultural communication systems. "Nowhere is the swirl more frenzied than in pop culture which hasn't even got time for names or seasons. . . . Funk, hip-hop, house music and gangsta rap jostle for attention" (Rothstein 1996). The commercial aspect of popular music is capitalist practice, pure and not so simple. This one must accept, more or less, as a given if one wants to take seriously the artistic aspects of music practices that, not unlike "serious" com-posers, use pastiche form as an innovative element in their arrangements and compositions.

A comment by music critic Christopher John Farley in a 1996 *Time* col-umn on the British musician Goldie could be seen as a generic statement on countless other innovators: "Mixing elements of techno, jazz and soothing am-bient music, Goldie's compositions defiantly slip the grasp of any one genre." The popular music pastiche has the structure of the creative medley that we found in most other artistic practices discussed in this study. In the late nine-ties, some of the blends included funk-rap-rock; hiphop/techno/jungle; coun-try and hiphop; hip-hop, metal, country and alternative rock; Afro-Celtic (Laura Love); the "intentionally sloppy patchwork" of U2 (Tom Mun, "All Things Considered," NPR, March 3, 1997); and "Rap and Requiem."[5]

The solo artist Sting has made no secret of his interest in "impure music," by which he means a blending of country, gospel, and Celtic music into pop. Rappers took to the practice of "sampling," a procedure in which parts of vari-ous records are spliced together in an act of creative borrowing. Confronted with copyright laws, remixing enthusiasts eventually named the "ingredients" of their pastiches.

Headlines such as "Hard Rock to Rap, the Trend Is to Blend" (*New York Times,* Sept. 13, 1998) capture the *Zeitgeist* at the turn to the new millennium. In many instances, the desire to produce impure music implies an affinity to multicultural commitment and themes. "Afro-Pop," "Ethno-Punk," and Jon Jang's conflation of Chinese opera and blues were some of the initiatives that promoted a multi-ethnic agenda.

## Madonna Pastiche

In her study *Rocking around the Clock,* E. Ann Kaplan problematizes the mode of representation of rock videos as an evasion of a position "from which to speak" (Kaplan 1987: 145). Lacking historical perspective, Kaplan claims, MTV videos resemble pastiche rather than parody, echoing Fredric Jameson's much-noted distinction (see the Introduction). Doubtless, the continual blur-

ring of boundaries and ahistorical presentness in MTV clips is worrisome in light of the young age of the typical viewer. As in other genres, there are outstanding examples that point to a more positive potential, such as Michael Jackson's "Black and White." By means of a technique called "morphing," different races, gender identities, and cultural differences are blended together. Jackson and his artistic team use the pastiche genre to communicate a progressive agenda of multi-ethnicity and multiculturality. Admittedly, "Black and White" cannot shed its nature as commercial commodity; it is, however, also the product of a critical aesthetic, much like the critical postmodern pastiche that we found in the other arts.

As a graduate of art school, Madonna came from the beginning very much from the plastic arts. When she splashed onto the music scene, she did so by quoting the kitsch of devotional Virgin artifacts that (Mexican) figurative painters critiqued in the seventies. MTV came along at the right moment to pick up the talents of the artist from Detroit. Writing against Fredric Jameson's dismissal of postmodern pastiche as "blank parody," Ramona Curry attempts to tease out the parodic potential of Madonna's music videos (Curry 1990: 15). The scholar of film and popular culture analyzes Madonna's star image as a multifaceted text that shows, among other things, that Madonna has "provoked and sustained exceptional interest as a female cultural icon." This, according to Curry, is due to the construction of the star as pastiche (17).

Ramona Curry's close-textual and semiotic reading of several of Madonna's videos before 1990 is worth visiting, in particular her analysis of Madonna's feminist critique of the virgin/vamp dichotomy as a construction of woman in Fritz Lang's *Metropolis* (1926). In our eyes, the 1989 video "Express Yourself" is also a quasi-homage pastiche of that silent classic, which had just been released in a colorized version by Giorgio Moroder, with a rock track—a musical collage—arranged by the Hollywood composer. *Metropolis* is a major intertext in "Express Yourself," which is shot through with other citations, such as an impersonation of Marlene Dietrich in her signature male attire.

Even a cursory familiarity with Madonna's styles leaves no doubt that the "Material Girl" is an artist at deconstructive practices, whether it is the ironic disjunction between performance and lyrics or rapidly changing pastiche moves that dismantle what they seem to fetishize. Ramona Curry opts to subsume this critical potential in Madonna's performance under parody, and in her eyes any flattening of this parodic quality leads to pastiche as an effect of the commodification of the material. Michael Jackson's videos and other sophisticated MTV clips, I hold, succeed as pastiche without the legitimizing code of parody.

One is tempted to relate the end-century wave of impersonations in films such as *Pulp Fiction* and *L.A. Confidential* or in print media to Madonna's identity switching and star cloning. It is said of "Generation X" that they do not see life as authentic but rather as a composite entity made up of quotations. The revival of the tradition of the *tableau vivant* on various levels of artistry may fit this context. A populist example is the "Pageant of the Masters," held yearly in Laguna Beach, in which more than a hundred volunteer actors model an array of famous works of visual art. "Athens 02138" was the title of a staging by Harvard students of Raphael's *The School of Athens* (Vatican) on the steps of Widener Library in 1993. Then there is the gender-crossing move by the Japanese artist Yasumasa Morimura, who inserts his body as the nude courtesan into (a copy of) Manet's *Olympia*. Morimura's pastiches—he also models the *Mona Lisa*—, blur the border between *tableau vivant*, performance art, and photo-pastiche, the final medium to carry the stylish message.

## Laurie Anderson's High-Tech Pastiche

Before there was Madonna as pasticheuse triumphant, there was Laurie Anderson, whose mixed-media theatrical style grew out of her performance art of the early seventies. Her performances typically blend electronic music and rock, collage sound, quotations from various text types and authors (Shakespeare, Melville, Pynchon, Burroughs, Fassbinder, et al.), technological gimmicks (the artist's tie turned musical instrument), projection to screen, and elements of the American entertainer tradition. Bridging the gap between high and low culture is programmatic in Anderson's public art of commitment.

A number in *Natural History* (1986) is memorable: Anderson pastiches Walter Benjamin. The skit offers a staging of the philosopher-critic's ninth historical-philosophical thesis, about the angel of history who faces the past as a single catastrophe, piling wreckage upon wreckage. The angel might have liked to mend the ruins. But a storm blowing from paradise is so strong that he can no longer close his wings. The storm drives him into the future, to which he turns his back while the pile of debris before him grows into the sky (Benjamin 1968).

In her attempt to insert a critical edge into popular culture with a vengeance, Laurie Anderson in the nineties sometimes compromised the artistic potential of her material by drowning it in electronic paraphernalia. Nevertheless, her use of the signs of popular culture in the irreverent spirit of Dada continues to be a most ingenious approach to raising the critical consciousness

of unenlightened consumers. And in contrast to so many of the anti-bourgeois directions in popular music discussed above, Laurie Anderson's project seems to resist being co-opted by corporate culture.[6]

## Robert Wilson: The Genre-Hopper as Mystic

In structural terms, Laurie Anderson and Robert Wilson are both genre-hoppers *par excellence;* in terms of style, they diverged considerably, certainly in their work of the eighties. Wilson's early collaborations with Philip Glass, from *Einstein on the Beach* (1978) to *CIVILwarS,* several evening-long segments in the mid-eighties, appear as authentically avant-garde when viewed from the "baroque" period of the artist in the nineties. To recruit Wilson for my catalogue of performance pastiches, I must confine my commentary to productions prior to 1990 and ignore the variety of endeavors that this artist has undertaken in recent years.

I was fortunate to be able to see the so-called "Cologne" segment of *CIVILwarS* in Berlin in 1985, and I was mesmerized by a visuality that blended surrealism, constructivism, and minimalism, by Wilson's semiotics of lighting, by the amalgam of quotations from history and literature, and by the non-mimetic acting style that contributed to the enigma of the staging. The unique mix was seen as "living sculpture," a "theatre of images," as "intercultural syncretism" and postmodern imitation. Negative judgments came from directors of innovative yet genre-faithful theatre productions, who called Wilson's work "thievery" (Peter Stein, Berlin). Pastiche structuration in the sense of a patchwork of elements from different art forms and historical styles is pervasive, but it is generally not recognized as such because the term "pastiche" would not be the choice of a reviewer who wants to applaud. Extensive referencing—visual, textual, acoustic—and hybridization has again and again evoked the association of Wilson's "operas" with the concept of a "total work of art," with Wagner's *Gesamtkunstwerk* in particular. Although Wilson does, at least in earlier productions, unify the pluralism of forms, the result is never a totalized unity but rather a deconstructive non-entity, disjunct in its difficult meaning production (cf. Greenaway, chap. 3).

*Black Rider,* a production from 1990, appears as an overly dense pastiche. The artist prepared the work—as well as others—for the stage in Germany; Hamburg's Thalia theatre then brought the production to the Brooklyn Academy of Music in 1993. Several main strands of intertextual energy can be discerned: Wilson used motifs of the Romantic opera by Carl Maria von Weber, *Der Freischütz* (1821), inserting them into other plots of a communal cul-

Fig. 20. *Bach Cantatas.*
Leipzig Ballet, 1996.
Courtesy Oper Leipzig.
Photo: Andreas Birkigt.

tural imagination regarding the devil. Thus Lucifer emerges from a coffin, resembling the vampire in Murnau's *Nosferatu* (1921), while other scenes quote the cubo-expressionist style of Wiene's *The Cabinet of Dr. Caligari* (1919). The text segments contributed by William S. Burroughs to this far-rago of stagy effects reinforce the equation of drugs = devil. Tom Waits's music for *Black Rider* genuinely mediates between the high and low culture domains.

Wilson's hybrid style has had a great influence in many avant-garde quarters, mostly in Europe. Artistic producers gained the courage to stage "high" art in new, often outrageous ways, as Uwe Scholz, the director of the Leipzig ballet, did in 1996: Bach cantatas choreographed quoting the art deco human ornaments of Busby Berkeley films from the thirties (fig. 20).

Next to a vibrant experimental international dance scene, "Broadway" is another fertile territory for pastiche beyond the high/low culture divide. Purloining style, newness of the old.

# CODA

At the end of the twentieth century and the dawn of the twenty-first, pastiche structuration in the arts both high and low is a ubiquitous presence. The idea of a newly established *fin de siècle* that feeds on a desire for commemorative repetition exerts a certain pressure to tie the pastiche phenomenon into the spirit of this time. How does it fit into the *Kulturbruch*, the cultural rupture that some say is about to discard twentieth-century traditions, the breakthroughs of yesteryear? Is our remodeled pastiche, lush, critical, and culturally intertextual, an element of a new *décadence*?

Even a superficial look back to the aestheticist direction in Europe before the turn of the last century will yield the historical certainty that not only were "decadent" tendencies pregnant with innovative impulses, from which modernism came, but they were also only one cultural discourse formation among others: naturalism, socialism (including the socialism of art nouveau practitioners), impressionism, nihilism/vitalism, and more. Although there were plenty of isms, the term "pluralism" did not exist then as popular coinage. The isms of this turn of the century have turned global, among them multiculturalism, global culture, with more to come.

It is possible that the enterprise of the self-conscious exploration of cultural memory, i.e., "postmodern pastiche," is an intuited or intentional response to globalism as an alleged new type of Enlightenment. One historian writes, "The global age is not characterized by the fact that it comes 'after' modernity or is touched by the fact that the calendar registers an ending. The marker of the new epoch is that it connects all people and nations, regions and cultures in one civilization" (Schäfer 1996; my translation). The authors and artists of our critical pastiches are sorters; the flattening of all differentiations—historical, ethnic, artistic—in a totally interconnected global culture is likely to be anathema to them.

To be sure, the artistic endeavors described in this study often make use

of features typical of the cultural connectivism thematized by the ideologues of a global cultural literacy: contamination of genres and styles, the blurring of boundaries between the arts, and between the arts and popular culture. Yet polysemic pastiches stop short of collapsing the signs of the enterprise of art itself—otherness, difference vis-à-vis societal pragmatics, an imagination tied to a specific cultural situation, complexity of reference, and the vibrations of a limited, not unlimited, cultural memory.

An influential early collection of essays on postmodern culture was entitled *The Anti-Aesthetic* (Foster 1983), a title that steered critical discourse on the arts in the direction of an exclusively theory-oriented and philosophical argument. Artists, not academic commentators, kept alive the heightened state of sensory perception and imagination we call aesthetic. Naturally, this notion of the aesthetic dimension has long since shed the idea of aesthetics as "pertaining to the sense of the beautiful," against which Foster formulated his program. The senses, however, are not about to give up their desire for visual and haptic experience which made art an anthropological constant in the first place.

The "hyper-reality" (Baudrillard) of digital simulation has created an overmanaged world, an escalation of Adorno's warning of an "administered world." "Connectivity" is a slogan of the promoters of a global economy, and it should be emphasized that the current cross-pollination among the arts is a qualitatively different connecting game from the one promoted by a financial world proud of its new twenty-four-hour trading day embracing the planet.

When Barnett Newman called his starkly abstract painting anti-capitalist, he had in mind, among other aspects, the radical difference that a viewer, coming in from the commercial buzz of the "real world," would experience before his canvases. The potential of art to provide for a discourse of difference and resistance will be needed the more the dehumanizing tendencies, the dark underside of technocracy, spread. In an interview in 1995, the former East German writer Heiner Müller held that art had to conceive of itself as automatically subversive, and that it must insert chaos into any system. "In the end, art is not controllable" (Theweleit 1995: 15). At the same moment in time, the artist-photographer of fashions and more, Richard Avedon, stated in a television portrait that "a work of art should disturb, should make you think" (PBS, 1996). Art from different "walks of life" will matter in the future as unpredictably as in the past.

# Notes

## Introduction

1. The Australian scholar of philosophy Margaret A. Rose was the first to challenge Jameson's debunking of postmodern pastiche (Rose 1991).

2. See also Danto's book *After the End of Art: Contemporary Art and the Pale of History* (1997).

3. Cf. Peggy Zeglin Brand's entry on "pastiche" for the *Encyclopedia of Aesthetics*, which, drawing upon Hutcheon, Jameson, and Rose, sees postmodern pastiche as "imitation *without* critical commentary," as a repetition "*without* difference." Brand concludes that "such 'failures' do not, however, hinder its [pastiche's] role as a unique creative force within the art world" (1998: 445).

4. In his paper "Deconstruction and Cultural Memory" (International Comparative Literature Association, Leiden 1997), Jonathan Culler proposed to differentiate between "cultural knowledge"—that which is learned—and "cultural memory"—that which cannot be learned.

5. Cf. Walt Whitman, "Years of the modern! years of the unperform'd!" (*Leaves of Grass*).

6. In the U.S. and Britain, the break with decorative postmodern style was named "deconstruction" because of the affinity of several practitioners, e.g., Peter Eisenman, to Derrida's project; the architectural historian Heinrich Klotz coined the term "Zweite Moderne" (second modernism) to stress the recourse to early modernism of the new style.

7. "Emanzipatorische Ästhetik" is a notion that emerged in the discursive climate of Frankfurt School critical theory.

8. The two-volume *Anthologie du pastiche* of 1926, edited by Léon Deffoux and Pierre Dufay, contains literary pastiches of mostly minor French authors. Attempts at defining the genre in the introductions are limited. Deffoux's 1932 monograph, *Le pastiche littéraire*, discusses some important concepts such as "pastiche involontaire." Gérard Genette has camouflaged a segment on pastiche in music, painting, and literature in his book on intertextuality, *Palimpsestes* (1982: 442–45).

## 1. A Discourse History of Pasticcio and Pastiche

1. I am much indebted to the art historians George and Linda Bauer at the University of California Irvine for acquainting me with the "selection theory" as well as the aforementioned Italian sources.

2. For Volterra's sculptures, see Pugliatti (1984).

3. "As to the pastiches, these are 'Pictures that are neither originals nor copies,' but counterfeit works. Their name comes from the Italian *pastici*, which means paté: because as the things that make up a paté are reduced to one taste, the falsities that constitute a pastiche tend to produce only one truth.'"

4. See also older dictionaries such as Bloch (1932), von Wartburg (1928), and Hempel (1965).

5. In his important study, Wido Hempel suggests that in the last sentence, de Piles should really have said that the truths which compose a pastiche amount only to falsity (my trans., Hempel 1965: 167).

6. In his *Réflexions critique sur la poésie et sur la peinture* of 1733, Jean Baptiste Dubos had ridiculed those "connoisseurs just returning from Italy with their Raphael, their Caracci, and their Veronese which turned out to be pastiches by Boulogne" (Littré 1957: 1533, my trans.).

7. The following brief introduction of the discourse formation in music is based on *The New Grove Dictionary of Music and Musicians* (1980) and *Die Musik in Geschichte und Gegenwart* (1997), cited as "Grove" and "MGG" in the text.

8. The American composer Richard Danielpour, for example, draws ostentatiously on a variety of twentieth-century styles, calling himself "an assimilator rather than an innovator" (New York Times, Jan. 18, 1998). It is also noteworthy that *Opera News* devoted a lengthy article to the operatic pasticcio (Apr. 16, 1994).

9. This study does not include a separate chapter on musical pasticcio/pastiche, because its author lacks authentic expertise in musicology. Music is cross-referenced and thematized again in the discussion of "pastiche culture" in chapter 5.

10. It seems likely that Marcel Proust reacted against the self-assured traditionalism of A. Albalat, who wrote in 1902, "Le pastiche est *l'imitation artificielle et servile des expressions et des procédés de style d'un auteur.*" Quoted in Wolf-Dieter Lange 1980: 411.

## 2. Pastiche in the Visual Arts

1. A case in point is Juliet Wilson-Bareau's article "'Pastiche' or 'Parallelism'? Baudelairean and Other Keys to Manet's Relationship with Goya," which cites Baudelaire's comment on Manet: "The word *pastiche* is unfair. M. Manet has never seen a *Goya*," but does not address the pastiche genre as such (Wilson-Bareau 1994: 209).

2. In *The Picasso Papers* (1998), a highly engaging hybrid of light biographical narrative and thorough art-historical analysis, Rosalind E. Krauss devotes a chapter to "Picasso/Pastiche." Although the phenomenon of the artist's post-cubist classicism, his "copies" of Ingres, Corot, and other precursors, is discussed through the use of an important psychoanalytical argument, the concept of pastiche itself is not re-examined. This is surprising in the case of an author who a dozen years ago dismantled the modernist notion of originality in her influential study *The Originality of the Avant-Garde and Other Modernist Myths* (1985).

3. I am indebted to Adriana Calinescu, Thomas Solley Curator of Ancient Art at the Indiana University Art Museum, for several of the identifications.

4. The visually powerful allegorical figures of Renaissance artists such as Michelangelo and Botticelli determined the tradition until the nineteenth century, when allegorical representation, especially in sculpture, became the (mediocre) style of the academy; hence the dismissal of allegory by modernists heading for abstraction.

5. Cf. Craig Owens, "The Allegorical Impulse: Toward a Theory of Postmodernism" (1980: 69). Embracing Walter Benjamin's theory of allegory, Owens sees allegory as "the model of all commentary," in that one text is always read through another. The allegorist confiscates images from the past that in his hands become something other. Owens refers us to the etymology of allegory as *allos,* "other," + *agoreuei,* "to speak."

6. The author attended some of the seminars, mostly on pre-Socratic philosophy and Carl Schmitt, at UC Irvine in April 1989. Derrida published *The Politics of Friendship* in 1997.

7. The Utopia motto on an early Bauhaus poster referred to a strong commitment to build social housing and livable factories for workers.

8. In the seventies, Jencks was not aware of the discourse formation on postmodern literature that had begun in the U.S. in 1960. In *The Language of Post-Modern Architecture,* he feels the need to distance his own perspective on postmodernism from that of Americanists such as Ihab Hassan, which he considers oriented toward an "ultra-modernism" (1984 [1977]: 6). A slim book published almost ten years later, the popular *What Is Post-Modernism?* (1986), shows Jencks as a more informed comparatist of the different postmodernisms.

9. It was this Biennale, which Habermas did not visit but read about, that prompted the Frankfurt School social philosopher to write his internationally known essay "Modernity: An Incomplete Project" (Habermas 1983). Originally given as an acceptance speech for the Adorno Prize of the City of Frankfurt, the essay became notorious for Habermas's dismissal of the concept of postmodernism in toto and his attack on major French poststructuralists such as Derrida and Foucault as "young conservatives" threatening the Enlightenment project. Both Foucault and Derrida protested their being grouped with the political right; shortly before his death in 1984, Foucault met with Habermas, who revised some of his perceptions in subsequent publications. For our context, it is noteworthy that the culturally literate philosopher was blind to changes in contemporary aesthetics, and that this perspective should have thenceforth determined German cultural discourse on the topic of postmodernism.

10. It was the interdisciplinary architecture and environmental art group SITE (Sculpture in the Environment), founded in New York in 1970, that first employed the ruin topos in their issue-oriented "de-architecture."

### 3. Cinematic Pastiche

1. Shklovsky introduced his concept in the essay "Iskusstvo kak priem," first published in 1917. Translated as "Art as Technique," the essay is part of David Lodge's *Modern Theory and Criticism.* For Brecht's adaption, see Martin Esslin's "Short Brecht Glossary," in Esslin 1961.

2. I owe the "film as writing" interpretation to a seminar paper by Rebecca Krug, now a professor of Medieval Studies, for a course on German film in 1990.

3. "Wir sitzen auf dem Platz des Volkes, und der ganze Platz ist voll von Leuten, die sich dasselbe wünschen wie wir." From the perspective of *Wings,* Handke's experimental play without words, *The Hour We Knew Nothing of Each Other* (1992), may appear as an imagistically enacted elaboration on the *Platz* as locus of meaning as encounter.

4. I am grateful to the baroque expert and professor emeritus Hugh Powell for sharing his expertise on the usages of *genera dicendi* in the baroque age.

5. The title *Europa* prompted German critics to connote Oswald Spengler's cultural history from the 1920s, *The Decline of the West*, i.e., a very different dystopian code (*Die Zeit* 27, July 5, 1991).

6. *Derek Jarman's Caravaggio* (1986) contains excerpts from the script and comments from various Italian seventeenth-century artists' biographers on Caravaggio's art and life. Photographs by Gerald Incandela.

7. Art-historical research has questioned the observations of early biographers of Caravaggio, who often wrote half a century after his death, e.g., the learned librarian of the Queen of Sweden, Giovanni Pietro Bellori. Apart from known records, it is the work itself that, for art historians such as Andreas Prater, reveals a deeply troubled personality, including such images as the gruesome self-portrait seen in the severed head of Goliath in *David with the Head of Goliath*, c. 1609–10, Galleria Borghese (Prater 1985).

8. Introductory information sheet distributed by the British Film Institute at screenings in 1986 that contains reproductions of all Caravaggio works featured in the film.

9. *Boy with a Basket of Fruit*, c. 1594, Galleria Borghese; *Bacchus*, c. 1596, Uffizi; *Bacchino Malato* (Sick Bacchus), c. 1593–94, Galleria Borghese.

10. A play of quotation was the second-order pastiche that was part of a British television mini-series titled *Painted Lady* (c. 1997) written for Helen Mirren. The actress could be seen as a female Marat in the tub, citing both David's painting and Jarman's quotation in *Caravaggio*.

11. *Dressing Table Still Life*, 1993, Salander-O'Reilly Galleries, New York. It should be noted that the painter Julian Schnabel incorporated Caravaggio's *Boy with a Basket of Fruit* (see note 9) into his appropriation painting *Exile* as early as 1980.

12. *Untitled No. 224*, 1990, C-print photograph, Collection of Linda and Jerry Janger, Los Angeles.

13. Greenaway's early structural films, products of a visual artist turned filmmaker, document his affinity to the avant-garde of the seventies; cinematic models from Frampton to Resnais's *Last Year in Marienbad* tell of his preference for non-narrative film. As a postmodern intermedia artist, Greenaway curated shows such as *Le bruit des nuages* (The Noise of Clouds) for the Louvre in 1992/93, a reflection on art and artist represented by graphics from the period of mannerism.

14. In discussion with Amy Lawrence (1997: 170) Greenaway claims that the "giant reproduction of the [Hals] painting in the restaurant is a template for bad behaviour—not good." Cf. Nita Rollins (1995: 75), who arrived at the same conclusion as we did.

15. Examples of this particular theme are a canvas by Abraham van Beyeren in the De Young Museum in San Francisco and paintings by Jan David de Heem in Berlin and Toledo.

16. Masaccio, *The Expulsion from Paradise*, c. 1427, fresco, Sta. Maria del Carmine, Florence; Michelangelo, *The Fall of Man and the Expulsion from the Garden of Eden*, 1508–12, fresco, Sistine Chapel.

17. Cf. Brigitte Peucker's insightful analysis of *The Cook, the Thief, His Wife and Her Lover* (Peucker 1995: 162–65). A first version of my reading was published at the same time (Hoesterey 1995: 505–506).

18. I am following here Alice Kuzniar's brilliant Freudian reading, "Ears Looking at You: E. T. A. Hoffmann's *The Sandman* and David Lynch's *Blue Velvet*," *South-Atlantic Review* 54 (1989), 10–11.

1. The brief introductory remarks on the antique cento are based on the entries in *The Oxford Classical Dictionary* (1970) and *Metzler Literaturlexikon* (1984), Freund 1981: 24. I am indebted to Elinor Leach, Classical Studies, Indiana University, for extensive advice regarding the status of the cento and the lost part of Aristotle's *Poetics* (for my discussion of Eco's novel).

2. Cf. Frank Leinen, "Proust, Flaubert und Deux Cloportes," *Romanische Forschungen* 103, no. 2–3 (1991): 211–35, and Wolf-Dieter Lange, "Poetik des Pastiche," in Hans Ulrich Gumbrecht et al., eds., *Honoré de Balzac* (Munich: Fink, 1980).

3. Romance language scholars are understandably the exception; Wido Hempel's article "Parodie, Travestie und Pastiche"(1965) effectively encouraged research on the subject of pastiche (see note 2), including this study. Most recently Ursula Link-Heer, Bayreuth University, devoted major articles to the topic of pastiche, including "Multiple Personalities and Pastiches: Proust *père et fils*" (1999).

4. Johann Gottfried Herder, the founder of folklore studies, developed his theory of the poetic as the natural temperament of a "wild and free" people in his celebration of "Ossian or the Songs of Early Peoples" (1773).

5. "Pastiche involontaire" is for Proust the avoidance of the exorcizing virtue of the "pastiche volontaire" (cited in Karrer 1977: 47). Deffoux speaks of the "mysterious ways" of the "pastiche involontaire," which may range from unconscious reception of influence to plagiarism and "imitation volontaire" (Deffoux 1932: 8).

6. In his novel *Alte Meister* (Old Masters) of 1985, Bernhard portrays anxiety of influence in an ingenious fashion. The text "forces" the reader to concretize the theme by way of a visit to a Tintoretto portrait of an old, white-bearded man in the Vienna Kunsthistorisches Museum. Cf. Hoesterey 1988: 177–79.

7. "My dear! You are lying in the grass, your head bent backwards, not a soul around you; you hear only the wind, and you look up into the open sky—into the blue above, where the clouds move—that is perhaps the most beautiful that you have done and seen in your life" (my trans.).

8. Cf. Chatman 1978 and Cohn 1990: n. 5 for similar pairings from Russian Formalism to Mieke Bal.

9. Cf. Eco's co-editorship with Thomas A. Sebeok of *The Sign of Three: Dupin, Holmes, Peirce* (1983).

10. It is easily discernible that Eco does not create mere characters à clef, as is quite common in the modern novel. Eco is more interested in the play of allusions as such, which is why his Jorge de Burgos is quite different from Jorge Luis Borges.

11. The pastiche of Voltaire's "Zadig ou la destinée" of 1747, considered to be the first detective story, occurs in William's dramatic description of the abbot's horse, which he has never seen, and not in the "Dies irae" segment (cf. Cohen 1988: 66).

12. A group of Italian visual artists in turn devoted thirty-one interpretive illustrations to Eco's novel (Associazione Illustratori 1985).

13. My discussion of the influence of Romanesque and earlier illuminations on Eco's text draws on Krisana Daroonthanom, "Original und literarische Transposition. Zur Semiotik von Portalskulpturen und Buchmalerei in Ecos *Der Name der Rose*," in Daroonthanom 1991: 225–45.

14. A longer version of this reading appeared in German in Hoesterey 1988: 172–75.

15. For an acerbic critique of "Murder in the Name of Art" and the "underlying destructive impulse" of modern art and artist (Grenouille, for one), see Tatar 1995: 178–81.

## 5. Pastiche Culture beyond High and Low

1. Niklas Luhmann's application of his systems theory to the different arts is problematic because it ignores specialized knowledge, thus contradicting the central premise of his influential constructivist project.

2. Throughout the nineties, the design of all kinds of everyday objects, especially rugby shirts, was inspired by Kenneth Noland's stripe paintings, which are characterized by unusual color combinations of stripes of irregular width.

3. The attempt of fashion discourse at "deconstruction" was bound to be misunderstood, e.g., the forced, ungracious bending of a model's legs as well as other displacements of regular glamour. Issues of gender-crossing, by contrast, generated becoming images with an androgynous flair, as did ads for a Giorgio Armani fragrance for men.

4. Marxist cultures resented this dichotomy and prescribed classical music for the workers in order to familiarize them with the "cultural heritage."

5. I am very grateful to Ms. Felicia M. Miyakawa, a doctoral student in musicology at Indiana University who works on "Musical Borrowings" and introduced me to "rap sampling" and the wealth of classical and other quotations used in art rock.

6. I saw live performances by Laurie Anderson in 1986 and 1990. For an in-depth analysis of her work, see Prinz 1989.

# Works Cited

Adorno, Theodor W. 1967. *Ohne Leitbild.* Frankfurt/Main: Suhrkamp.

———. 1984. *Aesthetic Theory.* Trans. C. Lenhardt. Ed. Gretel Adorno and Rolf Tiede-mann. London: Routledge & Kegan Paul.

Albertsen, L. L. 1971. "Der Begriff Pastiche." *Orbis Litterarum (OL)* 26: 1–13.

Artaud, Antonin. 1976. "The Theater of Cruelty (First Manifesto)." In *Antonin Artaud: Selected Writings,* ed. Susan Sontag, 242–256. New York: Farrar, Straus, Giroux.

Associazione Illustratori. 1985. *La Rosa Dipinta.* Milano: Azzurra Editrice.

Barbiero, Daniel. 1990. "'Dark Art' into Allegory: From Transfiguration to Refiguration." *M/E/A/N/I/N/G* 8: 11–17.

Barnes, Julian. 1984. *Flaubert's Parrot.* New York: Vintage International.

Barthelme, Donald. *Overnight to Many Distant Cities.* New York: Putnam, 1983.

Barthes, Roland. 1974. *S/Z.* Trans. Richard Miller. New York: Hill and Wang.

Battaglia, Salvatore. 1984. *Grande Dizionario della Lingua Italiana.* Vol. 12. Turin: Unione Tipografica-Editrice Torinese.

Baudrillard, Jean. 1983. *Simulations.* New York: Semiotext (e).

Bazin, André. 1967. *What Is Cinema?* Berkeley and Los Angeles: University of California Press.

Benjamin, Walter. 1968. *Illuminations.* New York: Harcourt, Brace & World.

———. 1977. *The Origin of German Tragic Drama.* Trans. John Osborne. London: NLB.

———. 1982. *Gesammelte Schriften.* Vol. V: 1: *Das Passagenwerk.* Frankfurt/Main: Suhr-kamp.

Bernhard, Thomas. 1982. "Goethe stirbt." *Die Zeit* 12 (March 26): 9–10.

Boozer, Jack, Jr. 1991. "Crashing the Gates of Insight." In Judith B. Kerman, *Retrofitting Blade Runner: Issues in Ridley Scott's "Blade Runner" and Philip K. Dick's "Do Androids Dream of Electric Sheep?,"* 212–28. Bowling Green, Ohio: Bowling Green University Popular Press.

Borges, Jorge Luis. 1963. "Pierre Menard, Author of Don Quixote." In *Ficciones,* 42–61. New York: Grove Press.

———. 1964. "The Library of Babel." In *Labyrinths,* 51–58. New York: New Directions.

Brand, Peggy Zeglin. 1998. "Pastiche." In *Encyclopedia of Aesthetics,* ed. Michael Kelly, 444–45. Oxford: Oxford University Press.

Broich, Ulrich. 1996. "A. S. Byatts *Possession* (1990)—ein Pastiche postmoderner Fiktion?" In *Expedition nach der Wahrheit,* ed. Stefan Horlacher and Marion Islinger, 617–33. Heidelberg: Universitätsverlag C. Winter.

Bruno, Giuliana. 1987. "Ramble City: Postmodernism and Bladerunner." *October* 41: 61–74.

# Works Cited

Brunot, Ferdinand. 1996 (1930). *Histoire de la Langue Française des Origines à Nos Jours.* Vol. VI: *le XVIII^e siècle.* Paris: Librairie Armand Colin.

Byatt, A. S. 1990. *Possession: A Romance.* New York: Vintage International.

Calasso, Roberto. 1994. *The Ruin of Kasch.* Cambridge, Mass.: Belknap Press of Harvard University Press.

Calinescu, Matei. 1987. "Parody and Intertextuality." *Semiotica* 65, no. 1–2: 183–90.

Chatman, Seymour. 1978. *Story and Discourse: Narrative Structure in Fiction and Film.* Ithaca: Cornell University Press.

Cohen, Michael. 1988. "The Hounding of Baskerville: Allusion and Apocalypse." In M. Thomas Inge, ed., *Naming the Rose: Essays on Eco's "The Name of the Rose,"* 65–76. Jackson: University Press of Mississippi.

Cohn, Dorrit. 1971. "Castles and Anti-Castles or Kafka and Robbe-Grillet." *Novel* (Fall): 19–31.

———. 1990. "Signposts of Fictionality: A Narratological Perspective." *Poetics-Today* 11, no. 4 (Winter): 775–804.

Culler, Jonathan. 1994. Preface to Special Issue on Avital Ronell. *diacritics* 24, no. 4.

Curry, Ramona. 1990. "Madonna from Marilyn to Marlene—Pastiche and/or Parody?" *Journal of Film and Video* 42, no. 2 (Summer): 15–30.

Danto, Arthur C. 1981. *The Transfiguration of the Commonplace: A Philosophy of Art.* Cambridge, Mass.: Harvard University Press.

———. 1992. *Mark Tansey: Visions and Revisions.* New York: Abrams.

———. 1997. *After the End of Art: Contemporary Art and the Pale of History.* Princeton, N.J.: Princeton University Press.

Daroonthanom, Krisana. 1991. "Original und literarische Transposition. Zur Semiotik von Portalskulpturen und Buchmalerei in Ecos *Der Name der Rose.*" In *Umberto Eco: zwischen Literatur und Semiotik,* ed. Armin Burkhardt and Eberhard Rohse, 225–46. Braunschweig: Ars & Scientia.

de Lauretis, Teresa. 1985. "Gaudy Rose: Eco and Narcissism. " *Substance* 47: 13–29.

de Piles, Roger. 1677. *Conversations sur la Connaissance de la Peinture, et sur le jugement qu'on doit faire des Tableaux.* Paris: Langlois.

Deffoux, Léon. 1932. *Le pastiche littéraire.* Paris: Librairie Delagrave.

Deffoux, Léon, and Pierre Dufay. 1926. *Anthologie du pastiche.* 2 vols. Paris: les Éditions Grès.

Derrida, Jacques. 1997. *The Politics of Friendship.* New York: Columbia University Press.

Eagleton, Terry. 1987. *Saints and Scholars.* London, New York: Verso.

———. 1996. *The Illusions of Postmodernism.* Cambridge, Mass.: Blackwell Publishers.

Eco, Umberto. 1983a. *The Name of the Rose.* San Diego: Harcourt Brace Jovanovich.

———. 1983b. *Semiotics and the Philosophy of Language.* Bloomington and Indianapolis: Indiana University Press.

———. 1984. *Postscript to the Name of the Rose.* San Diego: Harcourt Brace Jovanovich.

Eco, Umberto, and Thomas A. Sebeok, eds. 1983. *The Sign of Three: Dupin, Holmes, Peirce.* Bloomington and Indianapolis: Indiana University Press.

*Encyclopédie, ou dictionnaire raisonné des sciences, des arts et des métiers.* 1765. Vol. 12. Neufchâtel: Faulche & Compagnie.

Esslin, Martin. 1961. *Brecht: The Man and His Work.* Garden City, N.Y.: Doubleday & Company.

Everitt, David. 1997. "When Old Movies Land a Part in the New." *New York Times,* Oct. 19.

Fiedler, Leslie. 1969/1971. "Cross the Border—Close the Gap." In *Collected Essays II*, 461–85. New York: Stein and Day.

Foster, Hal, ed. 1983. *The Anti-Aesthetic: Essays on Postmodern Culture*. Port Townsend, Wash.: Bay Press.

Foucault, Michel. 1982. *The Archaeology of Knowledge*. New York: Pantheon.

Franco, Jean. 1990. "Pastiche in Contemporary Latin American Culture." *Studii Cercetari Lingvistici (STCL)* 14, no. 1 (Winter): 95–107.

Freund, Winfried. 1981. *Die literarische Parodie*. Stuttgart: Metzler.

Fried, Michael. 1986. "Antiquity Now: Winckelmann on Imitation." *October* 37 (Summer): 87–97.

Garrard, Mary D. 1989. *Artemesia Gentileschi: The Image of the Female Hero in Italian Baroque Art*. Princeton, N.J.: Princeton University Press.

Genette, Gérard. 1982. *Palimpsestes: la Littérature au Second Degré*. Paris: Seuil.

*Grand dictionnaire encyclopédique Larousse*. 1982. Vol. 8. Paris: Librairie Larousse.

*Le Grand Robert de la langue française*. 1985. Vol. 7. Paris: Le Robert.

Greenaway, Peter. 1989. *The Cook, the Thief, His Wife and Her Lover*. London: Verso.

———. 1997. Lecture given at Indiana University, April 29.

Grimm, Reinhold. 1968. "Die Formbezeichnung 'Capriccio' in der deutschen Literatur des 19. Jarhhunderts." In Heinz Otto Burger, ed., *Studien zur Trivialliteratur*, 101–116. Frankfurt: Klostermann.

Habermas, Jürgen. 1983. "Modernity: An Incomplete Project." Trans. Seyla Ben-Habib. In Hal Foster, ed., *The Anti-Aesthetic: Essays on Postmodern Culture*, 3–15. Port Townsend, Wash.: Bay Press.

Hagen, Charles. 1990. "Peter Greenaway and the Erotics of Form." *Aperture* (Special Issue): 72–74.

Hassan, Ihab. 1975. *Paracriticisms: Seven Speculations of the Times*. Urbana: University of Illinois Press.

Heffernan, Julie. 1996. *Paintings*. Catalogue. New York: Littlejohn Contemporary.

Hempel, Wido. 1965. "Parodie, Travestie und Pastiche." *Germanisch-Romanische Monatsschrift (GRM)* 15, no. 2: 150–76.

Herder, Johann Gottfried. 1773. *Von deutscher Art und Kunst*. Hamburg: Bey Bode.

Hibbard, Howard. 1983. *Caravaggio*. New York: Harper & Row.

Hoberman, John. 1988. "Earth Angel." *The Village Voice*, May 3.

Hoesterey, Ingeborg. 1988. *Verschlungene Schriftzeichen. Intertextualität von Literatur und Kunst in der Moderne/Postmoderne* (Intertextuality of Literature and Art in Modernism/Postmodernism). Frankfurt/Main: Athenäum.

———. 1995. "Postmodern Pastiche: A Critical Aesthetic." *Centennial Review* 39, no. 3 (Fall): 493–509.

Hollier, Denis (D.H.). 1975. "Pastiche." In *La grande Encyclopédie*, 9167–69. Paris: Librairie Larousse.

Hughes, Robert. 1990. "Modernism's Neglected Side." *Time*, Aug. 13.

Hutcheon, Linda. 1985. *A Theory of Parody: The Teachings of Twentieth Century Art Forms*. New York and London: Methuen.

Huxtable, Ada Louise. 1997. "Living with the Fake, and Liking It." *New York Times*, March 30.

Inge, M. Thomas, ed. 1988. *Naming the Rose: Essays on Eco's "The Name of the Rose."* Jackson: University Press of Mississippi.

J. Peterman Company. 1996–97. *Owner's Manuals*. Lexington, Ky.: J. Peterman Company.

Jameson, Fredric. 1984. "Postmodernism, or, The Cultural Logic of Late Capitalism." *New Left Review* 146: 53–64. Reprinted in *Postmodernism, or The Cultural Logic of Late Capitalism.* Durham: Duke University Press, 1991.

Jarman, Derek. 1986. *Derek Jarman's Caravaggio.* London: Thames and Hudson.

———. 1993. *Dancing Ledge.* Woodstock, N.Y.: Overlook Press.

Jencks, Charles. 1980. *Architecture Today.* New York: Rizzoli.

———. 1984 (1977). *The Language of Post-Modern Architecture.* New York: Rizzoli.

———. 1986. *What Is Post-Modernism?* London: Academy Editions/St. Martin's Press.

———. 1987. *Post-Modernism: The New Classicism in Art and Architecture.* New York: Rizzoli.

Kafka, Franz. 1998. *The Trial.* Trans. Breon Mitchell. New York: Schocken.

Kaplan, E. Ann. 1987. *Rocking around the Clock.* New York and London: Routledge.

Karrer, Wolfgang. 1977. *Parodie, Travestie, Pastiche.* Munich: W. Fink.

Kellner, Hans. 1988. "'To Make Truth Laugh': Eco's 'The Name of the Rose.'" In M. Thomas Inge, ed., *Naming the Rose: Essays on Eco's "The Name of the Rose,"* 3–30. Jackson: University Press of Mississippi.

Kennedy, Harlan. 1993. "The Two Gardens of Derek Jarman." *Film Comment* 29, no. 6 (Nov./Dec.): 28–35.

Kerman, Judith B. 1991. *Retrofitting Blade Runner: Issues in Ridley Scott's "Blade Runner" and Philip K. Dick's "Do Androids Dream of Electric Sheep?"* Bowling Green, Ohio: Bowling Green University Popular Press.

Krauss, Rosalind E. 1998. *The Picasso Papers.* New York: Farrar, Giroux, Straus.

Kristeva, Julia. 1969. *Semeiotiké—Pour une Sémanalyse.* Paris: Editions du Seuil.

Kundera, Milan. 1990. *Immortality.* Trans. Peter Kussi. New York: Harper Perennial.

LaCapra, Dominick. 1989. "On the Line: Between History and Criticism." In *Profession 89.* New York: MLA.

Lange, Wolf-Dieter. 1980. "Poetik des Pastiche. Zu Balzacs *Contes Drôlatiques.*" In *Honoré de Balzac,* ed. Hans-Ulrich Gumbrecht et. al., 411–35. Munich: W. Fink.

Lavin, Irving. 1980. *Bernini and the Unity of the Visual Arts.* New York: Oxford University Press.

Lawrence, Amy. 1997. *The Films of Peter Greenaway.* Cambridge: Cambridge University Press.

Lenain, Thierry. 1989. "Le Pastiche radical comme art du chaud-froid." *Annales d'histoire de l'art et d'archaeologie,* 125–37.

Link-Heer, Ursula. 1999. "Multiple Personalities and Pastiches: Proust *père et fils.*" *SubStance* 88: 17–28.

Littré, Emile. 1957. *Dictionnaire de la langue francaise.* Vol. 5. Paris: Gallimard Hachette.

Lloyd, Rosemary. 1993. "The Scholar in the Labyrinth." In *Literature and Quest,* ed. Christine Arkinstall, 7–16. Amsterdam: Rodopi.

Lodge, David. 1984. *Small World: An Academic Romance.* London: Secker & Warburg.

Lützeler, Heinrich. 1962. *Bildwörterbuch der Kunst.* Bonn: Dümmler's Verlag.

Lyotard, Jean-François. 1984. *The Postmodern Condition: A Report on Knowledge.* Trans. Geoff Bennington and Brian Massumi. Minneapolis: University of Minnesota Press.

Mack, Sara. 1988. *Ovid.* New Haven and London: Yale University Press.

Mai, Ekkehard, ed. 1996. *Das Capriccio als Kunstprinzip. Catalog.* Milano: Skira.

Mariani, Carlo Maria. 1997. *Dialogues.* Catalogue. San Francisco: Hackett Freedman Gallery.

Marmontel, Jean-François. 1787. *Elemens de littérature.* Vol. 4. [Paris: Nee de La Rochelle.]

Mersch, Dieter. 1993. *Umberto Eco zur Einführung.* Hamburg: Junius.

Müller, Heiner. 1984. *Hamletmachine and Other Texts for the Stage.* Trans. Carl Weber. New York: Performing Arts Journal Publications.

*Die Musik in Geschichte und Gegenwart.* 1997. Ed. Ludwig Finscher. Vol. 7. Kassel: Bärenreiter.

Musper, Heinrich Theodor. 1981. *Netherlandish Painting from Van Eyck to Bosch.* Trans. Robert Allen. New York: Abrams.

Nelson, Robert S., and Richard Schiff. 1996. *Critical Terms for Art History.* Chicago: University of Chicago Press.

Neubauer, John. 1997. "Uncanny Pastiche: A. S. Byatt's *Possession.*" In *Parodia, Pastiche, Mimeticismo; Atti del Convegno Internazionale AILC/ICLA, Venezia 1993,* ed. Paola Mildonian, 383–391. Rome: Bulzoni.

*The New Grove Dictionary of Music and Musicians.* 1980. Vol. 14. Ed. Stanley Sadie. London and Washington: Macmillan.

Novalis. 1964. *Henry von Ofterdingen.* Trans. Palmer Hilty. New York: F. Ungar.

Owens, Craig. 1980. "The Allegorical Impulse: Toward a Theory of Postmodernism." Part I. *October* 12 (Spring): 67–86.

Peucker, Brigitte. 1995. *Incorporating Images: Film and the Rival Arts.* Princeton, N.J.: Princeton University Press.

Prater, Andreas. 1985. "Caravaggio. Mit Pinsel und Degen." *Pan* (July): 4–23.

Prinz, Jessica. 1989. "'Always Two Things Switching': Laurie Anderson's Alterity." In *Postmodern Genres,* ed. Marjorie Perloff, 150–74. Norman and London: University of Oklahoma Press.

Proust, Marcel. 1919 (1970). *Pastiches et mélanges.* Paris: Gallimard.

Pugliatti, Teresa. 1984. *Giulio Mazzoni e la Decorazione a Roma della Cerchia di Daniele da Volterra.* Rome: Liberia dello Stato.

Raines, Robert. 1977. "Watteau and 'Watteaus' in England before 1760." *Gazette des Beaux-Arts* 89 (Feb.): 51–64.

Ransmayr, Christoph. 1990. *The Last World.* Trans. John Woods. New York: Grove Weidenfeld.

Rogowski, Christian. 1992. "'To Be Continued': History in Wim Wenders's *Wings of Desire* and Thomas Brasch's *Domino.*" *German Studies Review* 15, no. 3 (Oct.): 547–63.

Rollins, Nita. 1995. "Greenaway-Gaulthier: Old Masters, Fashion Slaves." *Cinema Journal* 35, no. 1: 65–80.

Ronnell, Avital. 1992. *Crack Wars: Literature Addiction Mania.* Lincoln and London: University of Nebraska Press.

Rose, Barbara. 1982. "SciFi." *Vogue* (Oct.): 557ff.

Rose, Margaret A. 1991. "Post-Modern Pastiche." *British Journal of Aesthetics* 31, no. 1 (Jan.): 26–38.

Rothstein, Edward. 1996. "Trend-Spotting: It's All the Rage." *New York Times,* Dec. 29.

Russell, Francis. 1977. "Sassoferrato and His Sources: A Study of Seicento Allegiance." *Burlington Magazine* 19 (Oct.): 694–700.

Ryan, Judith. 1990. "The Problem of Pastiche: Patrick Süskind, Das 'Parfum.'" *German Quarterly,* 63, no. 3–4 (Summer–Fall): 396–403.

Sack, Manfred. 1984. "Das Zitatenmuseum." *Die Zeit* 11 (March 16): 19.

# Works Cited

Schäfer, Wolf. 1996. "Das 20. Jahrhundert hat gerade erst begonnen." *Die Zeit* 44 (Nov. 1): 16.

Schama, Simon. 1987. *The Embarrassment of Riches.* New York: Knopf.

Scheib, Ronnie. 1990. "Angst for the Memories," *Film Comment* 26, no. 4: 9–26.

Schickel, Richard. 1998. "Mixed Doubles." *Time,* Apr. 20.

Schiller, Friedrich. 1902. "The Glove." In *The Works of Friedrich Schiller,* ed. Nathan Haskell Dole, 224–26. Boston: Wymann-Fogg.

Shklovsky, Victor. 1988. "Art as Technique." In *Modern Criticism and Theory: A Reader,* ed. David Lodge. London, New York: Longman.

Stadelmaier, Gerhard. 1985. "Lebens-Riechlauf eines Duftmörders," *Die Zeit* 12 (March 22).

Stoppard, Tom. 1975. *Travesties.* New York: Grove Press.

Süskind, Patrick. 1986. *Perfume: The Story of a Murderer.* Trans. John E. Woods. New York: A. A. Knopf.

Swindler, Mary Hamilton. 1929. *Ancient Painting: From the Earliest Times to the Period of Christian Art.* New Haven: Yale University Press; London: H. Milford, Oxford University Press.

Tatar, Maria. 1995. *Lustmord: Sexual Murder in Weimar Germany.* Princeton, N.J.: Princeton University Press.

Teyssèdre, Bernard. 1957. *Roger de Piles et les débats sur le coloris au siècle de Louis XIV.* Paris: La Bibliothèque des arts.

Theweleit, Klaus. 1995. "Artisten im Fernsehstudio, unbekümmert." *Die Zeit* 34 (Aug. 25): 13–15.

Thomson, Jon. 1985. "The Warning Hand." In *Stephen McKenna Catalogue,* 23–31. Berlin: Raab Galerie.

Turner, Jane, ed. 1996. *The Dictionary of Art.* Vol. 24. New York: Grove.

Van Wert, William F. 1990–91. "*The Cook, the Thief, His Wife and Her Lover.*" *Film Quarterly* 44, no. 2 (Winter): 42–50.

Venturi, Robert. 1966. *Complexity and Contradiction in Architecture.* New York: Museum of Modern Art.

Veeser, H. Aram. 1988. "Holmes Goes to Carnival: Embarrassing the Signifier in Eco's Anti-detective Novel." In M. Thomas Inge, ed., *Naming the Rose: Essays on Eco's "The Name of the Rose,"* 101–18. Jackson: University Press of Mississippi.

Walker, James F. 1981. "Understanding Pastiche." *Artscribe* 30 (Aug.): 30–34.

Watney, Simon. 1994. "Derek Jarman 1942–94: A Political Death." *Artforum* (May): 84–85.

*Webster's Third New International Dictinary, Unabridged.* Springfield, Mass.: Merriam.

Weisstein, Ulrich. 1987. "(Pariser) Farce oder wienerische Maskerade? Die französischen Quellen des *Rosenkavalier.*" In *Hofmannsthal Forschungen,* Bd. 9: *Hofmannsthal und Frankreich.* Freiburg i. Br.: Hofmannsthal-Gesellschaft.

Wilmington, Mike. 1992. "The Rain People." *Film Comment* 28, no. 1 (Jan./Feb.): 17–19.

Wilson-Bareau, Juliet. 1994. "'Pastiche' or 'Parallelism'? Baudelairean and Other Keys to Manet's Relationship with Goya." In *Goya. Neue Forschungen,* ed. Jutta Held, 205–25. Berlin: Gebr. Mann Verlag.

Zimmer, Dieter E. 1985. "Eco I, Eco II, Eco III." Interview with Umberto Eco. *Die Zeit* 49 (Dec. 6).

# Index

Adam and Eve motif, 75
adaptation, 10, 71
Adorno, Theodor W., x, 82
advertising, 104–12
Aertsen, Pieter, 75
Aldobrandini Wedding fresco, 2
allegory, 24–27, 35, 72–73, 122n4, 123n5
*Amor Victorious* (Caravaggio), 65–67
anachronism, 65, 86–87, 91
Anderson, Laurie, 115–16
Andriessen, Louis, 73
Ankoné, Franciscus, 107
*Anthologie du Pastiche* (Deffoux/Dufay), 14, 81,
    121n8
*Anti-Aesthetic, The* (Foster), ix–x, 119
apocalypse motif, 97–99
appropriation, 10
architecture, 24, 31–38, 44, 47, 108–109,
    121n6
"Architecture of the Ecole de Beaux Arts"
    (Museum of Modern Art), 32
Arcimboldo, Giuseppe, 75
Aristophanes, 80
Aristotle, 31, 79, 99
*Aristotle Contemplating the Bust of Homer*
    (Rembrandt), 31
Arlekan, Henri, 54
art deco, 36–39
Artaud, Antonin, 72
arte povera, 50
assemblage, 19–25
Astor, Josef, 107–109
authenticity, 16–17, 82

Bacon, Roger, 96
Bakhtin, Mikhail, 99, 102
Bakhtin, Nikolai, 102
Baldinucci, Filippo, 3

Ballard Design, 40
*Banquet of the Officers of the St. George Civic
    Guard* (Hals), 73–74
Barnes, Julian, 103
baroque, the, 27–29, 35–36, 42, 56, 67
Barr, Jean-Marc, 59
Barthelme, Donald, 87–88
Barthes, Roland, 29
*Battle of Greeks and Amazons,* Halicarnassus, 20
Baudrillard, Jean, 29, 48, 52
*Bauhaustreppe* (Schlemmer), 108–109
Beatus of Liébana, 97
*Beggar's Opera* (Gay), 71
Bely, Andrei, 93
Benjamin, Walter, 13, 29, 35, 115
*Berlin* (Ruttmann), 55
Bernhard, Thomas, 86–87, 125n6
Bernini, Gian Lorenzo, 2
Beuys, Joseph, 21, 41
*Bibliophile, The* (Arcimboldo), 75
*Birth of Venus* (Botticelli), 16–17
"Black and White" (Jackson), 114
*Black Rider* (Burroughs/Waits/Wilson), 116–17
*Blade Runner* (Scott), 46–54, 60
*Blue Velvet* (Lynch), 46, 77
Bofill, Ricardo, 35–36
Bois, Curt, 53
Borges, Jorge Luis, 54, 83–85, 96
Bosch, Hieronymous, 98
Brecht, Bertolt, 45–46, 59, 71–72
bricolage, 10, 38
Broch, Hermann, 91
Broich, Ulrich, 94
Bruegel, Pieter, 98
Bruno, Giuliana, 47–48, 52
Brunot, Ferdinand, 4–6
Bryan, Robert, 107–109
Bunuel, Luis, 77

133

# Index

Burgers, Marianne, 43
Burroughs, William S., 117
Byatt, A. S., 91–92, 101

*Cabinet of Dr. Caligari, The* (Wiene), 62–63, 117
Caesar's Palace Mall, Las Vegas, 34
Caffe Bongo, Tokyo (Coates/Nato), 39–40
Calasso, Roberto, 102–103
capriccio, 10–11
Caravaggio, Michelangelo Merisi, 24, 60–69, 75, 110, 124n7
*Caravaggio* (Jarman), 46, 53, 60–69, 91
cento form, 9, 11, 80–81, 83, 93, 95–101
Cervantes, Miguel de, 83–85
Cézanne, Paul, 29
*Chien Andalou, Un* (Bunuel), 77
*Christian III's Monument* (Norgaard), 21–25
cinema, pastiche in, 45–79
*Citizen Kane* (Welles), 44
*City of Angels* (Silbering), 57
*CIVILwarS* (Wilson), 102, 116
Cixous, Hélène, 92
classical, the, 19–21, 24, 32–38
Classical Symphony No. 1 in D-minor (Prokofiev), 8
*Close Reading* (Tansey), 29–30
Coates, Nigel, 39–40
*Coena Cypriani*, 98, 99
collage, 11, 96
column motif, 20, 35–36, 40
comparative arts discipline, xii, 83
*Contradiction and Complexity in Architecture* (Venturi), 32
contrefaçon, 11
"Conversation with Goethe" (Barthelme), 87–88
*Conversation with Goethe* (Eckermann), 86–87
*Conversations sur la Connaissance de la Peinture . . .* (de Piles), 4–5
*Cook, the Thief, His Wife and Her Lover, The* (Greenaway), 46, 48, 70–77
copying tradition, 2–6, 11–12, 24
"Corinthian Capitals Shower Curtain," 40
*Crack Wars: Literature, Addiction, Mania* (Ronell), 103
critical theory, 18, 21
Cronenweth, Jordan, 50
"Crouching Aphrodite" figure, 20
Curry, Ramona, 114
cyberspace, 103

Dada aesthetic, 21, 101, 115–16
Dali, Salvador, 24
*Dancing Ledge* (Jarman), 62
"Dans un roman de Balzac" (Proust), 81
Danto, Arthur C., x, 29, 85
David, Jean-Louis, 67–68
de Man, Paul, 30–31
de Piles, Roger, 4–6, 122n5
*Dead End* (Wyler), 51
*Death of Marat* (David), 67–68
*Death of Virgil* (Broch), 91
Deffoux, Léon, 14, 81, 121n8
*Demoiselles d'Avignon* (Picasso), 107
*Deposition* (Caravaggio), 24
Derrida, Jacques, 29–31, 94, 103, 123n9
*Derrida Queries Paul de Man* (Tansey), 30–31
*Descent from the Cross* (Fiorentino), 62–63
design, postmodern, 38–41
digital simulation, 119
Dimytrik, Edward, 58
*Don Quixote* (Cervantes), 83–85
double-coding, 35, 95, 100
Doyle, Arthur Conan, 30–31
*Draughtsman's Contract, The* (Greenaway), 73
Dubos, Jean Baptiste, 6
Duchamp, Marcel, 24
Dufay, Pierre, 14, 81, 121n8
*Dying Slave* (Michelangelo), 23–24

Eagleton, Terry, 102
Echelles du Baroque, Les, Paris (Bofill), 35–36
Eckermann, Johann Peter, 86–87
Eco, Umberto, 56–57, 95–99, 125n10
*Elémens de littérature* (Marmontel), 7
encyclopedic tradition, 4–6
*Encylopédie*, 3–6
Ernst, Max, 19
Erté, 107
*Europa* (von Trier). *See Zentropa*
"Everything Hurts" (REM), 57
"Express Yourself" (Madonna), 114

"fake" term, 11–12, 16–17, 78
Falconia, Proba, 80
Falk, Peter, 55
*False Mirror, The* (Magritte), 48, 54–55
fashion photography, 107–10
fictional biography, 101–103
*film noir*, 46, 51–52, 58, 60
"Final Problem, The" (Doyle), 30–31
Fiorentino, Rosso, 62–63

*Flaubert's Parrot* (Barnes), 103
Fluxus group, 21
Ford, Harrison, 52
forgery, 7–8, 12, 42, 73
Forstner, Leopold, 16–17
Foster, Hal, ix–x, 119
Franco, Jean, 84
Frankfurt School, x, 82, 123n9
*Frieschütz, Der* (von Weber), 116–17
*Frogs, The* (Aristophanes), 80

Gambon, Michael, 72
*Garden of Delights* (Bosch), 98
Gastel, Giovanni, 110
Gaudi, Antonio, 43
Gaultier, Jean-Paul, 70
Gay, John, 71
Gehry, Frank, 109
*genus grande* style, 56
Georges, Paul, 77
Gielgud, John, 77
Giordano, Luca, 2–3
"Glove, The" (Schiller), 92–93
Goethe, Johann Wolfgang von, 57, 81–82,
    85–90
"Goethe Dies" (Bernhard), 86–87
Grand Hotel Wiesler mosaic (Forstner), 16–17
*grand Odalisque, La* (Ingres), 105
Graves, Michael, 36–38
Greenaway, Peter, 46, 48, 70–77, 124n13
Greenberg, Clement, 82
Grosseteste, Robert, 96
Grove *Dictionary of Art*, 17–18

*Hallucinogenic Toreador* (Dali), 24
Hals, Frans, 73–74
*Hamletmaschine* (Müller), 102
*Hand Submits to the Intellect, The* (Mariani),
    25–27, 60–61
Handke, Peter, 52–57, 123n3
Hanna, Daryl, 51
*Harlequin* (Hockney), 43–44
*Head of Medusa* (Caravaggio), 110
Hearst, William Randolph, 44
Heartfield, John, 12–13
Heffernan, Julie, 42
*Histoire de la Langue Française* (Bruno), 4–6
Hockney, David, 43–44
Hoffman, E. T. A., 77
Hollein, Hans, 39
Hollier, Denis, 85

Holmes, Sherlock, 30, 96
homage, 80–83, 85–94, 108–109
Hopper Edward, 77
Howard, Alan, 72
Humana Building, Louisville (Graves), 36–38

imitation, 12
*Immortality* (Kundera), 88
influence, anxiety of, 81–88
Ingres, Jean-Auguste-Dominique, 105–107
intertextuality, 90–94, 99, 100
Irigaray, Luce, 92
Itami, Juzo, 78

J. Peterman catalog, 110–12
Jackson, Michael, 114
Jameson, Fredric, ix–x, 47, 113–14
Jarman, Derek, 46, 53, 60–69, 75, 91
Jaucourt, Chevalier de, 6–7
Jencks, Charles, 32, 35, 36, 38, 47, 123n8
*Joan d'Arc of Mongolia* (Ottinger), 78
Johnson, Philip, 33, 44, 108–109
Judith and Holofernes motif, 27–29

Kabakov, Ilya, 88–90
Kafka, Franz, 13, 58–60, 78
*Kafka* (Soderbergh), 13, 78
Keitel, Harvey, 79
Kettelhut, Erich, 49
Kieper, Jürgen, 54
*Killing of Frank O'Hara, The* (Leslie), 24
kitsch, 40, 44, 87
Klein, Calvin, 105
Knox, Bob, 105–107
Koons, Jeff, 42–43
Krauss, Rosalind, 18–19
Kundera, Milan, 88

Lacan, Jacques, 29, 92
Lang, Fritz, 46, 49, 55–56, 60, 114
language games, 104–105
*Language of Post-Modern Architecture, The*
    (Jencks), 32, 35, 36, 38, 123n8
*Last Word, The* (Ransmayr), 90–91
"Late Entry into the Chicago Tower Competi-
    tion" (Stern), 36
Ledoux, Claude-Nicolas, 44
Leslie, Alfred, 24
"Library of Babel, The" (Borges), 54
Lichtenstein, Roy, 19
literature, pastiche in, 80–103

# Index

Lodge, David, 102
*Looking Up, Reading the Words . . .* (Kabakov), 88–90
Loos, Adolf, 36
Luhmann, Niklas, 104–105
Lutens, Serge, 107
Lynch, David, 46, 60, 77
Lyotard, Jean-François, 104

Macpherson, James, 81–82
*Madame Bovary* (Flaubert), 103
Madonna, 114–15
Magritte, René, 48, 54–55, 109
*Man Ray Contemplating a Bust of Man Ray* (Wegman), 31
*Man with the Golden Helmet* (Rembrandt), 42
mannerism, 75–76
Mariani, Carlo Maria, 25–27, 60–61
Marmontel, Jean-François, 7, 58, 81
Marsilius of Padua, 96
martyr motif, 23
Marxism, x, 52, 99, 101, 104
McKenna, Stephen, 19–21
Mead, Syd, 50
*Meat Stall, The* (Aertsen), 75
Memphis group, 38–39
*Metamorphoses* (Ovid), 90–91
*Metropolis* (Lang), 46, 49, 60, 114
*Michael Jackson and Bubbles* (Koons), 42–43
Michelangelo, 2–3, 23–24
*Mimesis* (Paolini), 25–26
Mirren, Helen, 72
modernism, 18–19, 82, 101
*Mont Sainte-Victoire* (Tansey), 29
montage, 12–13, 53, 55, 102
motifs, reworking of, 18
Moore, Charles, 33–34
MTV, xi, 113–15
Müller, Heiner, 102, 119
Murnau (director), 78, 117
muse motif, 25–27
music, 7–9, 112–15

*Name of the Rose, The* (Eco), 95–99
Nato (designer), 39–40
*Natural History* (Anderson), 115
neo-classicism, 19–21, 25–27
Nerdrum, Odd, 41–42
Neue Staatsgalerie, Stuttgart (Stirling), 34–35
"New Pluralism," x
*New Yorker, The*, 105–107
Noland, Kenneth, 108, 126n2

Norgaard, Bjorn, 21–25
*Nosferatu* (Murnau), 78, 117
Nyman, Michael, 8, 76

*O, Ilium* (McKenna), 19–21
Ockham, William, 96
opera, 8–9
originality, 16–17, 24, 82, 122n2
*Ossian* (Macpherson), 81–82
Ottinger, Ulrike, 78
Ovid, 90–91

Paget, Sidney, 30–31
painting: in film, 60–77; forgery of, 7–8, 11–12, 16–17; modern, 18–19, 43–44; postmodern, 19–21, 25–31; Renaissance, 1–4; and theory, 29–31
Panini, Giampaolo, 20–21
Paolini, Giulio, 25–26
parody, 13–14, 80–81, 86–87, 92, 100
Pasolini (director), 62–63
"pasticcio" term, 1–2, 4
pastiche: in advertising, 104–12; in cinema, 45–79; in culture, ix–xiii; as homage, 80–83, 85–94; lack of study on, xii–xiii, 1; in literature, 80–103; in music, 7–9, 112–15; negative connotations, ix–x, 21, 82; as term, 1, 2, 4–7, 16; ubiquity of, 118–19
*Pastiches et mélanges* (Proust), 9
*Perfume* (Süskind), 100–101
*Petersburg* (Bely), 93
Piazza d'Italia, New Orleans (Moore), 33–34
Picasso, Pablo, 43, 107
"Pierre Menard, author of Don Quixote" (Borges), 83–85
plagiarism, 14
*Poetics* (Aristotle), 99
poetry, 93
"Politics of Friendship, The" (de Man), 30–31
pop art, 24, 31, 34–35
*Possession* (Byatt), 91–92, 101
postmodernism: in architecture, 24, 31–38, 44, 47; in design, 38–41; in film, 46–79, 83; in literature, 83–103; and pastiche, ix–xiii, 9–15, 24; in philosophy, 94; quotation in, 24; theft in, 68–69; in visual art, 19–31, 41–44, 88–90, 94
"Postmodernism, or The Cultural Logic of Late Capitalism" (Jameson), ix–x
*Postscript to the Name of the Rose* (Eco), 97
Pottery Barn, 39, 40
Prokofiev, Serge, 8

*Prospero's Books* (Greenaway), 76–77
Proust, Marcel, 9, 81, 85, 122n10, 125n5
*Pulp Fiction* (Tarantino), 46, 79

Ransmayr, Christoph, 90–91
Raphael, 3
Ray, Charles, 42
refiguration, 14–15
REM, 57
Rembrandt, 31, 41–42
Reni, Guido, 2–3
Renaissance, 1–4, 23, 122n4
*Ricotta* (Pasolini), 62–63
rococo, 42–43
*Roma Antica* (Panini), 20–21
Romanticism, 100–101
Ronell, Avital, 103
*Rosenkavalier, Der* (Strauss), 9
Rubens, Peter Paul, 18
ruin motif, 35, 38
*Ruin of Kasch, The* (Calasso), 102–103
Ruttmann, Walter, 55

*Saints and Scholars* (Eagleton), 102
Saks Fifth Avenue Folio catalog, 75, 110
sampling, 113
San Simeon mansion, 44
San Vitale mosaics, Ravenna, 97
"Sandman, The" (Hoffman), 77
Santrot, Claire, 15
Sarto, Andrea del, 3
Sassoferrato (copyist), 3
Schiller, Friedrich, 92–93
Schlemmer, Oskar, 108–109
School of Architecture building, Houston (Johnson), 44
Scott, Ridley, 46–54
sculpture, 19–25, 88–90
Shakespeare, William, 76–77, 102, 110
Sherman, Cindy, 27–29, 51
*Sick Bacchus* (Caravaggio), 63–65, 69
*Siegfried* (Lang), 55–56
Silberling, Brad, 57
simulacrum, 15
*Small World* (Lodge), 102
Soderbergh, Steven, 13, 78
*Sorrows of Young Werther* (Goethe), 57, 81–82, 90
Sottass, Ettore, 39
"Stairs and Stripes" (Astor/Bryan), 107–109
Stern, Robert, 36
Sting, 113

Stirling, James, 34–35
Stoppard, Tom, 101
Strauss, Richard, 9
Struth, Thomas, 42
Süskind, Patrick, 100–101

*Tampopo* (Itami), 78
Tansey, Mark, 29–31
Tarantino, Quentin, 46, 79
*Tempest, The* (Shakespeare), 76–77
Terry, Nigel, 63
theft, 68–69
*Theory of Aesthetics* (Adorno), x
*Thomas Howard, Earl of Arundel* (Rubens), 18
*Threepenny Opera* (Brecht/Weill), 71–72
*Touch of Evil* (Welles), 51
*Touched by an Angel* (CBS), 57
*Travesties* (Stoppard), 101
travesty, 15, 31, 97–101
*Trial, The* (Kafka), 58–60, 78
*Trial, The* (Welles), 78
Trumbull, Douglas, 50
*Two Children Are Threatened by a Nightingale* (Ernst), 19

*Untitled No. 224* (Sherman), 69
*Untitled No. 228* (Sherman), 27–29

V-effect, the, 45–46
Van Meegeren (forger), 73
Venice Biennale 1980, 33
Venturi, Robert, 32, 47
Venus motif, 16, 18, 24, 105–107
Vermeer, Jan, 73
"Versace Watches" (Gastel), 110
Vierny, Sacha, 74, 76
Virgil, 80
*Vogue*, 107
Volterra, Daniel da, 3
von Sydow, Max, 58
von Trier, Lars, 48

Waits, Tom, 117
Watteau, Antoine, 16–17
Weber, Carl Maria von, 116–17
Wedgwood Jasperware, 24
Wegman, William, 31
Weill, Kurt, 71–72
Welles, Orson, 44, 51, 78
Wenders, Wim, 46, 52–58, 60
West, Cornel, xi
Wiene, Robert, 62–63, 117

# Index

Williams-Sonoma catalog, 109
Wilson, Robert, 76, 102, 116–17
*Wings of Desire* (Wenders), 46, 52–58
Wittgenstein, Ludwig, 86–87, 96, 102, 104, 111
*Writing to Vermeer* (Andriessen/Greenaway), 73
Wyler, William, 51

*Young Lions, The* (Dimytrik), 58

*Zed and Two Noughts, A* (Greenaway), 73
*Zentropa* (von Trier), 46, 48, 58–60
"Zeus with Thunderbolt," 19–20
Zeuxis (painter), 2

# INGEBORG HOESTEREY

brings her dual background in art history (Berlin) and literary studies (Harvard) to bear on this first book-length study on the elusive genre of pastiche. A professor of Comparative Literature and Germanic Studies at Indiana University, she has published on comparative arts topics since the 1980s, including the 1988 monograph *Verschlungene Schriftzeichen: Intertextualitaet von Kunst und Literatur in der Moderne/ Postmoderne* (*Intertexuality of Art and Literature in Modernism/ Postmodernism*). She has edited several collections of essays, the earliest of which, *Zeitgeist in Babel: The Postmodernist Controversy* (1991), remains the most prominent.

Lightning Source UK Ltd.
Milton Keynes UK
UKOW06f2230240416

272805UK00013B/58/P